SLOW

Food worth taking time over

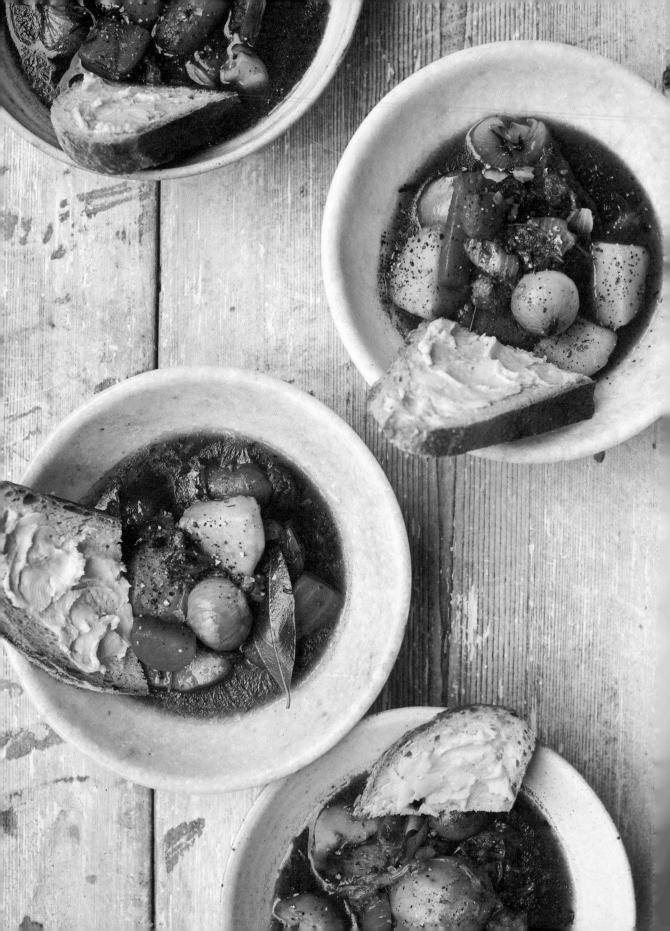

GIZZI ERSKINE

SLOW

Food worth taking time over

To the farmers, the producers, the chefs and journalists who tirelessly and wholeheartedly invest themselves into pushing for a more sustainable future for our world. I am in awe of all of you.

HQ
An imprint of HarperCollins*Publishers* Ltd
1 London Bridge Street
London SE1 9GF

10 9 8 7 6 5 4 3 2 1

First published in Great Britain by HQ
An imprint of HarperCollins*Publishers* Ltd 2018

ISBN 978-0-00-829194-5

Photographer: Issy Croker
Art Director, Props and Food Stylist: Emily Ezekiel
Designer: Dean Martin
Editorial Director: Rachel Kenny
Creative Director: Louise McGrory
Assistant Editor: Celia Lomas

Printed and bound in Great Britain by Bell & Bain Ltd, Glasgow

Contents

Introduction

Sometimes I feel out of sync with the modern approach to cooking, which seems to be all about valuing convenience over quality. Our obsession with ease and speed puts us in danger of failing to appreciate the joys of technique and process, and what it means to pour love and care into the food we are growing and cooking. Cooking shouldn't just be about the final result, it should be about the whole experience, and for me that includes finding the best produce and continually educating myself about the history and heritage of the dishes I cook.

There's no denying that I've spent time sitting at my desk reading reviews of my previous books or work on the internet feeling pretty disheartened. While much of my work has received acclaim, the biggest criticisms I get are that people think my work is more complicated than your average popular chef or food writer, and that I don't support using ingredients that are always easy to find. It's true that I don't make things simple for people. I've wondered whether I should answer the call for quick and easy recipes, whether I should say it's OK to use a stock cube and give alternatives for ingredients I love, such as gochujang paste or black vinegar, but I just can't bring myself to do it.

This is not to say that I haven't done it in the past. Very early in my career, a TV show wouldn't allow me to make my own curry paste as they thought this would be too challenging for its audience, so, despite finding the statement patronizing, I used the most basic of supermarket pastes. A different show wanted me to cook a braise in under an hour using chuck steak cut into small cubes. The results are out there for all to see, embedded in the internet; I still panic at the idea of them. At the time I knew I shouldn't have gone against my instincts, and now – even with the knowledge that I was young and malleable, and that as I've grown I've become more comfortable with the way I operate as a food writer – they still devastate me.

These examples may not sound that bad, but I see my job as a position of responsibility, being lucky enough to be out there educating people on how to cook. I accept that I run the risk of going against the grain, but what defines me as different is that I really really prefer doing things properly and that is how I want to demonstrate what I do. Unless something is naturally easy or quick, I don't cook in the easiest, fastest way. I love technique; I enjoy finding out the correct way to do something and investing the time and effort in ensuring it's made as well as possible.

The kick I get from cooking is the same now as when I first started. The day I made my very first stew is still etched in my memory: the anticipation of seeing a dish develop from raw whole ingredients, rolling my sleeves up and working out the right way to chop them, brown them, braise and bake them. I trusted my mother's advice as she dictated how things should be done, for she had done this a million times before and I knew of no one better equipped to teach me. Her stews, all gelatinous and sticky, were the best I'd tasted. I wanted to learn to make stew because that was the food that meant family. Coming home to the smell of a stew cooking made me feel cosy. It made me feel safe. It still does.

Now don't get me wrong, simplicity is something I value enormously. One of my favourite things to eat is a simple tomato salad. It can be really good, if maybe a little bit ugly, when made using tomatoes that are just a bit overripe and that have been slow-grown in soil. The journey of these tomatoes is wholly different from that of mass-produced Dutch 'double end' tomatoes, grown in nutritionless blue fluff in rows and rows of glasshouses in Holland. You know the type of tomato I mean? They're grown for yield, as money-makers; pumped full of growth promoters and poisoned with insecticides. These are the tomatoes that big corporate food producers palm off on the consumer, who often doesn't really understand the difference between various tomatoes, as the packaging is designed to allow each type to masquerade as a premium product. I mean the sexy little 'Italian' numbers that are rarely from Italy or Spain or anywhere Mediterranean as the packaging suggests, but mainly from Holland.

Now if you're the dream tomato – and I have this on great authority from one of the best greengrocers in the biz, Andreas Georghiou from Andreas on Chelsea Green – you live in the south of Italy on the Amalfi coast of Naples. The tomatoes are irrigated naturally as the 'magic mist' of the salty sea water is spritzed up into the air above the nutrient-dense charcoal and peaty soil of the volcanic hills. Here the tomatoes grow at a slow and steady pace, and the salt-water irrigation naturally fights off bugs while infusing the tomatoes and bringing out more flavour. You're the dream tomato; you smell of the sea, you smell as a real tomato should smell! These kings of the tomato world are called San Marzarno tomatoes. You wouldn't dream of eating them in any other way than raw and just a fraction beyond firm with salt and a trickle of the decadent first pressing of olive oil – and if you have it, a dash of high-quality reduced sherry vinegar, such as Capirete or El Majuelo.

What I'm saying is that this is the food and method of production that I value, and while I appreciate that it is not always available to everyone, it acts as a metaphor for the ideal approach to recipes. You can enhance the simplest ingredient with the same amount of care and attention and this will yield the same kind of experience as eating that magical tomato.

I also see this approach as one you can apply to all areas of modern consumption; if you value the ingredients you buy more highly, you are more likely to cook properly with them, less likely to create waste, less likely to consume more than you need. We cannot continue to live at our current relentless, reckless pace with no consideration for the impact it is having on the world around us, let alone our personal health. We need to start being more conscientious and considered. With this in mind, my book is focussed towards vegetables, meat and dairy products that have been produced with the same investment of time, energy and care.

We all need to reduce our consumption of meat, but I want this book to challenge the way in which you buy it, in order to ensure that the meat you *do* buy is of the highest possible quality. I also want to encourage you to try more unusual and economical cuts, to make use of the whole animal and respect and value the idea of eating meat. This to me is the most modern way of eating; realistic but aware! I've started to focus away from organic produce, instead seeking out slow-grown, ethically and properly produced food. By looking into the background of the ingredients we buy we can educate ourselves about where our food is coming from, and I guarantee that the best-quality food will be the tastiest, and will have the added bonus of offering the highest nutritional value.

Home is where the heart is. I don't know many chefs who value the food cooked in their restaurants more highly than home cooking. The modern dialogue we really need about home cooking should focus on learning how to slow things down. I know we live in a world where we work too much and have less and less time, but cooking purely for speed frustrates me – especially when I think back to my mother's stew. This was a weeknight supper and not always reserved for the weekends. So how do we find the time to cook like that these days?

I'm not living in some kind of fantasy land where I believe we all have time to spend hours cooking every day. But I guarantee that a well-spent Saturday afternoon in the kitchen, investing in the perfect stew or ragu, or even just an evening a week when

you park the troubles of the day and create nourishing soulful food, is attainable. So I hope to inspire you to get stuck in, enjoy the techniques and evaluate the food you eat in order to positively influence your health, your soul and the world.

Writing a cookbook and dividing the recipes into chapters is always hard. It often becomes complicated, as some recipes can serve a purpose in many chapters. In essence the techniques I offer here are quite simple. They cover methods of poaching, braising and stewing, as well as steaming, baking and salt baking, roasting and understanding heat, and also making the doughs and pastries we often allow the supermarkets to make for us. You will find notes that help to link recipes together and a whole chapter of useful basic recipes. I want this book not only to inspire and broaden your repertoire, but also to help you really get to grips with expanding your cookery skill set and make you a more confident and conscientious cook.

SOUPS AND STEWS

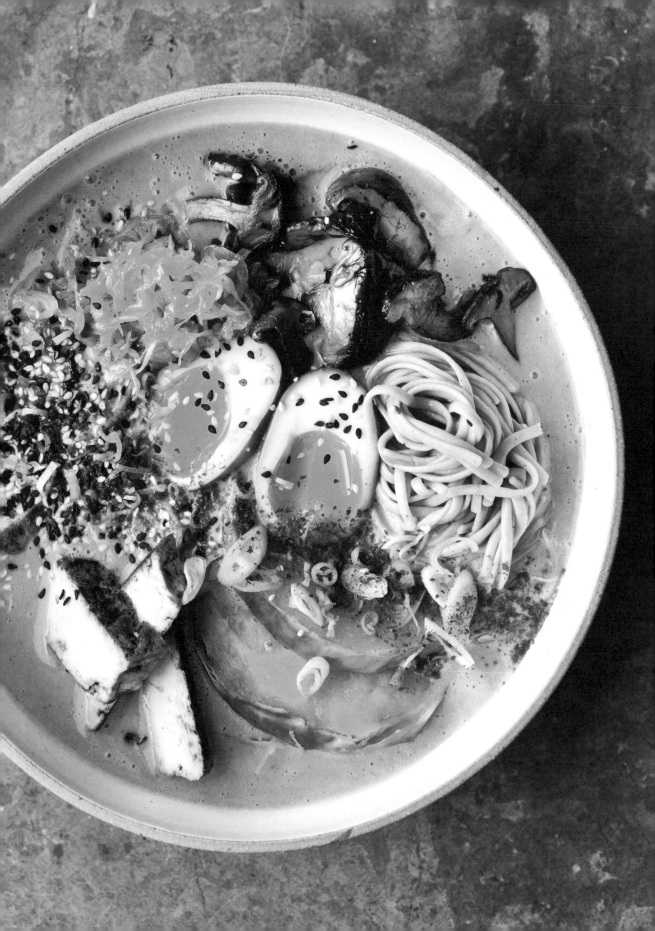

Curry Soy Miso Ramen with Roast Butternut Squash, Tofu & Kimchi

Vegan ramens tend to lack body and viscosity, and I wanted to make one which had the same depth of flavour as a tonkotsu – the king of ramens. I use an old Japanese technique of making a miso and soy milk broth and it's good (I eat it a lot) but then I add a curry base to the broth and there is no meat eater out there who would argue that this soup base doesn't have everything that you would ever want. The toppings are the extras that I like: the roasted butternut squash goes so well with the curry, the tofu adds protein and the kimchi acidic spice. I've also popped some shiitake mushrooms in there too and finished with sesame and Korean chilli pepper. Leave the eggs out to make this an entirely vegan dish.

In a medium casserole, heat the oil over a medium heat and add the onion. Allow to soften for about 15 minutes to develop their sweet flavour before adding the garlic and ginger. Sweat for a further 3–4 minutes before adding the spices. Next add the soy bean chilli oil and give this a couple of minutes on the heat, before adding the water. Whisk in the miso paste, followed by the mirin, nutritional yeast, Marmite, soy and sugar. Allow the sauce to reduce on a low simmer for 30 minutes and then add the soy milk. Transfer to a food processor and blitz until smooth, then return to the pan.

Meanwhile in a frying pan heat a glug of oil and fry the mushrooms over a high heat for 5 minutes until they start to caramelise, then set aside. Return the pan to the heat, add a little extra oil if necessary, ramp up the heat and fry the tofu for a minute on each side, or until really charred. Put the teriyaki sauce in a bowl, add the tofu and the eggs and coat thoroughly. Set to one side.

When ready to serve, divide the noodles between two ramen bowls and pour a quarter of the soup base into each bowl. Slice the eggs in half and place on top. Slice the tofu into strips and arrange next to the eggs, followed by the butternut squash and kimchi. Finally, sprinkle the spring onions, chilli powder and sesame seeds over the top and serve immediately.

SERVES 2 (MAKES ENOUGH SOUP FOR 4)

Preparation time 30 minutes
Cooking time 1 hour

2 tbsp coconut, light rapeseed or groundnut oil, plus extra for frying
1 onion, finely chopped
6 garlic cloves, roughly chopped
3cm piece of ginger, peeled and roughly chopped
2 tbsp curry powder (English or Malaysian)
1 tsp ground coriander
½ tsp turmeric
1 tbsp soy bean chilli oil (Chinese, Thai or Japanese)
1.2 litres boiling water
200g white miso paste
3 tbsp mirin
1 tbsp nutritional yeast
1 tsp Marmite
2 tbsp dark soy sauce
1 tbsp palm or brown sugar
400ml soy milk
200g shiitake mushrooms, sliced
200g firm tofu, cut into thick slices
100ml teriyaki sauce
2 free-range eggs, boiled for 6 minutes, quickly cooled in iced water and peeled
90g buckwheat noodles per person, cooked until al dente and refreshed in iced water
3 slices roasted butternut squash per person (see page 186)
2 heaped spoonfuls kimchi
2 spring onions, thinly sliced
½ tsp Korean chilli powder
1 tsp sesame seeds

Souped-up Kimchi Jjigae

A few years ago, I lived in Korea for almost six months while filming a show about Korean food. So believe me when I say Koreans live on kimchi – they have it for breakfast, lunch and dinner. But if you ask any Korean what their favourite dish is, they will all say jjigae. A jjigae is a stew and it's the heart of Korean home cooking. Most people love Doenjang Jjigae which is made with the famous Korean miso paste, but the real red-blooded Korean loves Kimchi Jjigae with its gochujang spiced base and heaps of shredded kimchi. Classically it is made with pork belly, but the Buddhists (who abstain from groin-rumbling fiery chillies) make it without so it can be made vegan with vegan kimchi. The reason this is souped-up is because, although the Koreans call it a stew, I've made it a little more brothy. If you want to add carbs you can cook some Korean sweet potato glass noodles and add them to the base.

SERVES 4

Preparation time 20 minutes
Cooking time 30 minutes

splash of rapeseed oil
100g pork belly, thinly sliced or unsmoked bacon (omit if vegetarian)
2 onions, thinly sliced
1 tbsp gochujang paste if you like it spicy or 1 tbsp doenjang paste if you prefer it milder
2 garlic cloves, grated
2cm piece of ginger, peeled and grated
1–2 tbsp Korean chilli powder
1 litre fresh chicken or vegetable stock
400g kimchi, shredded
300g silken tofu, drained and cut into 12 slices
3 spring onions, finely chopped
sesame seeds and toasted sesame oil, to serve

First heat a deep-sided frying pan over a high heat. Add a splash of oil followed by the pork belly or bacon. You want to render some of the fat and crisp it up, so fry it for about 8 minutes, moving it around the pan regularly. Once the pork is looking nice and caramelised, remove it with a slotted spoon and set aside. Add the onions to the pork fat and fry for about 5 minutes until they begin to soften and go translucent. (If you are making a vegetarian version, omit this stage and just fry the onions in a little rapeseed oil.)

Next add the spice paste of your choice. I prefer gochujang as I like a bit of extra kick, but you can get a great complexity of flavour from doenjang paste. Give this a stir and add the garlic, ginger and chilli powder and allow to sweat for a few minutes before adding the pork belly. After a couple more minutes pour in the stock. Bring this to the boil and allow to simmer for about 15 minutes. Finally, add the kimchi and simmer for a further 10 minutes.

When you are ready to serve, divide the soup between four bowls. Layer 3 slices of tofu per person on top of the soup, along with a sprinkling of spring onions, sesame seeds and a drizzle of toasted sesame oil.

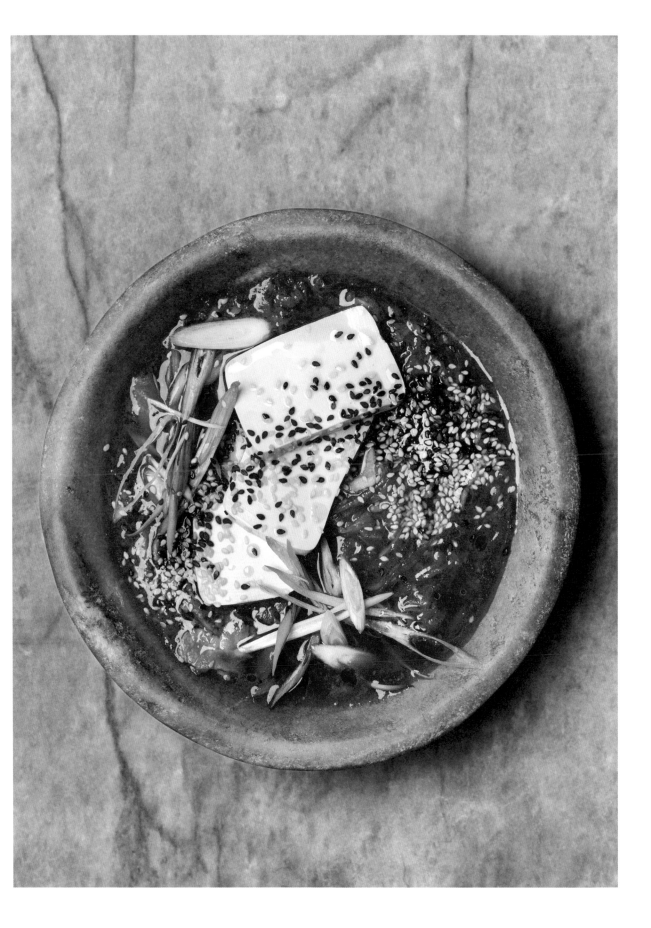

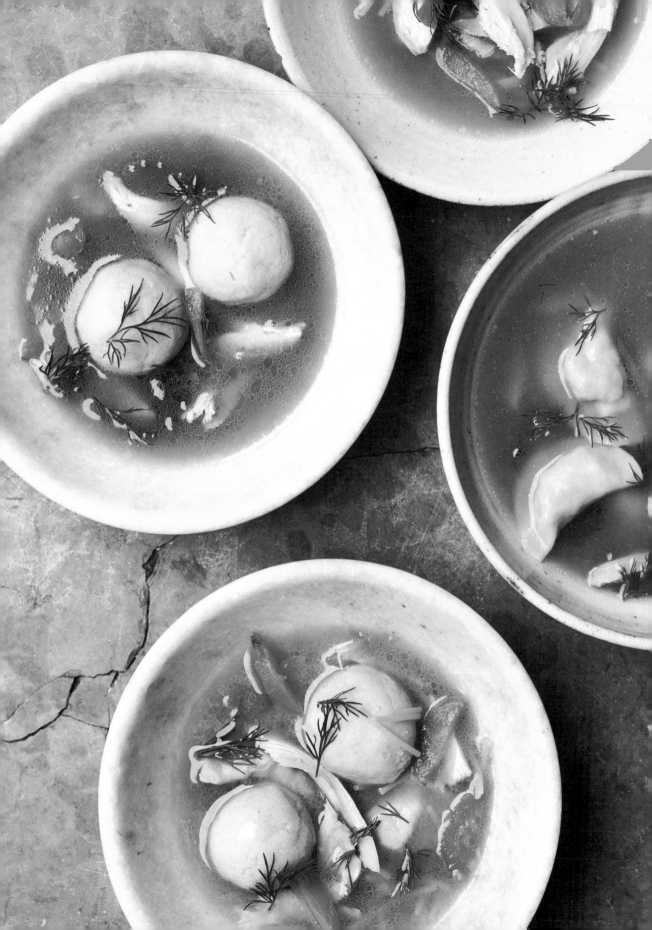

Jewish Chicken Soup

I love Jewish culture. Although I was not brought up within a religion, I think it's probably ingrained in me because of my grandparents. My grandmother was from Scotland and flitted between Communism and Buddhism before marrying a Pole who had escaped Nazi Poland during the war. My grandfather (who worked as a pharmacist, exporting pharmaceuticals back into a bleak post-war Poland) wasn't religious, not after all the atrocities he'd seen during the war, but he was brought up as a Jew before converting to Catholicism to escape Nazi rule. As a result, a lot of Jewish and Polish foods slipped into the meals we ate – and still eat – as a family.

Most of you will have tried a classic Jewish noodle soup, otherwise known as Jewish penicillin, thanks to its fabled power to cure every ailment. The soup is often served with matzo balls: dumplings made from fine crumbs of matzo crackers, which are a bit like water biscuits. They are sturdy little balls and make the soup much more filling. I am a greedy guts, so I like to serve my soup with kreplach dumplings too.

Most Jewish friday night suppers start with a hot bowl of this soup. I make mine with both a whole chicken and a really good chicken stock. Some might argue that you don't need the chicken stock as the chicken will make its own soup, but for me there is never enough stock by the time it's reduced. Always use fresh stock.

Place the chicken in the largest pot you have. You need about 3cm of space around the edges of the chicken and about 3cm of depth above it so it can be totally immersed in liquid. Lay the vegetables and herbs around the chicken, then pour over the stock. Top up with water if necessary so the chicken is totally covered. Add the peppercorns and salt. Cover and allow to poach gently on a low simmer for 1 hour 30 minutes.

When cooked, very carefully remove the chicken and set it aside. Remove the carrots and onion halves, set them aside to cool with the chicken for 15 minutes, then chop them up. I like the chicken meat torn into small bite-size pieces, the onions finely chopped and the carrots more roughly chopped. You can use the rest of the veg,

CONTINUED »»

SERVES 6. DEPENDING ON HOW HUNGRY YOU ARE

Preparation time 15 minutes
Cooking time 2 hours

1 large chicken of the best quality
 and ethical standing you can afford
2 medium onions, halved
2 large carrots, left whole
1 leek, trimmed but left whole
handful of celery leaves
3 bay leaves
few sprigs of thyme
2–3 sprigs of rosemary
500g fresh chicken stock (from the
 chiller cabinet)
1 tsp black peppercorns
½ tsp salt
sea salt and freshly ground black
 pepper

To serve (per person)
⅙ of the soup
30g Jewish noodles or vermicelli
2 matzo balls (see page 19)
3 kreplach (see page 19)
dill sprigs

though classically the soup is only served with carrots. There will be a fair bit of chicken meat and I sometimes keep a breast for making sandwiches. Put the meat on one side while you make the broth.

Strain the vegetables, herbs and peppercorns from the stock. Clean, rinse and dry the pot and pour the stock back into it. Bring to the boil. Reduce it for about 15 minutes, or until the broth has a really intense chicken flavour. You should end up with about 3 litres of really flavoursome broth. Keep reducing it until the flavour is right. Season with salt and pepper, return the chicken meat, carrots and onions to the pan and bring back to the boil.

Meanwhile poach the noodles and/or the matzo balls and kreplach. Add these to your soup bowls, garnish with some hand picked dill and ladle the hot chicken broth, carrots and onions over the top.

Matzo balls

When testing this I discovered that the recommended resting period was essential to allow the matzo meal to absorb all the liquid.

Put the matzo meal in a bowl with the eggs, shmaltz, chicken stock, baking powder, white pepper and salt. Mix together well until you have a wet dough and then leave to rest in the fridge for 30 minutes.

Put a large saucepan of salted water on to boil and shape the dough into 16 balls. When the water boils, poach the balls for about 5 minutes until they rise to the surface. Then add them to the soup along with the noodles and chicken.

MAKES 16 PING-PONG-SIZE BALLS

Preparation time 5 minutes, plus
 30 minutes resting
Cooking time 5 minutes

100g matzo meal
2 medium free-range eggs, whisked
50g schmaltz (chicken fat), ghee or
 clarified butter
100ml chicken soup or extra
 chicken stock
½ tsp baking powder
¼ tsp white pepper
1 tsp salt

Salt beef kreplach

I've used leftover salt beef (see page 58) to make these and although it's not traditional, I prefer them to the classic beef ones.

You need either a table-top mixer with a dough hook or a food processor. Blitz together the flour, eggs and fat. The dough should come together and look like lots of small pebbles of pastry. Turn it out of the bowl and knead for about 2–3 minutes until it is firm and shiny. Cover and leave to rest in the fridge for 20 minutes.

Cut the dough into 4, take one quarter and cover the rest with a warm damp towel. Roll out the first quarter. You shouldn't need much (or any) flour and sometimes it's better to roll with semolina to prevent the kreplach becoming sticky when you poach them. Use a 9cm cutter to cut rounds of dough as if you were making ravioli. Place a large teaspoon of the salt beef and onion filling into the centre of each disc of dough. Brush the edges with water or egg and fold the outside rim to close like half moons. Place the made dumplings onto a tray lined with greasproof paper and scattered with a little semolina flour if possible. Continue with the rest of the dough.

Cook this like fresh pasta: bring a large saucepan of salted water to the boil and cook the kreplach for 4 minutes. Drain and add to the soup.

MAKES 48 DUMPLINGS

Preparation time 10 minutes, plus
 20 minutes resting
Cooking time 4 minutes

300g 00 grade pasta flour
3 medium free-range eggs
1 tbsp beef dripping or chicken
 schmaltz
500g leftover salt beef (you can use
 raw minced beef chuck and a little
 beef fat)
1 onion cooked in the chicken soup,
 or 1 onion cooked slowly for
 15 minutes in oil or beef dripping,
 mixed with the salt beef

Under the Weather All the Veg Soup

SERVES 6

Preparation time 20 minutes
Cooking time 30 minutes

2 tbsp olive oil
2 onions, finely chopped
4 garlic cloves, finely chopped
2 leeks, halved and shredded
few sprigs of thyme, leaves picked
1 bay leaf
200g pearl barley
2 litres vegetable or chicken stock
1 large courgette, quartered then
 thinly sliced
bunch of cavolo nero, finely
 shredded
2 large spring onions, finely shredded
pinch of cayenne pepper
large pinch of white pepper
juice of ½ lemon
large handful of parsley, finely
 chopped
sea salt and freshly ground black
 pepper

In the grisly months when the weather is bringing you down both physically and emotionally, you can rest easy that at least winter provides you with some of the most important vegetables for your health. This soup is the perfect restorative – the barley is wholesome, the greens are health-giving and the broth will bring you back to life.

In a large heavy-based saucepan, heat the oil over a medium heat and add the onions. Cook for about 15 minutes until they have softened and started to go golden, before adding the garlic. Cook for a further minute or two, then add the white part of the shredded leeks (keep the green part for later), the thyme and bay leaf. Allow the leeks to soften for about 5 minutes. Next mix in the pearl barley and cook it for a minute before pouring in the stock.

Cook at a medium simmer for about 25 minutes until the pearl barley has cooked through but still retains some bite. At this stage add the courgette, cavolo nero, the green part of the leeks and the spring onions. The vegetables will only take a few minutes to cook through. Before serving season with the cayenne pepper, white pepper, black pepper, salt, lemon juice and parsley.

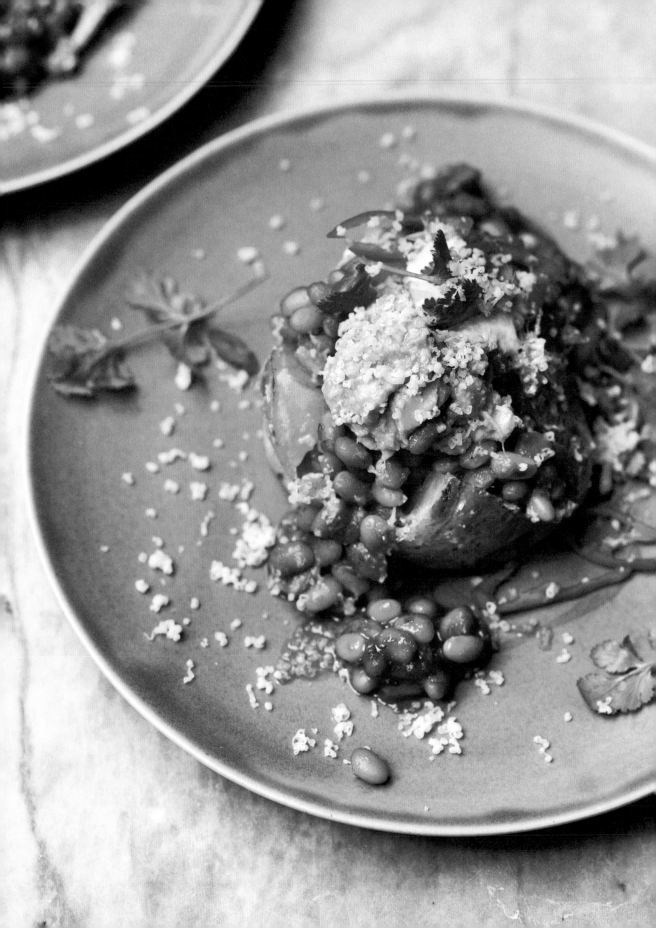

Boston Beer Baked Beans

Here we have haricot beans that have been slowly cooked in tomatoes, white wine, beer, vinegar, stock and spices until they become slick with this piquant sauce. You can eat these with a fry-up if you like, but they should really take centre stage. I love them stuffed into a jacket potato and topped with grated cheese, guacamole, sour cream, pico de gallo, jalapeños and fresh coriander.

Soak the beans overnight in plenty of cold water. The next day, drain and rinse the beans and put them in a heavy, ovenproof casserole and add fresh water to come about 10cm above the beans. Bring to the boil and cook for 10–15 minutes, then turn the heat down to a simmer for about 1 hour until the beans are tender but not completely soft. Drain and leave to one side.

Heat the oil in a medium casserole and slowly brown the onions for 10–15 minutes. Add the halved garlic, cut side down, for the last minute of cooking so it starts to caramelise. Next add the passata, white wine, beer and stock and bring to the boil. Mix in the brown sugar, vinegar, black treacle, mustard, cumin seeds, thyme, cloves and black pepper. Simmer this sauce for 30 minutes. Your sauce will be pretty loose, but fear not as it will have a few more hours cooking in the oven with the beans.

Preheat the oven to 150°C/130°C fan/gas mark 2. Put the sauce in a blender and blitz for a minute, or until super smooth. Wash out the casserole and put the beans and sauce back into it. Put on the lid and bake in the oven for 3 hours. The beans should be cooked through and the sauce should coat the beans with some slight charring on the edge. If the sauce is too thin, remove the lid and reduce it on the hob until it is thickened and full of flavour. Season with salt and pepper and you're ready to serve.

SERVES 4

Preparation time 30 minutes
Cooking time 4 hours 30 minutes

300g dried white haricot beans
2 tbsp rapeseed oil
2 onions, finely chopped
1 garlic bulb, halved
300ml passata
250ml white wine
250ml Boston beer
500ml fresh gelatinous chicken or
 vegetable stock
2 tbsp soft brown sugar
2 tbsp sherry, red wine or cider
 vinegar
1 tsp black treacle
1 tbsp English mustard
1 tbsp cumin seeds, toasted
few sprigs of thyme
good pinch of cloves
sea salt and freshly ground black
 pepper

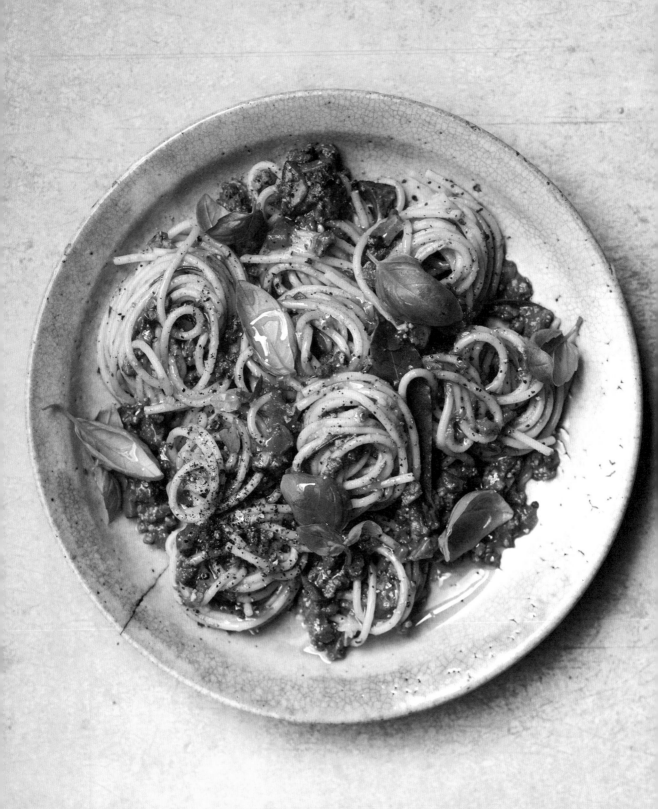

Planet Friendly Bolognese

This vegan spag bol has been niftily made, carefully building layers of flavour so that even the most hardened meat eaters won't feel that they're missing out. The base begins in the same way, with a really buxom soffrito, but in place of the meat, I've used soy mince (Sainsbury's own frozen is the best I've tried) and a combination of fresh and rehydrated dried mushrooms with a smoky tofu chopped into a mince. It's imperative to use all three as they each add something different. This, along with the umami dense miso, mushroom stock, Marmite and nutritional yeast, gives you an outstandingly 'meaty' finish without harming a soul, as well as boosting the nutritional value to a level that a normal spag bol could only dream of. This makes stacks and freezes brilliantly, so it's a perfect batch cook recipe.

First rehydrate the dried mushrooms. Empty both packets into a small bowl and cover with 1 litre of boiling water. Place a smaller bowl on top and leave for 20 minutes while you chop up your vegetables. When rehydrated, chop the mushrooms fairly finely to resemble mince, making sure you reserve the water.

Heat a decent slug of olive oil in the largest flameproof casserole you own (I use a deep Le Creuset casserole 30cm wide), then put the onions, carrots, celery and leeks into the pan and sweat them slowly for about 20 minutes, stirring every so often. Add the garlic for the last few minutes to soften. Ramp up the heat and add the tomato purée. You want to cover all the veg in the purée and start to caramelise the edges of the vegetables. This takes about 5–10 minutes.

Pour in the wine and cook for 10 minutes. Add the blitzed tomatoes, lower the heat and let the sauce cook for 15 minutes while you prepare the rest.

In another pan fry the fresh mushrooms, the soy mince and tofu, together with the rehydrated mushrooms. Just as when you cook meat, you want a dark golden caramelisation over the outside of the mushrooms and soy, and to get that you will have to fry in batches. I did it in about 5 or 6 and it takes a bit of time. When each batch is nicely caramelised, transfer to a plate.

CONTINUED »»

SERVES 15

Preparation time 30 minutes
Cooking time 1 hour 30 minutes

1 x 50g packet dried porcini
 mushrooms
1 x 50g packet dried shiitake
 mushrooms
olive oil, for frying
2 large onions, finely chopped
2 carrots, finely chopped
2 celery sticks, finely chopped
2 leeks, finely chopped
1 head of garlic, cloves finely
 chopped
2 tsp tomato purée
300ml white wine
400ml red wine (or wine of any
 colour)
2kg fresh tomatoes,
 blitzed into a purée
120g fresh shiitake mushrooms,
 roughly chopped
300g portobello mushrooms,
 roughly chopped
250g chestnut mushrooms,
 roughly chopped
1 x 500g packet frozen soy mince,
 defrosted
300g smoked tofu, whizzed in a
 blender
2 tbsp white miso paste
1 tsp Marmite
1 tbsp nutritional yeast flakes
3 sprigs of rosemary
6 or 7 sprigs of thyme
3 bay leaves
500ml vegetable stock
½ tsp celery salt
½ nutmeg, grated
sea salt and freshly ground
 black pepper
basil leaves, to serve

Add the caramelised soy, tofu and mushrooms to the tomato sauce, with the miso, Marmite, yeast, herbs, reserved porcini water and vegetable stock and leave to braise with the lid off for 1 hour. Keep stirring and scraping the bottom every so often to prevent the sauce catching.

After an hour it should be rich, well reduced and full of flavour. Season with the salts, pepper and nutmeg and then you're ready to cook your pasta. I usually cook about 90g pasta per person, and reduce the cooking time by a minute or two. I like to finish the dish in the traditional way by mixing the sauce with the pasta over a medium heat, which completes the cooking of the pasta and binds everything together nicely. I suggest about 2 ladles of sauce per person – be generous! Scatter over basil leaves to serve.

Blonde Ragu with Pork, Veal & Sage

I'm going to go out on a limb here and claim that not many Brits have eaten a blonde meat sauce. It's probably the least known of all the ragu pasta sauces, and this is a shame, because it's really delicious. It's cooked in almost exactly the same way as the other sauces: a mix of butter and olive oil, soffrito (I use garlic although classically you don't), veal and pork mince, pancetta or smoked bacon, all the woody herbs, but then instead of tomato you add white wine and milk and finish the sauce with cream, sage, lemon zest and nutmeg. The sauce clings to the pasta – always use a wide variety such as pappardelle or tagliatelle – and is then finished with loads of freshly grated Parmesan.

Any leftover ragu works really well on a pizza or in a grilled cheese sandwich. Strange but fantastic.

SERVES 8

Preparation time 45 minutes
Cooking time 2 hours

4 tbsp olive oil
2 tbsp butter
2 large onions, finely chopped
2 medium carrots, finely chopped
2 leeks, trimmed and finely chopped
2 celery sticks, finely chopped
6 cloves of garlic, finely chopped
400g pork mince
400g veal mince
200g piece of smoked bacon or
 pancetta, skinned, trimmed,
 chopped and minced in a
 food processor
3–4 bay leaves
3 sprigs of rosemary
few sprigs of thyme
400ml dry white wine
1 pint whole milk
1 pint fresh chicken stock
300ml double cream
zest of 2 lemons
leaves of ½ small bunch of sage
½ nutmeg, grated
½ tsp freshly ground black pepper
Parmesan, to serve

Heat 2 tablespoons of the oil and 1 tablespoon of the butter in a large flameproof casserole. Add the onions, carrots, leeks, celery and garlic and cook over a very low heat for about 30 minutes, or until they have softened, lost all their water and are tinged with a golden hue.

Meanwhile heat a frying pan until very hot, add the rest of the oil and brown the pork and veal mince together with the bacon or pancetta in batches. Transfer the meat and any juices to the casserole. Add the bay leaves, rosemary and thyme and then pour over the white wine. Bring to the boil and cook for 5 minutes, then pour over the milk and stock. When the liquid comes to the boil, lower the heat and partially cover the casserole with a lid. Cook gently for 2 hours.

The sauce is ready when the meat is cooked and the sauce reduced and super-rich. At this point pour over the cream and add the lemon zest, sage leaves and nutmeg and give everything a good stir. Let this cook for a further 5 minutes to reduce a little and take on these last flavours. In the meantime cook your pasta. Season the sauce and then pour a couple of ladlefuls over each portion of pasta and serve with Parmesan and lots of black pepper.

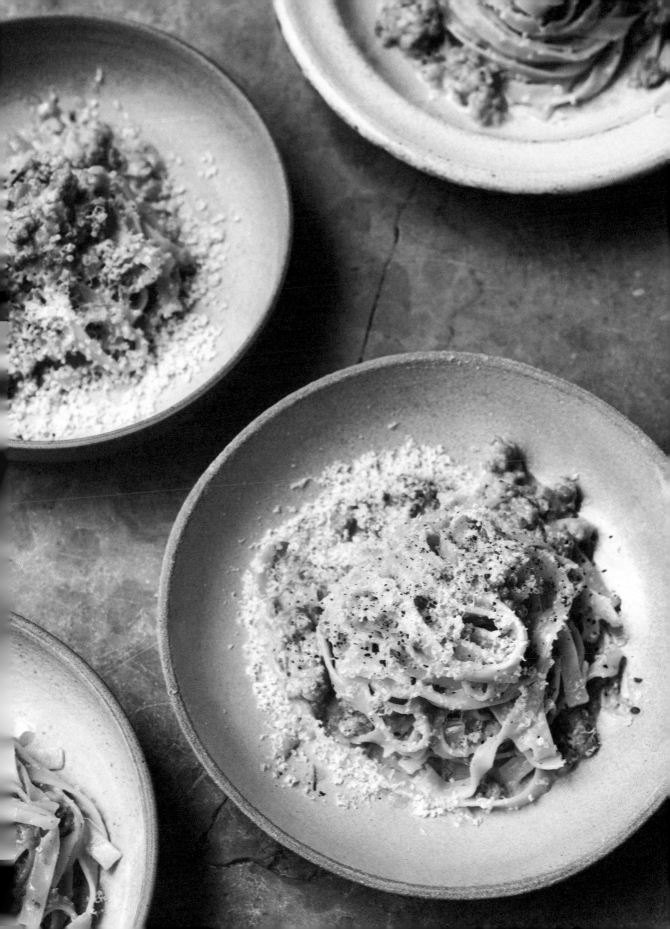

Beef & Potato Stew

When making a stew, I always favour ox cheek, oxtail or featherblade because they cook into juicy, falling-apart meat and a mouth-sticking braise, which is what makes them so perfect for dishes like this one.

When cooking simple dishes like this, it's important to remember that the quality of ingredients is key. Always use fresh stock, rather than a cube – the flavour and consistency of the stew just won't be the same without. If you don't have time to make your own, you can find fresh stock in the chiller cabinet of most supermarkets – I think Truefoods or Waitrose stocks are the best and I have a freezer full of them.

I always serve this stew with mash (when I said this on social media I was told I was insane, although you will be hard pushed to convince me that double potato is ever a bad thing), but you can also serve with buttered crusty white bread if you prefer!

SERVES 4

Preparation time 25 minutes
Cooking time 3 hours 10 minutes

olive or rapeseed oil or ghee, for
 frying
2 ox cheeks (roughly 900g), each cut
 into 6 pieces
10 small onions or shallots, peeled
 but left whole
1 bay leaf
2 sprigs of rosemary
few sprigs of thyme
2 carrots, halved lengthways and cut
 into 6cm pieces
1 tbsp plain flour
500ml fresh beef stock
1 leek, cut into 4 long sections
400g potatoes, peeled and cut into
 chunks
handful of parsley, chopped
sea salt and freshly ground
 black pepper

First, get a frying pan really hot and put in 1 tablespoon of your chosen fat. Season the ox cheek pieces well with salt and pepper and brown them in batches. Remove them from the pan once nicely caramelised and set aside.

In a heavy-based casserole, heat another couple of tablespoons of fat and throw in the onions and the bay leaf, rosemary and thyme. Allow to cook for 5 minutes over a higher heat than normal, until the onions start to soften and caramelise a little at the edges. Next add the carrots and cook for a couple more minutes, stirring regularly.

Stir in the flour and allow to cook for a couple of minutes. Add the stock and the leeks, followed by the ox cheeks and their residual juices. If necessary top up the casserole with water so that everything is just covered with liquid. Bring to the boil, then reduce the heat to a simmer and cover with a lid.

Allow the stew to cook gently for 2 hours 30 minutes. After this time, add the potatoes to the stew, stir gently, replace the lid and cook for a further 40 minutes until the potatoes are cooked through and the meat gives way when pushed. Check the seasoning and stir in the parsley. Turn off the heat and leave the stew to rest with the lid on for 10 minutes before serving with crusty bread and butter – or double up your potatoes and serve with creamy mash.

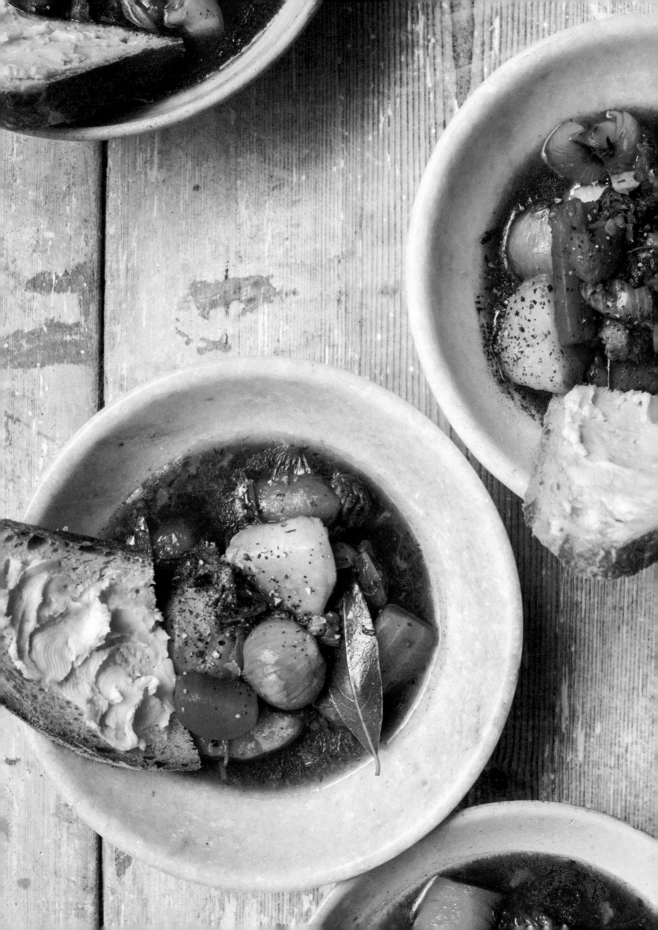

Ox Cheeks Stewed with Wine & Beer

This dish started as a boeuf bourguignon but has evolved into something a bit different. Simply, boeuf bourguignon is a beef and red wine stew. Purists believe that it should be made with a whole bottle of wine, use no stock and that the stewing veg should remain in the sauce. Needless to say, it's delicious like this, but I've refined it by adding ox cheeks, which contain a mammoth amount of tooth-sucking gelatine and make for sticky, soft, falling-apart meat and a glossy sauce. I also add stock (for an even glossier and stickier sauce) and use a heady mix of wine, beer and spices to really bring it to life. I strain out the veg and I've ditched the classic bourguignon accompaniments as this is now a new dish with its own identity.

A note about the wine: Burgundy is famous for being home to some of the best vineyards and wines in the world. I love a glass of red wine and if I have the dosh always go for a good Burgundy over any other. I find Burgundy wines much lighter and more refined in flavour than other red wines.

SERVES 4

Preparation time 40 minutes
Cooking time 5 hours

3 tbsp olive or rapeseed oil or ghee
2 ox cheeks each weighing about
 900g, cut in half
2 onions, roughly chopped
2 carrots, roughly chopped
1 leek, roughly chopped
1 head of garlic, cut in half
 horizontally
1 tbsp tomato purée
2 tsp plain flour
500ml full-bodied red wine
300ml decent ale (as dark as you like
 for flavour)
500ml fresh good-quality beef or
 veal stock
handful of celery leaves
1 bay leaf
2 sprigs of rosemary
4–5 sprigs of thyme
4–5 parsley stems
½ star anise
3 cloves
2 tbsp butter, ice-cold and cut into
 cubes
1 tbsp chopped parsley
sea salt and freshly ground
 black pepper

Preheat the oven to 160°C/140°C fan/gas mark 3. Heat a frying pan until really hot and pour in a tablespoon of oil. Season the ox cheeks all over and then fry them for 2–3 minutes on each side to caramelise the outside. Remove from the pan and set aside. Deglaze the pan with water or wine, scraping away at the base to pick up all the meaty residue. Pour the liquid into a cup and save for later.

Heat the remaining 2 tablespoons of oil in a medium lidded casserole and add the onions, carrots and leek. Fry them over a medium heat for 5–8 minutes. For the last minute ramp up the heat and make space in the pan for the halved garlic bulb. Fry until the cut faces are golden, then remove from the pan and set aside with the ox cheeks. Keep the veggies moving around the pan while frying the garlic.

Now add the tomato purée and fry the vegetables until they are caramelised. Add the flour and coat the vegetables then cook for 1 minute. Pour over the wine, beer, stock and reserved glazing liquid and bring to the boil. Turn down the heat to a simmer and add the ox cheeks and garlic halves. Add the celery leaves, herbs and spices and then pop the lid on and put in the oven for 3 hours 30 minutes until the meat has become springy because the gelatine has softened and the sinew is starting to melt away.

Remove the cheeks from the stew, being careful not to let them break up, and lay them on a plate. Place a sieve over a large bowl and pour the liquor from the casserole into the sieve, pressing down on the vegetables to squeeze out all the juices. It's the liquid you want, so throw away the braising veg; it will be fairly watery now with a hint of beefy flavour. Wash out the casserole and pour the liquid back into it. You are going to reduce the sauce to make the flavour really punchy. Put the casserole back on the hob, bring the liquid to the boil and simmer over a low heat. What you're looking for is a rich reduced sauce that has thickened to an almost syrupy consistency and is full of meaty flavour.

Whisk in the butter over a low heat, until the sauce becomes super-shiny. Now you can return the cheeks to the pan. Stir through the parsley and then season to taste.

Sticky Oxtail Stew

If I had to choose, this stew reigns supreme. Oxtail needs a long slow braise with lots of vegetables and aromatics. At the end of the cooking time, I like to strain out the vegetables and reduce the sauce to a glossy sheen, before glazing the bones with it. By this point the meat will be almost falling off the bone. Serve with mash and more sauce.

SERVES 4

Preparation time 40 minutes
Cooking time 4 hours 20 minutes

olive oil, for frying
1 oxtail, cut into 6–8 pieces (ask your
 butcher to do this)
1 onion, roughly chopped
2 carrots, quartered
1 celery stick, roughly chopped, plus
 a handful of celery leaves
1 head of garlic, halved horizontally
1 tsp tomato purée
2 tsp plain flour
150g streaky smoked bacon, cut into
 lardons
500ml fresh beef stock
1 bottle red wine
2 bay leaves
2 sprigs of rosemary
few sprigs of thyme
4–5 sprigs of parsley
sea salt and freshly ground
 black pepper

Preheat the oven to 150°C/130°C fan/gas mark 2. Start by browning the meat. Put a frying pan over a high heat and add a tablespoon of oil. Season the oxtail pieces well and fry them for 3 or 4 minutes on all sides in two batches, making sure they are deeply caramelised all over. Remove from the pan and set aside.

Add a little more oil to the pan if necessary, add the onion, carrots and celery and fry for 5–8 minutes, scraping up any residual meaty bits left over from browning the oxtail with a wooden spoon – this is where the flavour is. For the final minute, turn up the heat and add the halved garlic. Fry until the cut sides of the garlic have gone nice and golden, while keeping the other veg moving around the pan. Remove the garlic from the pan and set aside with the oxtail.

Next add the tomato purée and cook for a minute or two until it starts to caramelise. Add the flour, give it a good stir and allow to cook for a further minute. Transfer everything to a large casserole, being sure to give the pan a good scrape.

Heat a little more oil in the frying pan and fry the bacon lardons for a few minutes, before adding to the casserole. Pour over the stock and the wine and bring to the boil. Lower the heat to a simmer and carefully add the oxtail, garlic and herbs to the casserole. Cover with a lid and put in the oven for 4 hours.

Remove the casserole from the oven and gently transfer the oxtail on to a plate, being careful not to let it break up. Clean off any bits of vegetable, herb or bacon that have stuck to the meat, as you are aiming for a really smooth sauce. Place a sieve over a large bowl and strain all the stewing vegetables, bacon and herbs and discard them. Give the casserole dish a rinse before returning the liquid to it.

Bring the sauce to the boil and simmer gently to reduce. You are aiming for a thin sticky film to form around the meat. This should take 10–20 minutes. Check for seasoning and serve immediately with some creamy mashed potato.

SLOW • SOUPS AND STEWS

Stews & Pies

Braising meat must be one of the more satisfying processes in the kitchen, often taking the more unloved cuts and investing time and care until they yield beautiful, tender delicious meat. Whichever meat you choose, the qualities you are looking for are plenty of fat, sinew and dense, collagen-rich connective tissue. In short, the very things that make the meat unsuitable for fast cooking, but ideal for a slow braise.

When it comes to beef, shin, cheek, featherblade and oxtail are the perfect cuts for braising. Many people favour chuck steak for stewing, but personally I would recommend the others as they are far more flavourful and cook to a perfect wobble, which melts away the second a fork sinks into them. All these cuts come from the parts of the cow that do the most work, which means the muscles are more exercised, the connective tissues stronger, and therefore the meat tougher. The stronger the muscle, the more collagen it contains. Given the right conditions (cooked in stock, wine or beer with stewing vegetables and herbs, slowly, at a low heat) these tissues break down and soften, resulting in beautifully moist, falling apart meat. The same principles apply to lamb; the shoulder, shank or neck respond well to slow braising, and pork, for which shoulder or cheek are the obvious choices – although in fact you can braise any part of a pig or a sheep and still get decent results.

Having leftover stew in the fridge is never a problem. It's a well known fact that stews and ragus taste better the day after they are cooked, as the flavours have developed and intensified. Of course they are a treat eaten as they are, but why not add an extra dimension to a stew's potential with the always-welcome addition of pastry – thus creating a pie? The following recipes create perfect pie fillings: my Steak & Kidney Pudding (see page 69), Ox Cheeks Stewed with Wine & Beer (see page 32), Pork & Apple

'Stroganoff' (see page 80), Braised Chicken with Shallots, Orange Wine & Brandy – though you need to take the chicken off the bone (see page 83), Braised Lamb Mince (see page 112), the stew from my Lamb Hotpot (see page 138) – and, of course, my Chicken, Buttermilk & Wild Garlic Pie (see page 127) recipe is a classic. I probably wouldn't use my Oxtail Stew as I think this is one occasion you'd lose something by not eating the meat from the bone. Please don't judge me but one of my guilty pleasures is sucking any remaining marrow from the oxtail bones.

Pretty much any stew can be easily transformed into a pie if you follow a few simple guidelines. First you need to ensure that you have a nice thick stew as too much liquid will make your pastry soggy, so you may need to reduce your stew a little. On the other hand, there's nothing worse than a dry pie, so if the sauce looks a little thick, you may want to loosen it with a little water or stock.

It's essential to chill your pie filling before it makes contact with the pastry as the key to achieving crisp pastry is keeping it cold. Depending on your preference, you can opt for either shortcrust or puff pastry. Shortcrust works best if you want the entire filling encased in pastry, and puff is better if you just want a pastry lid on top to make a pot pie. Although it's perhaps an easier option, an American pot pie is not strictly a pie in my view. Call me a traditionalist, but I want pastry top and bottom!

To achieve a lovely glossy finish, always glaze your pastry with beaten egg. A good rule of thumb for cooking a shortcrust pie is to preheat the oven to 190°C/170°C fan/gas mark 5 and to cook the pie for 35–40 minutes until the pastry is golden brown and cooked through. Puff pastry requires a hotter, shorter cooking time, so I suggest 220°C/200°C fan/gas mark 7 for about 30 minutes.

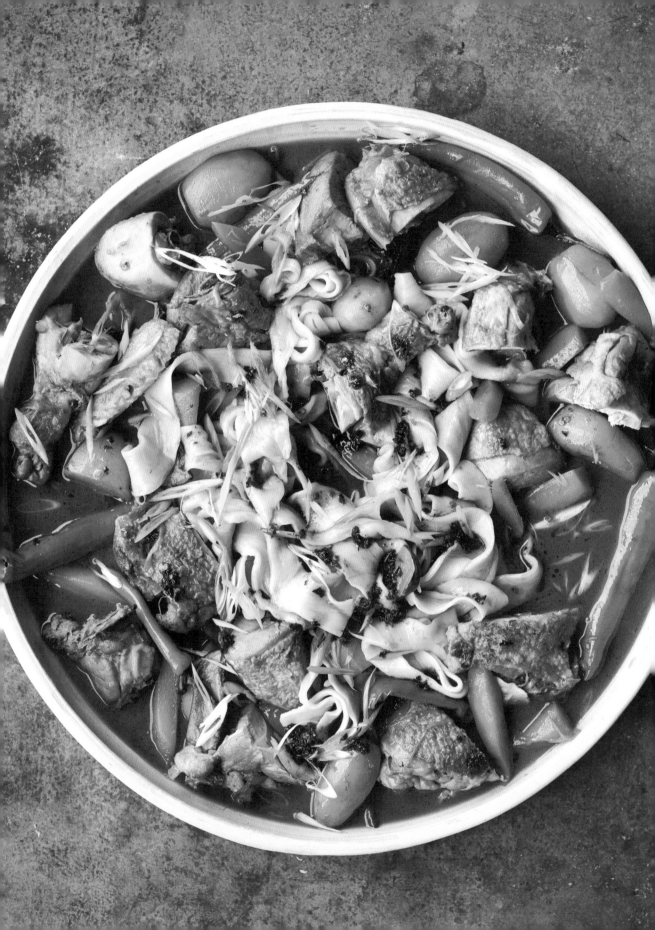

Big Plate Chicken

What first got me interested in north-western Chinese cooking was a trip to the fantastic Silk Road restaurant in Camberwell, South London which specialises in noodles, stews and dumplings originating from the Xinjiang province. There is a particular flavour spectrum that you don't get in other Chinese cooking, that of mouth-numbing Sichuan pepper, chilli and spices such as cumin and star anise. There is a large Muslim population in Xinjiang and Muslim influences echo through the food; for example you see less pork compared to other cuisines like Shaanxi (see Xian Lamb & Cumin Hand Pulled Noodles page 209).

This is a warming, nourishing, soupy stew, full of aromatics, and a brilliant way to utilise my Hand Pulled Noodles (see page 205). I've suggested using between half and a whole teaspoon of Sichuan peppercorns, and while I love the sensation they provide, be mindful of just how mouth-numbing they can be. If you're a first timer, perhaps err on the side of caution.

Preheat the oven to 150°C/130°C fan/gas mark 2. Heat a little oil in a frying pan or wok and season the chicken pieces. Fry them hard and fast in order to caramelise the pieces all over. Classically this step is missed out, but I think the chicken skin is always improved by being rendered and caramelised – though you don't have to do it if you want to be more traditional.

Heat a glug of oil in a heavy-based casserole over a high heat, then slowly cook the onions for about 10 minutes until they soften and start to caramelise. Add the garlic and ginger and cook for 15 more minutes. Next add the mushrooms, then the chicken stock, soy sauces, vinegar and rice wine. Bring to a fast simmer. Add the chillies and spices, then top up with water (about 500ml) so that the chicken is just covered. Bring back up to temperature, cover and place in the oven for 50 minutes.

Remove the casserole from the oven and add the potatoes and carrots, then return to the oven for a further 30 minutes. At the end of the cooking time bring a large saucepan of salty water to the boil. Drop your noodles in one by one. You will know they are cooked when they float to the top, which should take only a minute or two, after which they're ready to drain. Remove the casserole from the oven and take to the table. Serve the boiled and steaming noodles on plates with the chicken pieces and sauce over them.

SERVES 8

Preparation time 30 minutes
Cooking time 1 hour 30 minutes

2 tbsp oil
1 whole chicken, cut into 12 pieces, (ask your butcher to do this)
3 onions, finely chopped
8 garlic cloves, peeled
hand-size piece of peeled ginger, about 80g, cut into thick slices
40g dried shiitake mushrooms
500ml fresh chicken stock
3 tbsp light soy sauce
½ tbsp dark soy sauce
4 tbsp Chinkiang vinegar
400ml Shaoxing rice wine
5 whole Sichuan chillies
½–1 tsp Sichuan peppercorns
1 cinnamon stick
1 star anise
1 tsp fennel seeds
1 tsp black peppercorns
3 large, waxy potatoes, peeled and cut into quarters
2 carrots, peeled, each cut in half lengthways, and then cut into four diagonally
1 portion Hand Pulled Noodles (see page 205)
sea salt and freshly ground black pepper

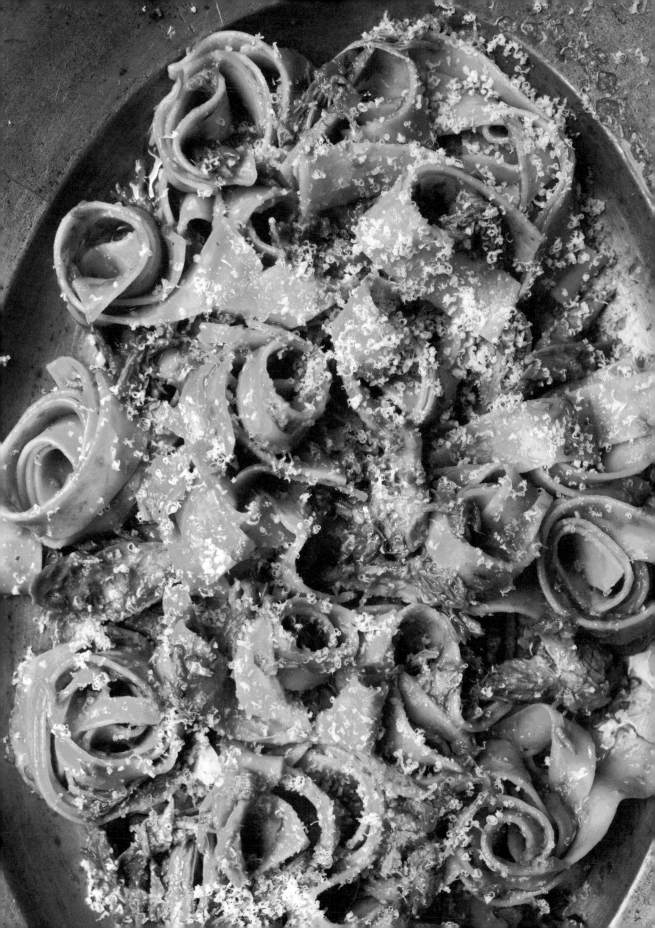

Venetian Duck Ragu

Venetian cooking is arguably the most interesting in the whole of Italy. The city is a maze of canals and waterways that run from the Adriatic, which made it the perfect trade pathway for the Ottoman Empire. You can still see these influences in dishes like this ragu, which combine classic Italian cooking and Middle Eastern spicing. The combination of duck, red wine, orange and cinnamon, cooked long and slow until the duck falls off the bone and the fat clings loosely to the meat, create a full-bodied but gently spiced sauce that slips over pappardelle like a dream.

First brown the duck legs. Heat a frying pan with a little glug of olive oil. Duck is very fatty so you don't need to add much oil to the pan at this stage. Season with plenty of salt and sear on both sides until they are a nice deep golden colour all over. Remove the legs from the pan and leave to one side.

In a heavy-based casserole heat the rest of the olive oil over a medium heat. Add the onions and cook for about 20 minutes until they are nice and soft. Add the garlic and sweat for a couple of minutes. Next, add the wine and allow to bubble for a few minutes to cook off some of the alcohol, before pouring in the blitzed tomatoes and stock. Add the duck legs, followed by the bay leaves and cinnamon, and a good pinch of salt and pepper. Cover with a lid, turn the heat right down and allow to simmer gently for 1 hour 30 minutes.

Once the cooking time has passed you will see that the sauce has reduced and become lovely and rich. At this stage remove the duck legs from the pan. Let them cool for a couple of minutes, and then use two forks to pull the meat from the bones and shred it a little. Discard the skin as it is only delicious when rendered crisp.

Return the duck meat to the sauce and add the orange zest and juice and the celery salt. Check for seasoning and let the sauce cook for a further 10–15 minutes.

At this point put your pasta on. Pappardelle is the only pasta to eat with ragu as its large flat surface is perfect for holding the sauce. When cooked, drain the pasta and reserve a little of the cooking water. Combine the pasta with the sauce and add one or two tablespoons of the cooking water. Divide between bowls and serve with a generous grating of Parmesan.

SERVES 4

Preparation time 20 minutes
Cooking time 2 hours

2 tbsp olive oil
4 duck legs
2 large onions, finely chopped
6 fat garlic cloves, very finely
 chopped
500ml red wine
800g fresh vine tomatoes, blended
 into passata
300ml duck or chicken stock
2 bay leaves
decent pinch of ground cinnamon
zest of ½ orange, plus a squeeze of
 the juice
¼ tsp celery salt
sea salt
plenty of white and black pepper
Parmesan, to serve

Fruit and Vegetables

The UN Food and Agriculture Organization (FOA) estimates that one-third of all food produced globally every year – which amounts to a staggering 1.3 billion tonnes – is wasted. A large part of that can be attributed to fruit and vegetable production, as up to 40% of vegetable crops are rejected simply because they do not meet the arbitrary, but extremely stringent, aesthetic requirements laid down by supermarkets. In this country, farmers are forced to throw away tonnes and tonnes of perfectly good produce that the supermarkets deem to be unsaleable, which means they have to constantly overproduce in order to meet targets. Not only is this a criminal waste of food, it's a catastrophic waste of all the resources that go into growing them! I truly feel that this kind of squandering can no longer be accepted as normal.

Supermarkets sell 85% of the fruit and vegetables we buy, so they have a stranglehold on the farmers who produce them. Whenever possible I recommend that you try to buy fruit and vegetables from local greengrocers' or farmers' markets – or that you investigate the many great veg box schemes now available. We need to fight the supermarkets' tyrannical rule! I could go on about how corrupt the supermarkets have become in trying to offer cheap, poor-quality produce for 'the masses', but I'll simply say that their commercial methods have produced an abhorrent version of economic colonialism that dominates the agricultural industries of less affluent countries. It is important for people to be able to buy affordable fresh fruit and vegetables, but the cost to the producers, the economy and the environment is unaffordably high.

The responsible modern consumer who is eating more fruit and vegetables than previously, needs to consider the resources required to produce these crops in an ethical and sustainable way. This can be even more important for fruit and vegetables than meat and fish. What is the cost of the resources required to grow these crops that may not be produced in their natural environments? Are the rights of the growers, pickers and other labourers fairly respected, and how much plastic packaging is involved? We now know that most soy is grown to feed livestock reared for meat and that soy farms have almost as detrimental an effect on the environment as meat and dairy farms. There are many reasons for this, but the quantity of water required to grow soy is a key factor.

Does this mean we should not eat soy products? Of course not, but we do need to know the kind of farm on which the soy we eat has been grown. Soy was one of the first food plants to be genetically modified and we can look for non-GMO soy, but is that enough? Finding out the facts and deciding what to buy and eat is difficult. There is a minefield of information out there and my brain is hurting even writing this. We can only do our best and buy the best we can afford. The sad truth is that the best-tasting and most nutritious food, which is slow-grown in the way nature intended, is expensive. So how do we address this if we want to eat well but affordably?

I admit that it's unrealistic to expect everyone to be virtuous all the time, and part of the joy of the modern world is that we have access to exotic fruits, vegetables and other produce, but I do think we should all aim to buy seasonal, locally-sourced produce whenever possible. Produce that has travelled shorter distances and been stored for less time should be cheaper, helped by a glut when a particular crop is in season. Unfortunately, smaller farmers have a hard time competing with more extensive farms that can produce crops more cheaply because of their vast scale, so prices have shot up.

Looking beyond the supermarkets is also a great way to discover new varieties and flavours. For example, there

are more than 2,200 varieties of apple, all with their own unique characteristics, and the supermarkets usually sell only about five of them, with just one in three grown in the UK. That is crazy when you consider that this country has grown apples for centuries – and it also means that we as consumers are missing out!

Although I fully support the ethos of organic farming – and even biodynamic farming for that matter – I believe that there is a lot of misleading information about organic produce, and that organic doesn't always mean the best. Much of the land certified as organic soil can retain previously applied synthetic chemicals for decades, meaning that produce from that land will contain them too. Also, pollination often contaminates the soil, although regulations frequently allow the produce grown in it to be sold under the organic banner. Of course I am greatly in favour of organic farmers' generally higher standards and consideration for the environment, but organic methods don't always produce the best crops, so I look for producers who have slow-grown their harvests.

A monthly guide to which fruits and vegetables are in season

January
apples, beetroot, blood oranges, Brussels sprouts, cabbage, cauliflower, celeriac, chicory, clementines, grapefruit, Jerusalem artichokes, kale, leeks, mushrooms, parsnips, pears, pomegranates, potatoes, rhubarb, satsumas, spring onions, squash, swedes, turnips

February
blood oranges, Brussels sprouts, cauliflower, celeriac, chicory, clementines, grapefruit, Jerusalem artichokes, kale, kiwi fruit, kohlrabi, leeks, lemons, oranges, parsnips, passion fruit, pineapples, pomegranates, potatoes, purple sprouting broccoli, rhubarb, salsify, shallots, swede, truffles (black), turnips

March
beetroot, blood oranges, cabbage, cauliflower, chicory, cucumber, grapefruit, Jerusalem artichokes, kale, leeks, nettles, oranges, parsnips, pineapples, purple sprouting broccoli, radishes, rhubarb, sorrel, spinach, spring greens, spring onions, watercress

April
beetroot, cabbage, chicory, grapefruit, Jerusalem artichokes, kale, morel mushrooms, new potatoes, parsnips, rhubarb, rocket, sorrel, spinach, spring greens, spring onions, watercress

May
apricots, asparagus, aubergines, beetroot, chicory, chillies, elderflowers, globe artichokes, grapefruit, lettuce, marrow, new potatoes, nectarines, peas, peppers, radishes, rhubarb, rocket, samphire, sorrel, spinach, spring greens, spring onions, strawberries, watercress

June
apricots, asparagus, aubergines, beetroot, blackcurrants, broad beans, broccoli, carrots, cauliflower, cherries, chicory, chillies, courgettes, cucumber, elderflowers, fennel, globe artichokes, gooseberries, lettuce, marrows, nectarines, new potatoes, peas, peppers, radishes, raspberries, redcurrants, rhubarb, rocket, runner beans, sorrel, spring greens, spring onions, strawberries, summer squash, Swiss chard, turnips, watercress

CONTINUED »»

July

apricots, aubergines, beetroot, blackberries, blackcurrants, blueberries, broad beans, broccoli, carrots, cavolo nero, cauliflower, cherries, chicory, chillies, courgettes, cucumbers, fennel, French beans, garlic, globe artichokes, gooseberries, greengages, loganberries, new potatoes, onions, peas, potatoes, radishes, raspberries, redcurrants, rhubarb, rocket, runner beans, samphire, sorrel, spring onions, strawberries, summer squash, Swiss chard, tomatoes, turnips, watercress

August

apricots, aubergines, beetroot, blackberries, blackcurrants, broad beans, broccoli, carrots, cauliflower, cavolo nero, celery, cherries, chicory, chillies, courgettes, cucumbers, damsons, fennel, figs, French beans, garlic, globe artichokes, greengages, leeks, lettuce, mangetouts, marrows, mushrooms, parsnips, peas, peppers, plums, potatoes, pumpkins, radishes, raspberries, redcurrants, rhubarb, rocket, runner beans, samphire, sorrel, spring greens, spring onions, strawberries, summer squash, sweetcorn, Swiss chard, tomatoes, watercress

September

apples, apricots, aubergines, beetroot, blackberries, broccoli, Brussels sprouts, butternut squash, carrots, cavolo nero, cauliflower, celery, courgettes, chicory, chillies, cucumbers, damsons, fennel, fig, garlic, globe artichokes, leeks, lettuce, mangetouts, marrows, onions, parsnips, pears, peas, peppers, plums, potatoes, pumpkins, radishes, raspberries, rhubarb, rocket, runner beans, samphire, sorrel, spinach, spring greens, spring onions, strawberries, summer squash, sweetcorn, Swiss chard, tomatoes, turnips, watercress, wild mushrooms

October

apples, aubergines, beetroot, blackberries, broccoli, Brussels sprouts, butternut squash, carrots, cauliflower, cavolo nero, celeriac, celery, chestnuts, chicory, chillies, courgettes, cranberries, cucumbers, elderberries, figs, kale, leeks, lettuce, marrow, onions, parsnips, pears, peas, potatoes, pumpkins, radishes, rocket, runner beans, spinach, spring greens, spring onions, summer squash, swede, Swiss chard, tomatoes, turnips, watercress, wild mushrooms, winter squash

November

apples, beetroot, Brussels sprouts, butternut squash, cabbage, carrots, cauliflower, celeriac, celery, chestnuts, chicory, cranberries, elderberries, Jerusalem artichokes, kale, leeks, onions, parsnips, pears, potatoes, pumpkins, swede, Swiss chard, turnips, watercress, wild mushrooms, winter squash

December

apples, beetroot, Brussels sprouts, cabbage, celeriac, celery, chestnuts, clementines, cauliflower, cranberries, dates, grapefruit, Jerusalem artichokes, kale, onions, raddichio, quince, parsnips, pears, pomegranates, pumpkins, salsify, swede, sweet potato

POACH
AND
STEAM

Gingered Coronation Chicken

Coronation Chicken is one of the best dishes to eat. I make and develop this recipe on what feels like an annual basis and it just gets better and better. The key is to cook out the paste and blend it to intensify the flavour. The garnish is a modern take but I think it lifts and freshens the dish, making it more of our time.

Put the chicken breast up in a large saucepan along with the onions, sliced ginger, cinnamon, peppercorns, saffron, salt and bay leaf and cover with cold water until only the top of the breast is exposed. Cover the pan with a lid and bring to a simmer, then turn the heat down very low so only the occasional bubble rises to the surface. Cook the bird gently for about 1 hour, or until the juices run clear when you insert a skewer between the thigh and breast joint.

Turn off the heat and allow the chicken to cool completely in the cooking liquid. (This makes the most delicious, fragrant stock so don't throw it away when your chicken is cool. Try freezing the stock in 500ml batches for future use in soups and stews.)

Heat the oil in a small frying pan and fry the onion very gently for about 10 minutes, or until softened and tinged with gold. For the last minute add the garlic and ginger. Mix in the curry powder and toast until fragrant. Leave this to cool in the pan for about 10 minutes.

Put the mixture into a blender with the Worcestershire sauce, mayonnaise, Greek yoghurt and mango chutney and whizz until you have a smooth, light yellow paste. Once the chicken is cold, remove the meat from the bones and shred into bite-size chunks. I like to do this with my hands, but forks are also good if you are a little squeamish. Mix the meat with the sauce.

Mix together the mango, chilli and most of the coriander in a small mixing bowl. Lay a bed of salad on a platter, top with the cold rice, and then the chicken in its sauce. Scatter over a topping of fresh mango salsa, almonds and fresh coriander and serve.

SERVES 8 AS PART OF A PICNIC

Preparation time 30 minutes
Cooking time 1 hour, plus
 3 hours cooling

For the chicken
1 chicken, about 1.5kg
2 onions, thinly sliced
4 thin slices of fresh ginger
1 cinnamon stick
5 black peppercorns
pinch of saffron
1 tablespoon salt
1 bay leaf

For the sauce
1 tsp vegetable oil
1 onion, very finely chopped
2 garlic cloves, grated
3cm knob of ginger, peeled and
 grated
2 tbsp good curry powder
2 tsp Worcestershire sauce
200ml mayonnaise
200ml Greek yoghurt
5 tbsp good-quality mango chutney

To serve
1 ripe but firm mango, very finely
 chopped
1 red chilli, very finely chopped
small bunch of fresh coriander,
 roughly chopped
green salad leaves
cold cooked multigrain rice
50g flaked almonds, toasted

How to Poach & Break Up a Crab

Lots of people baulk at the idea of preparing a whole crab and I know it can seem daunting, but it's a really satisfying process once you have some guidelines. It's worth doing as it guarantees the freshest, tastiest crab meat, and it works out cheaper than buying prepacked crab meat. Britain's cold coasts produce some of the best crab in the world, but most of it is sold to Europe, where they seem to really understand its value. It's high time Brits got in on the action and started appreciating what's on our doorstep!

Preparing a crab starts with a trip to the fishmonger (something I always advocate), as that's the only way to ensure that you are buying the freshest crab. When choosing your crab, make sure it feels heavy and dense, that it smells fresh and is relatively active. Crabs are best cooked immediately after they're dead, so ask your fishmonger to dispatch it for you and cook it as soon as you get home (within two hours). Don't ever buy a dead raw crab as you won't know how long it has been hanging around, and that is not a risk worth taking!

Check that your stock pot is big enough to hold the crabs, then place the bouillon ingredients in it, along with enough water to cover. Bring to the boil and cook the bouillon for 10–15 minutes.

Place the crabs in the bouillon water and boil for 10–12 minutes, depending on how big they are. Scoop them out and plunge them into iced water to cool quickly, but don't leave for more than 2–3 minutes as you don't want the meat to become saturated. Allow to cool and put in the fridge as soon as you can if not preparing immediately.

To prepare the crabs, set out one bowl for white meat and one bowl for brown meat. Remove the claws and smash them with the back of a cook's knife (not the sharp side or it will blunt it). Try to break them with one sharp blow, to prevent the shell shattering into tiny pieces. Remove the meat from inside the claws and put into the bowl reserved for the white meat. It should pull away relatively easily but be careful to leave any shell pieces behind. Discard the cartilage from the middle of the claws. Next twist off the legs. With a lobster pick, skewer or the end of a teaspoon, carefully pull the white meat out of the legs. In my opinion it's only worth bothering with the larger section of each leg.

SERVES 4

Preparation time 45 minutes
Cooking time 30 minutes

2 large 1.5kg cock crabs, freshly
 killed (ask your fishmonger to do
 this for you)

For the bouillon
2 onions, sliced
2 fennel bulbs, sliced
2 carrots, peeled and sliced
3 bay leaves
small bunch of parsley
splash of white wine or white wine or
 cider vinegar
50g salt
1 tbsp black peppercorns

To remove the meat from the main body of the crab, lay it on a surface with the underside facing you. Use the palm of your hand to push down on the shell and put your fingers into the gap where the body meets the shell around the mouth. Pull quite firmly and it should come apart in one piece. Pull away the feathery gills (grimly known as dead man's fingers) around the sides of the body and the shell. Use a spoon to scoop out all the brown meat from the crevices of the shell into the second bowl.

Cut the degilled body in half using a sharp knife. Using your implement of choice, carefully pick out all the meat from the crevices into the white meat bowl. I find this an exceedingly satisfying task; if you take your time you will be surprised how much meat you find. Finally, go through the bowl to check for any stray pieces of shell.

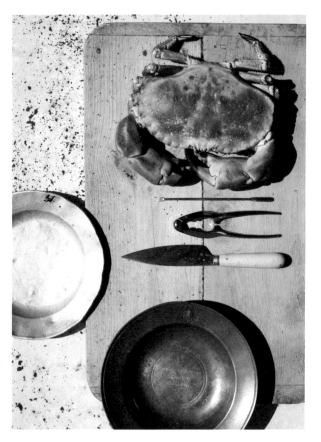
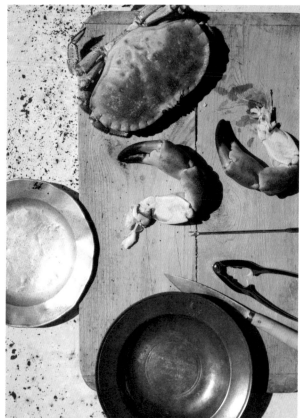
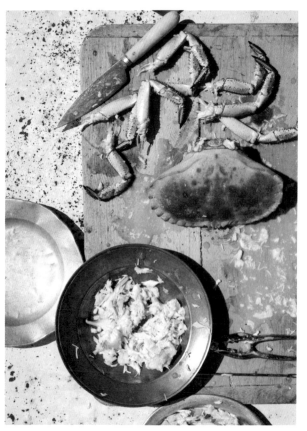
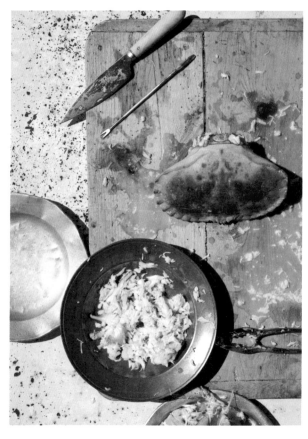

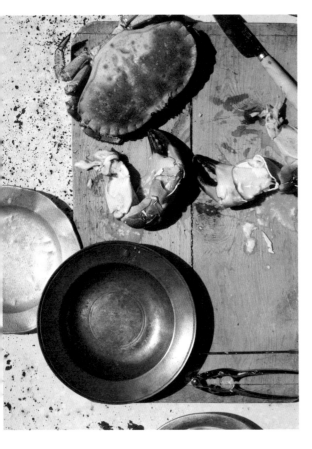
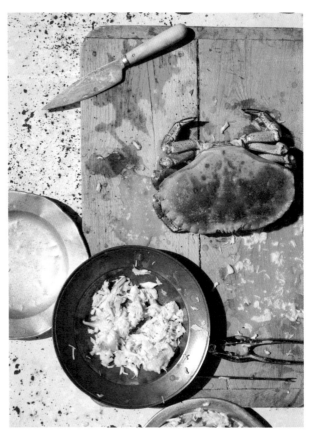
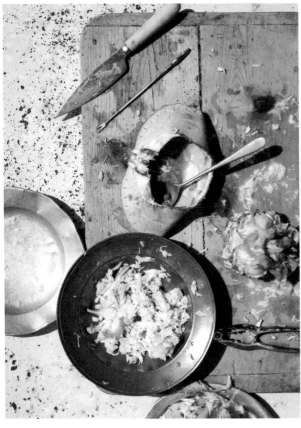
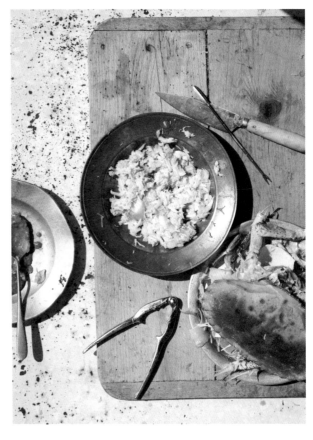

Dressed Crab On Toast

The most important of all crab dishes. Freshly cooked and picked crab – the white meat with a lick of fresh mayo and the brown pretty much the same – simply placed on top of freshly charred toast and topped with grated egg has to be one of the best things one can eat. Ever. Please, please, if only once in your life, give this a go.

SERVES 2

Preparation time 20 minutes

2 free-range egg yolks (I like Cotswold Legbar or Burford Brown), plus 1 hard-boiled egg
1 tsp English mustard
1 tsp white wine vinegar, such as Sauvignon Blanc
250ml vegetable oil
150ml light olive oil
squeeze of lemon juice
cayenne pepper
brown and white meat of a cooked 1.5kg cock crab
pinch of curry powder (optional)
olive oil, for grilling
2 slices of good white or brown sourdough bread
handful of parsley, finely chopped
lemon wedges, to serve
sea salt and freshly ground black pepper

Make the mayonnaise by placing the egg yolks in a large bowl with the mustard and vinegar. Mix the oils together in a jug. Very slowly trickle in the oil while beating the yolks with a whisk. It will take about 8–10 minutes to whisk all the oil into the eggs and the mayonnaise should be thick and fully emulsified when you have finished. Squeeze in the lemon juice and season with plenty of salt, pepper and cayenne.

Mix the picked white crab meat with 1 tablespoon of the mayo and season with more salt if needed and a little squeeze of lemon. You can add a pinch of curry powder to this too if you fancy it.

You can leave the brown meat as it is, but I always pop it in the small compartment of the food processor, with 1 tablespoon of mayonnaise, a squeeze of lemon and a pinch of salt and blitz for a few second until smoothish.

Next separate the white and the yolk of the boiled egg, then grate the white and yolk separately with a fine Parmesan grater or the fine blade of an upright grater.

Heat a griddle until it's almost smoking. Oil the sourdough bread and griddle until crips and golden with a few charred bits. Spread half the brown meat over the toast, with a good pile of picked white meat on top. Liberally sprinkle the grated egg white over the crab, followed by the grated egg yolk. Finish with a nice sprinkling of finely chopped parsley and a light dusting of cayenne pepper. Serve straight away with lemon wedges.

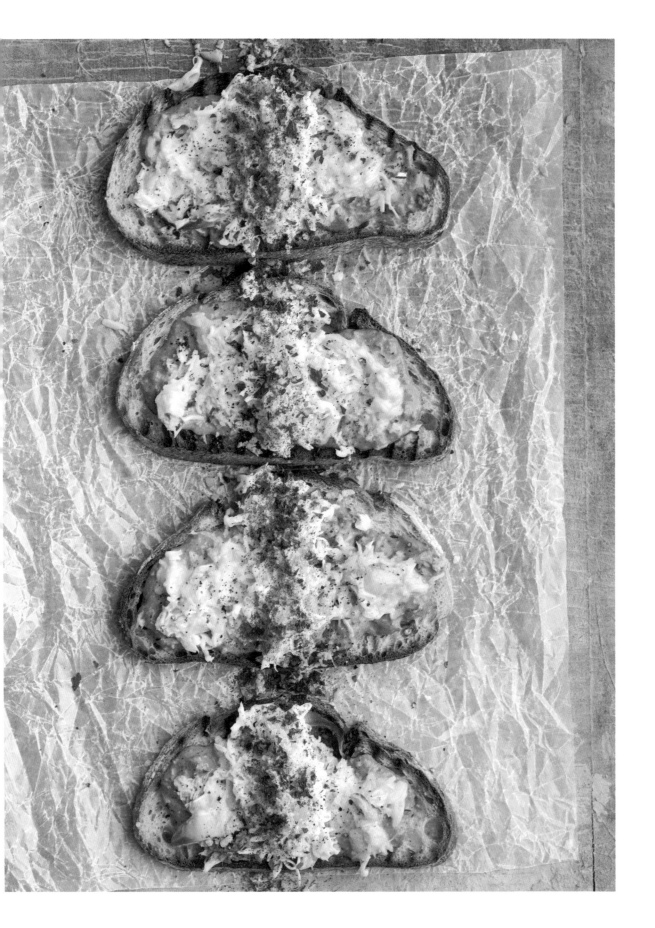

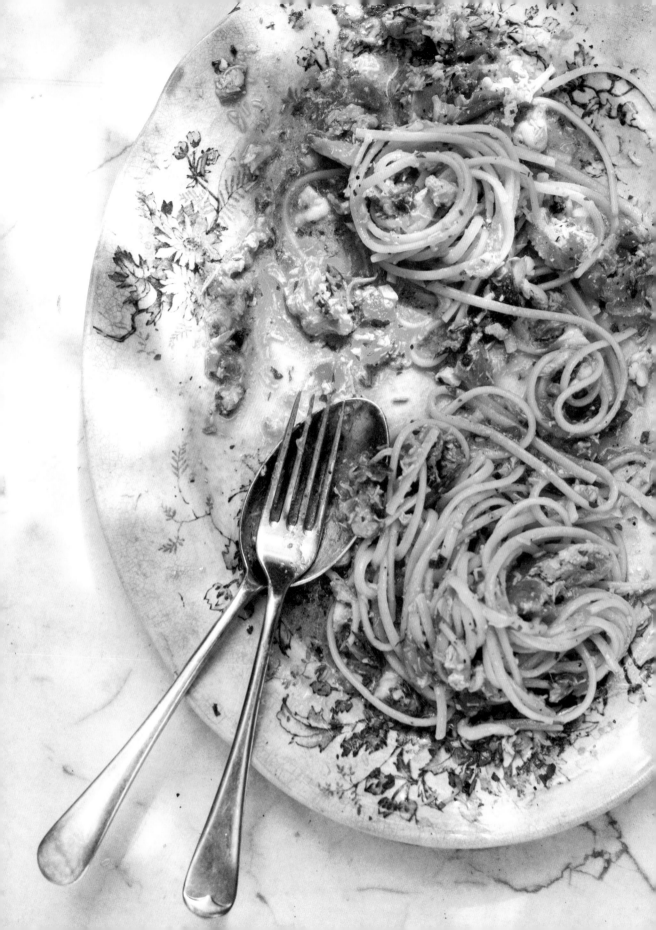

Crab, Chilli & Lemon Linguine

This might be one of my favourite crab dishes of all time. Chilli, lemon, parsley and crab make a heavenly union, only bettered by the addition of pasta. This is really quick and simple to make. It's important to work quickly to maintain the freshness of the crab, which doesn't need any cooking as the heat of the tomatoes will warm it through. Even if you are put off by the appearance of the brown meat, I really recommend adding this to the sauce as it provides extra crab flavour and enhances the texture of the sauce.

Heat the oil in a large wok or saucepan. Add the garlic and chilli and fry over a low heat for 1–2 minutes, or until the room is filled with the smell of garlic and the garlic is translucent. Pour in the wine and allow to bubble for a few minutes to cook off the alcohol and reduce. Add the tomatoes and cook over a medium-high heat for 8 minutes, or until the tomatoes have broken down and the sauce tastes rich. Season with salt and pepper and stir through both the white and the brown crab meat (if using). Add the lemon juice and zest before throwing in the parsley.

Meanwhile cook the linguine in lots of boiling heavily salted water for 8–10 minutes, or until the pasta is al dente. Drain, reserving a little of the water and immediately stir the pasta through the sauce over the heat with 1 tablespoon of the cooking water until the sauce clings to the pasta. Serve straight away.

SERVES 2

Preparation time 20 minutes
Cooking time 10 minutes

50ml really good olive oil
4 garlic cloves, finely chopped
1 large red chilli, finely chopped
300ml white wine
4 medium to large vine-ripened
 tomatoes, each cut into eight
300g fresh picked white crab meat
2 tablespoons brown crab meat,
 blitzed to a smooth paste (optional)
zest and juice of 1 lemon
handful of parsley, finely chopped
200g high-quality durum wheat
 linguine
sea salt and freshly ground black
 pepper

Ginger Ham

A whole baked ham is not just for Christmas! Why wait all year to enjoy something which can form the central part of quite a humble – but utterly delicious supper. Ham will never go to waste as there are so many ways to use it and it lasts for ages in the fridge. Yes, the spices in this dish are synonymous with Christmas, but rules were made to be broken!

Inspired by Nigella's classic Ham in Coca Cola, it made sense to me to harness the sweetness of ginger beer but with an added kick of spice and heat. This ham is delicious on its own, or in a sandwich or salad, but I recommend trying it at least once with my updated Gingery Pease Pudding, retro Parsley Sauce (see page 244) and Pickled Pears (see page 243). It's a dish of harmonious balance; salty yet slightly sweet spiced ham and comforting and mellow pease pudding, freshened up with fragrant, creamy parsley sauce, and then rounded off with a kick of acidity from the pickled pears. Make the pears at least two weeks before you cook the ham for the best flavour.

SERVES 6 WITH LEFTOVERS

Preparation time 15 minutes
Cooking time 3 hours

3kg smoked, boned and rolled smoked gammon ham shoulder or leg, soaked overnight in lots of cold water (change the water a few times)
2 litres ginger ale (a good fiery one)
2 medium onions, quartered
2 carrots, halved
2 leeks, halved lengthways
6 whole cloves
1 star anise
1 cinnamon stick
8 allspice berries
10 black peppercorns
1 bouquet garni: 2 bay leaves, a few sprigs of thyme, a few parsley stalks bundled together

For the glaze
4 tbsp ginger syrup (from a jar of stem ginger)
2 tbsp butter
1 tsp ground ginger
1 tsp mixed spice
50 whole cloves

Put the ham into the biggest saucepan you can find, into which it fits easily. Place it over a medium heat and pour in the ginger ale. Add the onions, carrots, leeks, spices and bouquet garni and add water to cover. Slowly bring to the boil. Using a large spoon, carefully remove any scum that appears and repeat until the surface looks clear.

Once the liquid is bubbling, reduce the heat to a simmer for 2 hours. Top up regularly with cold water and remove any scum from the surface every time you do so.

Preheat the oven to 200°C/180°C fan/gas mark 6. Once the ham is cooked, remove it from the pan very carefully so as not to tear the meat. You may find it easier to let the ham cool a little in the cooking liquid, then transfer it to a colander to drain (reserving the cooking liquid) and cool for 10 minutes. Place the ham in a large roasting tin. Slice the skin off very carefully to reveal the thick layer of white fat, then score the fat all over in a diamond pattern.

Put all the glaze ingredients, except the cloves, in a saucepan over a medium heat. Stir until everything has melted. Allow to cool slightly then rub all over the ham. Push a clove into the corners of each diamond shape. Roast for 30 minutes, until sticky and caramelised. Leave it to rest for 1 hour if you want to eat it warm, or let it cool completely.

Gingery Pease Pudding

Pease pudding is an underrated classic in my opinion, and one of this country's oldest and most traditional dishes. Perhaps people assume it has the potential to be a bit muddy or one-dimensional in flavour, but using the gingery stock gives it a real lift if you're looking to convert anyone.

Put the soaked peas into a saucepan. Add the onion, carrot and bay leaves and cover with the stock. Bring to the boil, skimming off any scum from the surface if need be, then lower the heat and simmer for 1 hour, or until the peas have softened and most of the liquid has been absorbed.

Remove the bay leaves and tip the veg and peas into a blender. Blitz to a purée, then pour into a clean saucepan. Add the vinegar and butter, reheat gently and season with salt and pepper.

SERVES 6

Preparation time 10 minutes
Cooking time 1 hour

500g yellow split peas, soaked
 overnight in cold water and drained
1 onion, roughly chopped
1 carrot, quartered
2 bay leaves
1.2 litres gammon stock
2 tbsp apple cider vinegar
50g butter
sea salt and freshly ground black
 pepper

Salt Beef Brisket

Making salt beef is a labour of love and the idea should have been in your head for about two weeks before you come to eat it. When you're ready, it all starts with going to the butcher to buy the right piece of brisket. I suggest asking for a piece with a neat but thick layer of fat over it – you may need to ask your butcher for this in advance. You then need to order the curing salts and leave it to cure for a minimum of five days (I like to leave it nearer eight), before soaking it overnight. Then finally you come to the long, slow cook. The end result should be easy to carve and still bright pink inside.

I'm lucky to know Mark Ogus of the brilliant Monty's Deli in Bermondsey and I got him to spill the beans on his recipe. The spice addition is mine, but the cure blend is Mark's and it works like a dream! As well as serving up to six people for supper, the quantities below will make a multitude of sandwiches (see page 60) and provide the filling for a large number of kreplach dumplings (see page 19).

SERVES 4–6

Preparation time 20 minutes, plus
 5–8 days brining
Cooking time 4 hours 30 minutes

To brine
100g light brown muscoavado sugar
300g curing salt (buy it online at
 weschenfelder.co.uk)
5 cloves
2 onions, quartered
½ head of garlic
2 star anise
1 tbsp white peppercorns
20 juniper berries
4 bay leaves
few sprigs of thyme
2kg beef brisket

To cook
1 carrot
1 celery stick
1 leek
2 onions

First make the brine. Put all the ingredients into a large casserole and cover with 2.5 litres of water. Bring to the boil and then allow to boil for 2–3 minutes, whisking regularly, to dissolve the salt and sugar. Turn off the heat and allow to cool to room temperature, then pop in the fridge for an hour to chill completely.

Once the brine is completely cool, submerge the brisket in the liquid, cover tightly with both cling film and a lid and leave in the fridge for 5–8 days.

Remove the beef from the brine and rinse it in cold water. Discard the brine. Fill the same casserole with cold water and soak the brisket, covered, in the fridge overnight, changing the water regularly.

When you're ready to cook, place the brisket in a large wide casserole and cover with cold water. I like to add simple stock ingredients such as a carrot, a celery stick, a leek and onions at this stage, though it's still great without them. Bring to the boil then turn down the heat and simmer for 4 hours 30 minutes, making sure the meat is always covered with water. You will know it's ready when the meat feels springy. Carefully remove the brisket from the water. Discard the cooking liquid which will be too salty to use as stock. Allow the brisket to rest for 10 minutes on a board that will catch all the juices. Now you are ready to serve this in a multitude of ways.

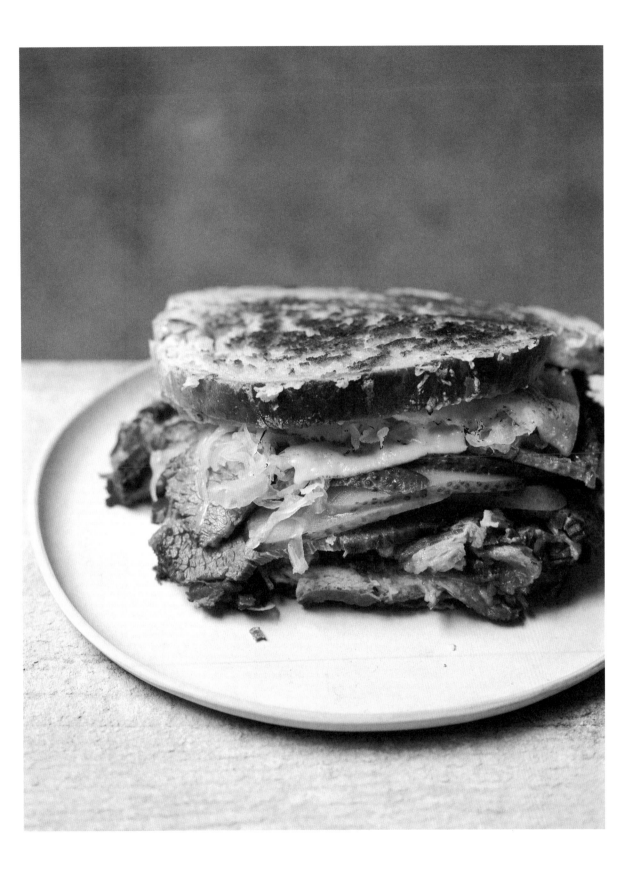

A Salt Beef Bagel or a Reuben Sandwich?

The bagel (Jewish spelling: beigel) originated in the Jewish community in Poland, their first mention being traceable to the early 1600s. I am lucky to live not far from Brick Lane in Hackney, which boasts a number of Jewish bakeries serving bagels in various guises 24 hours a day, but I wanted to amp up my version into something a little bit more special.

First, even if I say so myself, my salt beef is second to none (see page 58), so we're already winning in this game. But you also need to make sure you buy fresh bagels with plenty of chew – remember, your sandwich is only as good as the bread you make it on. Rule to live by!

The Perfect Bagel

The three essentials of a classic salt beef bagel are beef, pickles and mustard, but I want to look at the pickles. Dill pickles are the standard acompaniment and originated in the US, where they are often referred to as kosher pickles. They are cucumbers fermented in a salt brine with added dill and garlic. In New York, they may be called 'full sours' or 'half sours', the name correlating to how long they have been brined. Recently I have been really into new green pickles, which are much 'younger', fresher pickled cucumbers that last only a few days. They are a brighter green colour and have much more crunch. They are traditionally served with chopped liver but they also work fantastically as an accompaniment to either the bagel or the Rueben Sandwich.

To construct the perfect bagel, first split it in two. Now the question is to grill or not to grill, but a real deli bagel wouldn't be grilled – and with super fresh bagels grilling would be a travesty. Spread a very generous slathering of mustard on both halves of the bagel, as it is essential to experience the proper mustard-up-your-nose sensation. In America they use deli mustard, which is the bright yellow, milder and more vinegary sauce which doesn't sting your nose, but I won't settle for anything other than proper English mustard. Then put a layer of thickly sliced hot salt beef on the bottom half, top with three thinly-sliced pickles on the meat, and then the other half of the bagel.

The Perfect Reuben Sandwich

The components for a Reuben sandwich are slightly different but it also has salt beef as its foundation. While the sandwich is definitely American, there is a dispute about who made the original Reuben sandwich, with claimants in both Nebraska and New York, so let's just go with the fact that we can be sure it dates back to the early twentieth century. The base is a Jewish rye bread, which is a sourdough with a chewy texture and a tangy rye flavour – and often has caraway running through it. It's not essential to fry your sandwich, but – let's be honest – everything is nice fried.

To construct the perfect Reuben take two slices of rye bread and butter one side of each slice. Then take one slice and lay it, butter side down, in a frying pan off the heat. Spread on a thick layer of Russian Dressing (see page 246), then a layer of Sauerkraut, a layer of Swiss cheese (such as Emmental – or if you're feeling greedy, even Edam) then hot salt beef, in thin or thick slices, whichever you prefer. The trick here is depth: a good 2.5cm of salt beef makes a real deli sandwich! Finish with another spoonful of Russian Dressing and place the second piece of bread on top, butter side up. Heat the pan and gently fry on both sides until it's golden and crispy, the cheese has melted and the meat is warm all through.

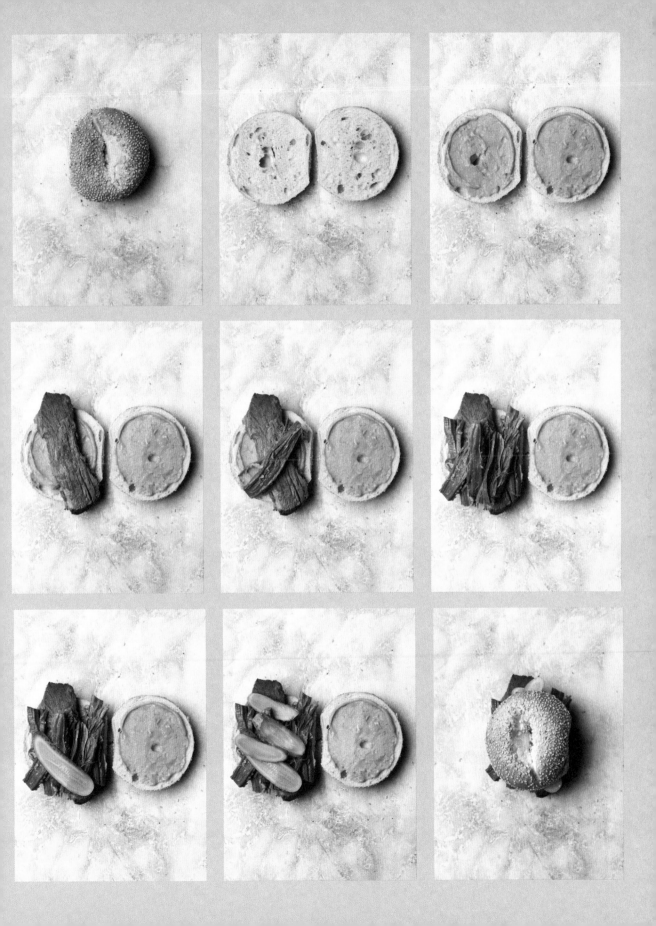

Confit Garlic

I've become slightly obsessed with confit garlic. It's so easy to make, harnessing the classic French technique of slowly poaching in fat, and is such a great addition to so many dishes. This process caramelises the garlic, rendering it soft, sweet and mellow, with a rich creamy texture. To be honest this is pretty incredible just spread on some nice bread, but there are so many different uses for it, for example in my Flageolet, Anchovy, Rosemary & Confit Garlic Gratin (see page 124), or my Braised Peas with Little Gems, Spring Onions & Wild Garlic (see page 88). It keeps for ages as the garlic is preserved in the oil, and the garlicky olive oil is also an incredibly useful by-product.

Preparation time 20 minutes
Cooking time 30 minutes

4–5 heads of garlic, tops sliced off
enough good-quality olive oil to
just cover the garlic

Put the heads of garlic into a small saucepan and pour over the olive oil until the garlic is just submerged. Heat over the lowest flame as it's very important that the garlic doesn't burn or the whole thing will turn acrid. Allow the garlic to very slowly cook in the oil for about 20–30 minutes until it is soft and buttery. You do not want it to boil. And you do not want any colour on the cloves. This is a game of patience and trust, but worth every second of the time it takes.

Suet

I came across the most brilliant website recently of traditional English recipes. It lists a stream of suet-based recipes and it got me thinking about how good we are at exploring new foods and pushing boundaries in cooking but we can be guilty of not valuing our food heritage enough. While I think it's fair to say that we get a bit of a rough ride in the traditional cuisine stakes compared with some of our continental neighbours, our culinary repertoire is pretty steadfast and strong. While many foreigners may not grasp the concept, when cooked properly suet pastry and steamed puddings, can be as light and refined as some famous French stalwarts.

Suet, the fat found around the kidneys of cows and sheep, has been used in British cooking for centuries. One of the earliest suet pudding recipes dates back to the seventeeth century. English College Pudding, which was not dissimilar to a Christmas pudding and made with spices and dried fruit, was served to students in Oxford and Cambridge. English classics such as Spotted Dick, Steak & Kidney Pudding, Jam Roly Poly and Sussex Pond Pudding have fallen out of favour in recent years and I think that's a real shame as we run the risk of losing a great part of our traditional food culture. Perhaps people have preconceived ideas about suet puddings being heavy, stodgy, meaty affairs, when actually the opposite is true. Suet is brilliant to use in baking as it has a higher melting point than most other fats, so creates a soft, light and spongy texture full of flavour.

Another quality in suet pastry's favour is that it is probably one of the easiest and quickest pastries to make as it doesn't require resting. Ready grated suet is easy to come by, and the vegetarian version works very well, even if you do lose a little flavour compared with the traditional variety. You can also buy fresh suet from a good butcher for pennies; it used to be a good rule of thumb that the whiter it is the better. But now that we're experimenting with old grass-fed dairy cows the bright yellow stuff has an aged flavour and is full of beta carotene.

I must say that the Steak & Kidney Pudding (see page 69) was one of the highlights of this book's recipe testing and it is going on my restaurant's menu, so you would be crazy not to try it. I think there is something wonderful about carrying the threads of history through the food we eat, especially when it offers such delicious, comforting dishes as these.

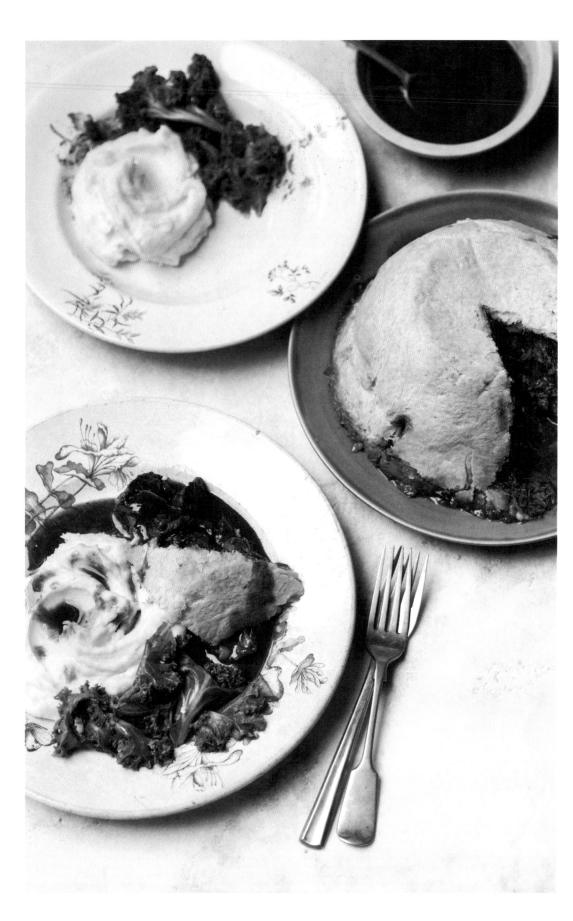

Steak & Kidney Pudding

There may be an Instagram and Twitter hashtag dedicated to suet pudding but I think it's still fair to say that over the years we've seen a decrease in the number of savoury suet puddings. My cheesemonger friend Holly Chaves and I have scoured the land for the places that serve the best. Rules in Covent Garden and the Hind's Head in Bray are my favourites although I must also give a shout out to Fergus Henderson's Leek Suet pudding with Kidney Gravy. This recipe uses the same method as my Sticky Oxtail Stew (see page 34) for the base, because it provides that perfect deep, satisfying richness that is essential in a steak and kidney pudding. I know that some people struggle with kidneys so feel free to exchange the kidney with mushrooms, chorizo or simply more ox cheek – although if anything is going to convert you to their earthy sweetness it's this pudding. Let's keep this recipe alive!

Brown the ox cheek pieces in olive oil first, ensuring that you caramelise them all over, before removing them from the pan and setting them aside. It's best to do this in batches so as not to overcrowd the pan. Add a little more oil to the same pan and repeat this process with the kidneys.

From this point follow the steps outline in the Sticky Oxtail Stew recipe on page 34, substituting ox cheek and kidney for oxtail.

Once you have strained the sauce and achieved a beautiful glossy, smooth consistency, I recommend allowing the filling to chill overnight in the fridge. This develops the flavour further, and you want the filling to be cold when it makes contact with the suet pastry.

To make the pastry, sift the flour into a large bowl with the salt. Add the suet and rub it together with the flour between your fingers, to break it down into a crumb-like texture. Add 150ml of the water and bind the mixture with a cold knife. With your hands, bring the pastry together; this should only take a minute. Be careful not to overwork it or you will have tough pastry. Test whether the mixture needs more water by how it feels; you are aiming for soft, smooth dough that doesn't stick to your hands.

CONTINUED »»

SERVES 4–6

Preparation time 1 hour
Cooking time 5 hours 15 minutes

For the filling
olive oil, for frying
2 ox cheeks (roughly 900g each), trimmed and each cut into 5 pieces
500g ox or veal kidney, trimmed of fat and cut into bite-size pieces.
1 onion, roughly chopped
2 carrots, quartered
1 celery stick, roughly chopped, plus a handful of celery leaves
1 head of garlic, cut in half horizontally
1 tsp tomato purée
2 tsp plain flour
150g streaky smoked bacon, cut into lardons
500ml fresh beef stock
1 bottle red wine
2 bay leaves
2 sprigs of rosemary
few sprigs of thyme
4–5 sprigs of parsley
sea salt and freshly ground black pepper

For the suet pastry
350g self-raising flour
large pinch of salt
175g suet
150–200ml ice-cold water
1 free-range egg, beaten

Unlike most pastry you don't need to rest it at this stage, as the raising agent in the flour will start to activate on contact with the water. Turn the pastry out on to a well-floured surface. Cut the dough into two pieces, two-thirds of the dough for the base of the pudding and the remaining third for the lid.

Pat the larger piece into a circle, and then roll out until it is roughly 1.5cm thick. Use this piece to line a 1.5 litre pudding basin, carefully pushing it into shape. Make sure the pastry comes about 1cm above the rim of the basin so you have pastry for the lid to adhere to. Next, fill the basin with the meat, but reserve about 4 tablespoons of the congealed sauce for extra gravy, and to prevent the pudding becoming too wet.

Roll out the small piece of dough to make a lid of the same thickness for the pudding. Fold the excess base pastry in on itself. Brush the edges of the lid with beaten egg and press it down on the pudding to seal it to the base pastry.

Cover with a circle of baking parchment and a layer of muslin, then tie it with kitchen string under the rim of the basin. Before cutting the string, take it over the top to create a loose handle, then tie securely. Trim off any excess baking parchment.

Place the basin in a large saucepan and fill with hot water two-thirds of the way up the sides of the basin. Cover and allow it to steam for 1 hour 15 minutes. Once an hour has passed, heat the reserved gravy in a saucepan for the last 15 minutes of the cooking time.

Remove the pudding from the pan and allow it to cool for a couple of minutes. Remove the muslin, string and baking parchment. With a knife, carefully edge the pastry away from the walls of the basin in preparation for turning it out. This is a bit tricky, but be brave! When the pudding is loosened, place a plate on top of the base, and with one hand on the base of the basin and one hand under the plate, turn it upside down in one swift, confident movement. Carefully lift off the pudding basin and a perfect pudding should be revealed! Bring it to the table whole, and cut it into quarters or sixths depending on how hungry you and your guests are. Pour over a little of the extra gravy and serve with buttery mash and greens.

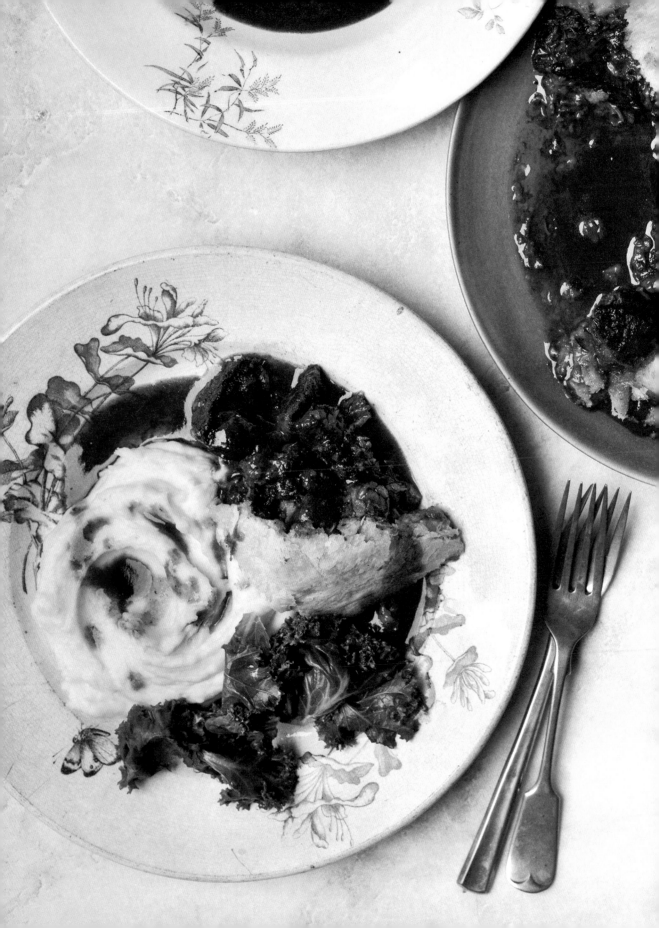

Sussex Pond Pud

I couldn't not include this absolute classic in my crusade to resurrect the steamed pudding. It seems weird to plonk a whole lemon in the centre of the pudding, but when cooked really slowly with the butter and sugar it slowly releases its juice to form a beautiful lemony sauce which pours out over the plate when you cut into the pudding – hence the pond! In my opinion, it is absolutely essential to serve this with double cream (Jersey cream if you can get it).

Prick one of the lemons all over with a skewer and grate the zest. Juice the other lemon. Combine the flour, 20g of the sugar, the lemon zest and juice and the suet in a bowl, then add the milk. Knead to form a dough, but be careful not to overwork it. Divide the dough into two rough balls, comprising one-third and two-thirds of the mixture respectively. Line the bottom of a 1.5 litre pudding basin with a small circle of baking parchment and then liberally grease some butter on top of it and around the sides of the basin to prevent sticking. Flour a worktop and roll out the larger ball to about 1.5cm thick. Use this to line the base and sides of the basin.

Fill the pudding with half the cold butter cubes and half the remaining sugar. Pop the whole lemon on top, then add the rest of the sugar and butter. Roll out the smaller ball of dough to make a lid for the pudding (this will become the base so make it nice and thick). Brush the edges of the lid with water, put on top of the pudding and press to seal. Cover with a circle of baking parchment and a layer of muslin, then tie it with kitchen string under the rim of the basin. Before cutting the string, take it over the top to create a loose handle, then tie securely. Trim off any excess baking parchment.

Place the basin in a large saucepan and fill with hot water two-thirds of the way up the sides of the basin. Cover and simmer for 3 hours 30 minutes. Keep an eye on the water level, and top up as necessary. Allow the pudding to rest for 10 minutes before carefully turning it out on to a serving dish. When serving, ensure that everyone gets a little of the lemon.

SERVES 6

Preparation time 20 minutes
Cooking time 3 hours 30 minutes

2 large unwaxed lemons
250g self-raising flour, plus extra for
 dusting
170g golden caster or soft light
 brown sugar
100g beef suet
130ml whole milk
100g butter, finely diced and chilled,
 plus extra for greasing

Poached Fruit

Here is a base poaching stock syrup. I've found over the years that a classic wine poaching syrup can be too sweet. I have a theory that you should always start with a sweet wine, meaning you can use less sugar in the poaching. You need the sugar for viscosity as well as sweetness, but still it can be a bit much. I use apple cider vinegar to cut through it – it's a lot cleaner and more mineral flavoured than citrus and fruit sits well in it. So this is a base recipe I've used on a variety of fruits and aromatics and how best to cook them.

Poaching Liquor

SERVES 4

Preparation time 10 minutes
Cooking time 5-15 minutes, plus cooling time

200ml Sauternes, or other medium sweet white wine
50ml apple cider vinegar
350ml water
30g runny honey
50g agave nectar

Put all the ingredients in a saucepan big enough to hold them, putting the fruit in last. Set over a medium heat until the liquid comes to the boil, then reduce the heat so that it is barely simmering. The cooking time will vary according to the ripeness of the fruit.

Poached Pears

4 ripe pears (preferably William or Conference) peeled, with stalks on and cores removed from base with corer or melon baller
1 vanilla pod, halved
4 cardamom pods, bashed

Very ripe pears will take only 5 minutes, much less ripe fruit will need up to 15 minutes. As soon as the pears are ready, turn off the heat. Transfer the pears with their poaching syrup to a bowl and leave at room temperature until needed or chill in the fridge overnight.

Poached Rhubarb

400g rhubarb, cut into 5cm lengths
600ml poaching liquor (see left)
1 tsp pink peppercorns

Poach as described for the pears, simmering gently for 5 minutes, until the rhubarb has softened but still holds its shape.

Poached Apples

5 firm English apples (not Bramleys which fall apart) peeled, with stalks on and cores removed from base with corer or melon baller
600ml poaching liquor (see left)
1 cinnamon stick

Prepare and cook as for the pears, but simmer for 15 minutes, until the apples are soft but still hold their shape.

CONTINUED »»

Poached Plums

400g plums, halved, stones removed
600ml poaching liquor (see overleaf)
1 star anise

Prepare and cook as for the pears (described overleaf),
but simmer for 5–10 minutes, depending on how ripe the
plums are, until they are soft but still hold their shape.

Poached Strawberries

500g strawberries, hulled
600ml poaching liquor (see overleaf)
1 tsp peppercorns

Prepare and cook as for the pears (described overleaf), but
simmer for only 5 minutes.

Poached Peaches

5 firm, ripe peaches
600ml poaching liquor (see overleaf)

Start by skinning the peaches. Set out two large bowls and
fill one with iced water. Place the peaches in the second
bowl and pour over enough water from a just-boiled kettle
to cover them. Leave them for 30 seconds then remove
them with a slotted spoon and plunge them into the iced
water. The skins should peel away easily, but be careful to
keep the peaches whole and smooth.

Poach as described for the pears (described overleaf),
simmering for 10–15 minutes until the peaches are soft but
hold their shape.

BRAISE

Pork & Apple 'Stroganoff' with Hot Dog Onions

This is somewhere between a pork stroganoff and a pork, apple and crème fraîche stew. I haven't used pork fillet because it cooks too fast and, as I'm sure you've gathered by now, I am a sauce obsessive and like my meat to fall to bits, so instead I've used the criminally underused pork neck steaks. Classically you would probably use French Dijon mustard, but I think the fieriness of English mustard works better here.

Heat a large flameproof casserole and add 3 tablespoons of ghee. When it has melted add the onions and rosemary and fry very slowly with the lid on for about 25 minutes until the onions are really soft, making sure you give it the odd stir to prevent the onions catching on the bottom of the pan. Then whack up the heat and fry the onions hard for another 5 minutes or so until dark golden. The best kind of onions are almost soft enough to squash your fingers through them, a bit like a hot dog onions.

While the onions are cooking, season the pork and brown it in batches over a high heat in a tablespoon of ghee. You want the pieces to be a really dark caramel, which is why it's important not to overcrowd the pan. Remove the pork pieces with a slotted spoon and set aside while you brown the next batch. When this is done fry the mushrooms, again in batches, in a tablespoon of ghee, until dark golden on all sides, and finally, do the same with the apple pieces. When browning the apples, place them cut side down in the ghee in the hot frying pan, and leave them there for a few minutes until golden brown. Then flip the pieces over to brown the other side. Set the apples aside on a separate plate.

Keeping back half the onions and the apples, which you need as garnish, put everything back into the pan. Add the flour and cook for 1 minute, then pour over the wine or cider and the stock. Bring to the boil, then reduce the heat and slowly braise the pork for 1 hour, making sure that you give it a good stir and scrape the bottom of the pan every so often.

It's ready when the pork is tender and the sauce is thick and almost syrupy. Mix together the mustard and crème fraîche and pour them in to make a sauce. Put the apples back in to warm them through, but don't overcook them or they will explode into the sauce. Check the seasoning; it will want lots of black pepper and it may need perking up with some lemon juice. Add the parsley, then you're ready to serve, topped with the hot dog onions. I love this with short grain old-fashioned rice!

SERVES 4

Preparation time 30 minutes
Cooking time 2 hours

5 tbsp ghee or rapeseed oil
4 medium onions, thinly sliced
3 sprigs of rosemary
700g pork neck steaks (about 3 steaks), cut into thickish slices
250g mushrooms, thinly sliced
2 Granny Smith apples, cored but not peeled, each cut into 8
1 tsp plain flour
300ml white wine or cider
500ml fresh chicken stock
1 heaped tsp English mustard
4 rounded tbsp crème fraîche, plus extra for serving
squeeze of lemon juice
2 tbsp finely chopped parsley
sea salt and freshly ground black pepper

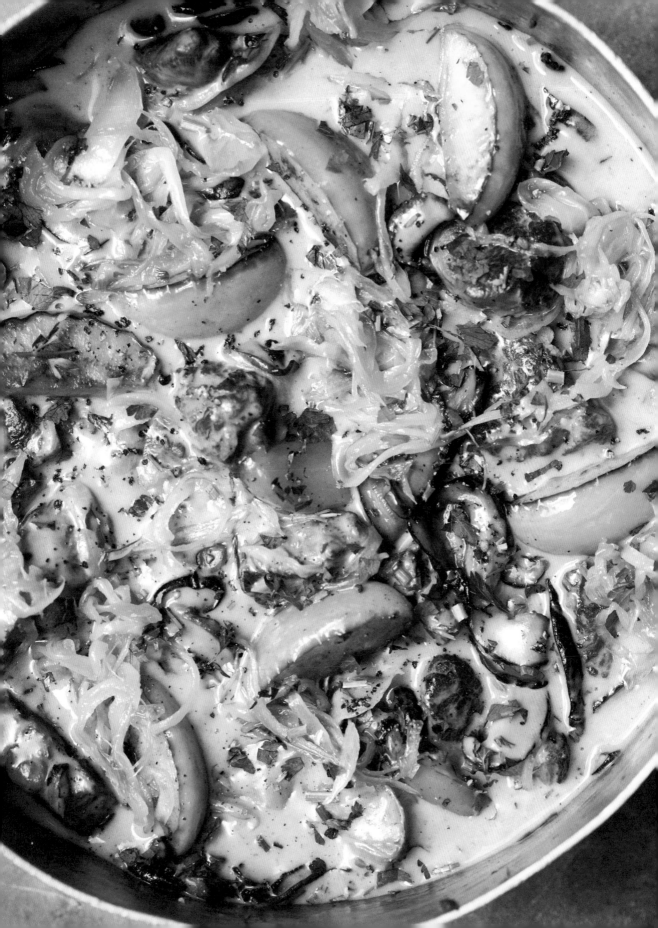

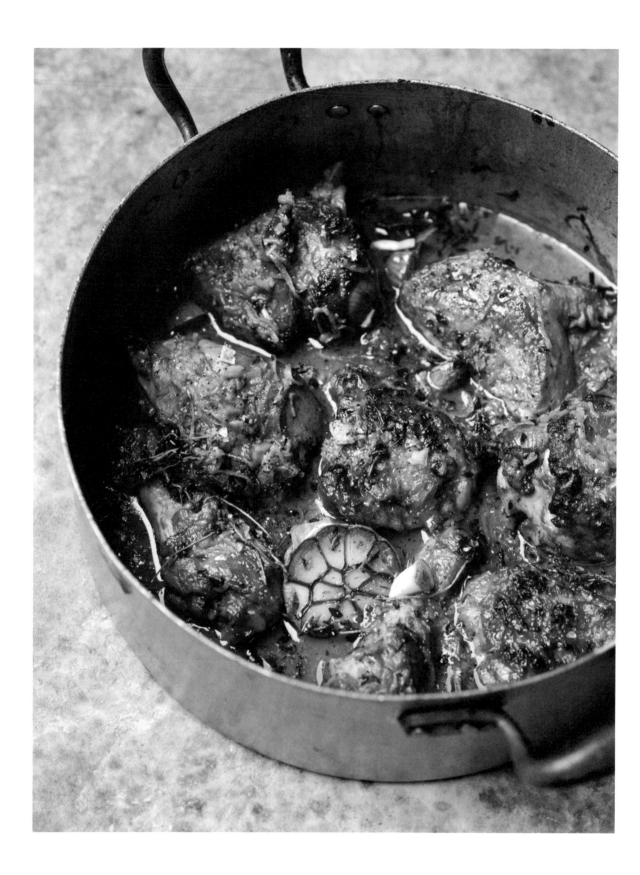

Braised Chicken with Shallots, Orange Wine & Brandy

This dish is very similar in principle to a classic Coq au Vin, but instead of using a robust red wine I have opted for a more modern approach and used orange wine instead. And in place of the smoky body from the bacon we're getting sweetness from the shallots. Orange wine is pretty trendy at the moment and is increasingly available in good wine shops and really worth investigating. It creates a more complex sauce, with rusty, sherry-like undertones, while the brandy injects extra life in the dish.

Preheat the oven to 180°C/160°C fan/gas mark 4. Heat a good lug of the oil or clarified butter in a large, heavy-based, lidded casserole. Season the chicken pieces and brown them in two batches. Cook for 4 minutes on each side and set aside. Add some more oil to the pan and place the garlic halves cut side down for a few minutes until they begin to caramelise. Next throw in the shallots and and cook in the chicken juices for 30 minutes. Scrape the bottom of the pan to remove all the delicious chicken residue. Add the tomato purée and flour and cook for a few minutes.

Return the chicken pieces to the pan. Now you need to flambé! The easiest way to do this is to put half the brandy into a metal ladle, and the rest into the casserole. Set the brandy in the ladle alight and pour it over the chicken. Allow the flame to die down. Next pour in the wine and the stock, then add the bay leaves and thyme sprigs. Season well with salt and pepper. Put the lid on the casserole and place in the oven for 1 hour.

Once the cooking time is up, remove from the oven and stir in the sugar and vinegar. This might sound a bit unusual, but trust me, it really elevates the flavours of the stew. Serve with mashed potatoes and greens.

SERVES 6

Preparation time 30 minutes
Cooking time 1 hour

2 tbsp rapeseed oil or clarified
 butter
1 chicken, cut into 8 pieces
1 head of garlic, halved horizontally
8 banana shallots, thinly sliced
½ tsp tomato purée
1 tbsp plain flour
50ml brandy
1 bottle medium-bodied French
 orange wine
500ml chicken stock
3 bay leaves
few sprigs of thyme
1 tsp sugar
1 tsp sherry vinegar
sea salt and freshly ground black
 pepper

Aligot

I only discovered this dish last year. If you haven't heard of it, Aligot is a cheese and potato purée that's whipped into a stringy cheesy frenzy. It's from the L'Aubrac region in the southern Massif Central of France. I just need to point out that 37 years of my life have gone by without my knowing that there is a hybrid between fondue and pomme purée (and that's not even the best bit, which is that you eat it with sausages). Seriously! What a waste of time!

One could argue that now I've discovered it my life is sorted, which it is. This love affair has been pretty intense. As with many dishes I've come across, the second my friend Holly Chaves, cheese buyer (yes, that's a job!) and proprietor of Wine & Rind, told me about it, I saw it on two menus in the space of a week.

The classic method calls for Tomme de Savoie cheese to be added to the potatoes and whipped and whipped until the texture becomes glutinous and stringy. I've tried multiple times and the only way I got a genuine stringiness was by cheating and adding some mozzarella. I also felt that while the Tomme adds acidity, Gruyère helps to give it an earthy flavour and stringiness. Much to my dismay (honest guv) I had to test this recipe multiple times and this version won out massively.

SERVES 4

Preparation time 10 minutes
Cooking time 25 minutes

1kg floury potatoes, peeled and cut
 into quarters
300ml double cream
100g Gruyère
200g Tomme de Savoie, grated
125g mozzarella
100g unsalted butter
good grating of nutmeg
sea salt
white pepper

Put the potatoes in a saucepan and cover with cold water. Bring to the boil and cook for 20 minutes until cooked through. Drain and allow to steam dry for 5 minutes. Blitz in a food processor until smooth. Return the potatoes to the saucepan over a medium heat to ensure that all the moisture has evaporated.

Now turn the heat down low and prepare for the hard work. Get your whisk ready, and take a firm grip on your saucepan. Add the cream, Gruyère and Tomme de Savoie and whisk together. Forget everything you've ever been taught about not overworking mashed potato. Once the two cheeses have melted add the mozzarella, butter, salt, nutmeg and a good pinch of white pepper and keep beating rapidly until all the cheese is incorporated. You want a really stringy, gloopy consistency. Serve with my sausage recipe on the next page and that's it. I give you the dirtiest thing you can do with cheese and a sausage. You can thank me later.

Lightly Braised
Toulouse Sausages

I'm not making a meal out of this recipe because it's not often you'll see sausages as the side dish but in this case they are. These braised Toulouse sausages are exactly what you want to eat with your Aligot. The Aligot is the hero after all, but every hero needs a sidekick!

SERVES 4

Preparation time 10 minutes
Cooking time 1 hour 10 minutes

1 tbsp olive oil
4 good-quality Toulouse sausages
3 onions, thinly sliced
1 tsp plain flour
200ml white wine
500ml fresh chicken stock, from the
 chiller cabinet
few sprigs of thyme
1 bay leaf
sea salt and freshly ground black
 pepper

Heat the oil in a heavy-based casserole. Fry the sausages until they are browned, but not cooked through, remove from the pan and set aside. Add a spot more oil to the pan and fry the onions slowly for 20 minutes, scraping away at the sausage residue on the bottom of the pan. Cook until the onions have fully softened and started to go golden.

Preheat the oven to 180°C/160°C fan/gas mark 4. Stir the flour into the onions, then cook for 10 minutes. Pour over the wine, bring to the boil and cook for 2 minutes. Add the stock and herbs, pop the lid on the casserole and put in the oven for 35 minutes, or until the sauce is bubbling, thickened and full of flavour. Remove the bay leaf, then season with salt and pepper and serve alongside the Aligot with a dab of French or English mustard.

Braised Sour Red Cabbage

My mum's red cabbage beats everyone else's. We all think things like this, don't we? I'm sure when I make these statements some people might find them irritating or become overprotective of their own mum's dishes, but I eat a lot of really good food and when I claim that my mum makes the best version of a recipe, I really and truly mean it. Red cabbage is one of my mum's great side dishes. We have it with everything from sausages to pork chops to Christmas lunch. She's half Polish, so a lightly pickled hot red cabbage is inherent to her. It cuts through a stew or braise with perfect vibrant acidity.

In a large pan or wok heat the olive oil. Fry the onions gently for 8 minutes, or until they have softened and started to take on a golden tinge. Add the cabbage and stir-fry for a further 5 minutes.

Pour over the vinegar, 150ml water and the sugar, then stir until the sugar has dissolved. Add the spices then pop on a lid and allow to simmer slowly for 40 minutes.

You may need to check the water level at this stage. When you move the cabbage aside with a spoon it should leave a pool of lightly syrupy liquid. You don't want it too dry, but not too wet either. Season with salt and pepper before serving.

SERVES 4

Preparation time 15 minutes
Cooking time 45 minutes

2 tbsp olive oil
2 red onions, thinly sliced
½ large red cabbage (or 1 small one), cored and thinly sliced
100ml red wine vinegar
3 tbsp brown sugar
3 juniper berries
pinch of ground cloves
sea salt and freshly ground black pepper

Braised Peas with Little Gems, Spring Onions & Wild Garlic

This is my version of the French classic Petits Pois à la Française. It's the perfect combination of seasonal ingredients from early spring into summer. I use confit garlic as a base and finish with wild garlic. This works really well alongside a classic roast chicken, roast lamb or grilled fish or you can swap out the chicken stock for veggie stock to make this a great vegan dish in its own right.

SERVES 6 AS A SIDE

Preparation time 10 minutes
Cooking time 15 minutes

12 spring onions, roots removed
5 Confit Garlic cloves (see page 64)
 plus 2 tbsp oil from the confit
500g frozen peas
250ml fresh chicken stock
2 baby gem lettuces, cut crosswise
 into 3 pieces each
large handful of wild garlic leaves,
 washed and cut in half crossways
sea salt

First char the spring onions. Heat a frying pan over a high heat and lay the spring onions flat in the pan. Find a heavy pan that fits inside the frying pan to weight down the spring onions. Allow to cook for a few minutes before turning. Remove from the pan once they have started to brown, and cut them into thirds.

In a heavy-based casserole, heat the garlic oil over a medium flame. Add the garlic cloves and fry for a couple of minutes. Add the peas followed by the stock and allow to braise for 5 minutes. Next add the spring onions, followed by the lettuce. Cover with a lid and continue to braise for a further 3–4 minutes until the lettuce has wilted. Finish by adding the wild garlic for the last minute and allowing it to wilt. Season with a little salt and serve immediately.

Fish

We are all becoming increasingly aware of the precarious state of the world's seas. Overfishing, pollution, rising sea temperatures and increasing levels of acid in our seas have led to many fish stocks going into serious decline over the past two decades. As consumers it is our responsibility to be aware of where our fish comes from. We can all play a role in helping to protect the future of our seas by buying sustainably managed, environmentally friendly fish and seafood.

The boats that fish off the coasts of our island bring in more than 150 different species of fish daily, but most of us play it far too safe and tend to buy only five of these – namely salmon, cod, haddock, prawns and tuna. This creates huge pressure on the industry to meet demand, which often leads to intensive and unethical production methods. We cannot be short-termist about these issues any more. The UN Food and Agriculture Organization (FAO) estimates that 70% of the world's fish population is fully used, overused or in serious crisis.

The barrage of frightening statistics about the state of our oceans can sometimes feel overwhelming, and it's easy to feel powerless to effect any meaningful change. But what we put in our shopping baskets is what drives the market, so if you follow some guidelines you can still enjoy fish with less guilt!

The best way to ensure that you know where your fish comes from is to establish a good relationship with your local fishmonger, who will be able to tell you the provenance of the fish you are buying. Any fishmonger worth their salt should be able to give you good cooking advice too. Buying locally is the best way to support this country's fishermen, but you will find that your fishmonger will agree that a lot of our prime local fish are exported. For example, our shores boast some of the most highly prized crabs in the world, and hardly any of us Brits are eating them, so most are whisked off to China! It's devastating to think that we barely capitalise on the fact that our fishing fleet catches some of the tastiest and fittest fish that swim in the Atlantic and that our shellfish is arguably the best in the world. We need to wise up about what we have on our doorstep and also try to buy what's in season whenever possible.

So how do we know if our fish is British, sustainable and fresh? How do we check which fish are sustainable at what times? The cod crisis is a good example: people believe that we shouldn't eat Atlantic cod right now, when in fact stocks are increasing. This year I wanted to make herring recipes, but herring stocks were very late arriving due to seasonal changes, which means that the mackerel season is also late. The fishing seasons are complicated and change all the time. In a dream world we would be line-catching wild fish or eating the small hauls of small boats, but that would come at a price, so how do we decide what to do?

How to identify the fish we should eat
When buying seafood look out for the following:
• The Marine Stewardship Council (MSC) logo. This is a good indicator of fish that has been certified as coming from sustainably managed stocks.
• The Aquaculture Stewardship Council (ASC) logo. This also certifies fish that is farmed responsibly.
• Organically farmed fish. This tends to be raised using higher welfare standards; for example enjoying more space and better environmental standards.
• Atlantic fish. Buy this whenever possible. Look for UK coastlines on labelling, but you can eat fish from the rest of the world occasionally and as a treat. The sad truth is that even if we in the UK stopped eating all the endangered fish in the world it would have zero impact on overfishing by China, Japan and Spain!

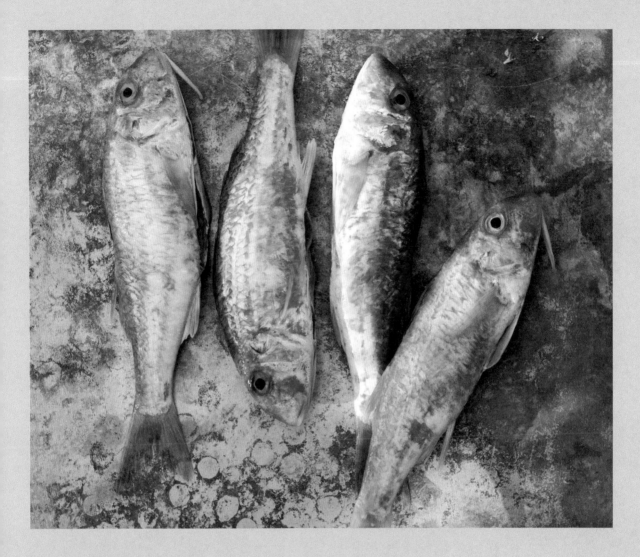

How to check your fish is really fresh

• Fish should not smell overpowering or unpleasant; it
should smell fresh and of the sea, almost briny.

• The eyes should be bright and clear; if they have clouded
over this is a sign that the fish is not at its freshest.

• The gills should be a bright, rich red. If the fish is old
they will have faded and become more brown.

• The fresher the fish the brighter and more metallic
the skin.

• When buying shellfish such as mussels, clams and
oysters, make sure they are live. They should smell fresh
and have tightly closed shells. If their shells are slightly
open, give them a little tap to see if they close. If they do
not, discard them.

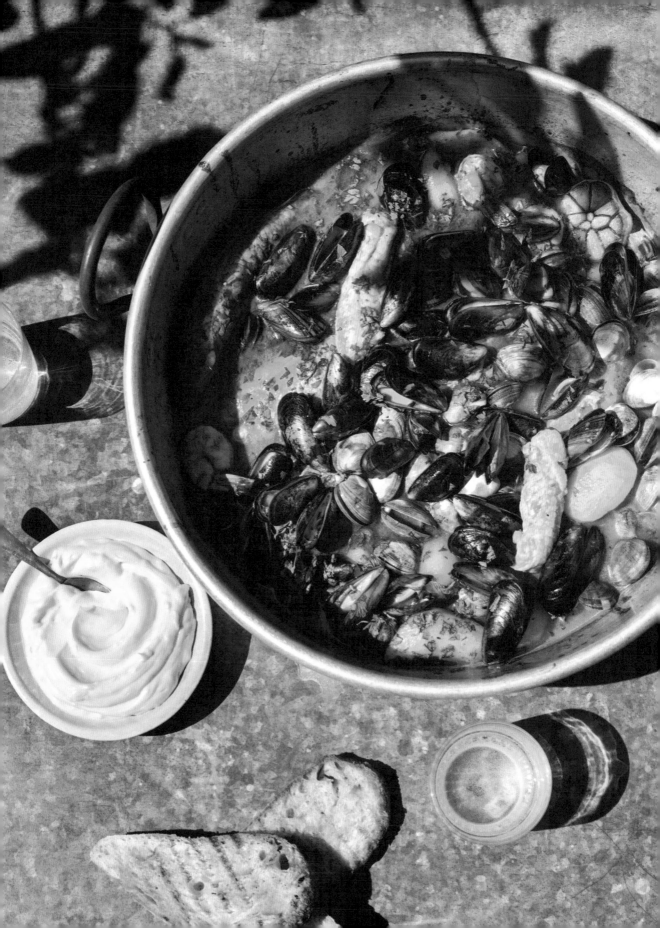

Caldeirada Fish Stew

Every coastal country has its own fish stew recipe, perhaps the most famous of which is the southern French Bouillabaisse, but the unsung hero has to be Caldeirada from Portugal. This is a multi-layered stew of a variety of different fish and seafood, potatoes, tomatoes, saffron, wine (the classic Portuguese green wine if you can find it) and a healthy dose of good shellfish stock. We don't have the luxury of really cheap seafood here in the UK, so this normally 'peasant' dish is going to be more on the expensive side.

All these ingredients are valuable, so make sure you treat them with due care. Make sure the stock is reduced so it has a deep, delicious flavour before you add the fish, and once it's added, don't stir the stew because the fish will break up and you will lose its elegance.

First intensify the stock. Heat a large, heavy-based frying pan with a glug of olive oil over a high heat, add the prawn heads and shells and fry until they turn pink and start to get a crunch on the outside. Add the two chopped onions, the carrot, the halved garlic, parsley stalks and 1 bay leaf. Fry for a few minutes until everything starts to caramelise, then add a teaspoon of tomato purée and cook for a further couple of minutes. Pour over the stock and stir. Simmer for 30 minutes, stirring occasionally. Strain the liquid into a bowl and discard the stock ingredients.

In a separate heavy-based casserole, heat 50ml olive oil over a medium heat and add the sliced onions. Cook slowly for about 20 minutes until they are softened and start to get a golden brown tinge. Now add the sliced garlic, the other bay leaf and the dried chillies, and cook for a further 5 minutes. Add 2 tablespoons of tomato purée and cook for another 5 minutes.

Meanwhile char the tomatoes over the flame on your hob. Lay them around the burning ring and turn every couple of minutes with tongs, until the skins are nice and charred and starting to peel away. If you do not have a gas stove, you could do this with a blowtorch, or heat the oven to its hottest, place the tomatoes on a baking tray and put in the oven for a few minutes until the skin starts to blister and char. It might seem counter-intuitive to include 'burned' tomato skin, but trust me, it adds an extra smoky element to the dish, and won't taste acrid, I promise.

CONTINUED »»

SERVES 8

Preparation time 45 minutes
Cooking time 1 hour 30 minutes

50ml olive oil, plus extra for frying
8 tiger prawns, peeled except for the tails and deveined (keep the heads and shells)
6 onions, 2 roughly chopped, 4 thinly sliced
1 carrot, halved and cut into 6 pieces
2 heads of garlic, 1 cut in half, the cloves of the other peeled and thinly sliced
bunch of parsley, leaves and stalks
2 bay leaves
2 tbsp tomato purée, plus 1 tsp
1 litre fish or chicken stock
½ tsp crushed dried chillies
4 tomatoes
pinch of saffron
300ml Vinho Verde or very dry crisp white wine
700g waxy potatoes, peeled and cut into quarters
2 monkfish tails (about 600g), trimmed and cut sharp against the central bone into 2 pieces
500g squid, cleaned, wings removed, slashed and cut into large pieces
500g clams
2 bream, gutted, heads removed and each cut into 3 steaks
4 small red mullet, gutted, heads removed
1½ tsp sea salt
freshly ground black pepper
juice of 1 lemon

Place the tomatoes and the saffron in a food processor and whizz into a purée. Add this to the pan with the onions and reduce down for 10 minutes until it is really thick and the tomato flavour is well concentrated. Now add the wine and allow to bubble for 2–3 minutes. Follow this with the stock and bring to a simmer. Season with salt and pepper. Leave to simmer for 15 minutes. The sauce will be on the soupy side but taste it now; it should be beginning to concentrate in flavour. Season with a little salt.

At this stage add the potatoes, and allow to cook for 8 minutes. Taste the base again. You will notice that the potatoes have absorbed the salt and the base will have reduced and become even more concentrated in flavour. I like to get the flavour just right at this stage, so keep boiling the base until the flavour is perfect. You may want to take the potatoes out if you feel the sauce is a bit insipid, but if you've followed the instructions everything should be on track.

Now for the fish. Start with the monkfish, followed by the squid, then prawns, clams and finally lay the bream and mullet on the top so they don't break up when you are serving. Do not stir the fish at this stage for the same reason.

Cover with a lid and simmer for 8–10 minutes. Finely chop the parsley leaves now. Take the lid off and carefully remove the fish pieces. Add the parsley and lemon juice, give a stir and check the seasoning before gently laying the fish pieces back on top. Serve ladlefuls in shallow bowls with plenty of broth, a generous scattering of parsley and some crusty bread and butter or extra virgin olive oil on the side.

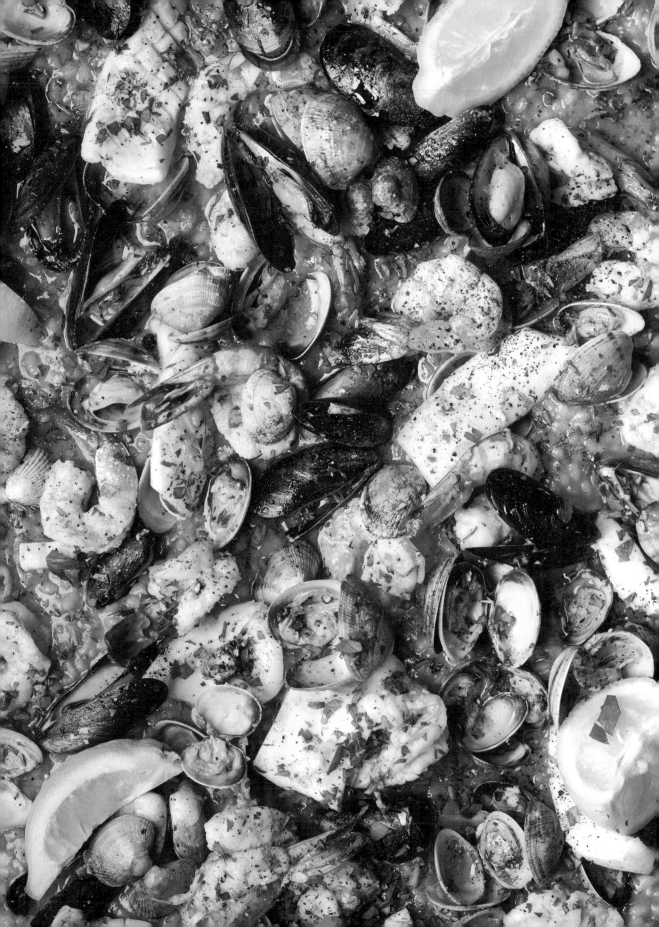

Arroz con Mariscos (Hot Bisquey Rice with Oven Roasted Seafood)

I spend a good few weeks of the year in the south of Spain and have done ever since I was a kid. Now the summers in Spain are spent nostalgically running around fitting in all the stuff we've always done. I've had churros in Orange Square in Marbella more times than I've probably eaten at any other restaurant and I always have to have my annual fix of paella at Los Sardinales. A newer dish is Arroz con Mariscos and this is all thanks to my great friend Nieves Barragan. She was head chef of Barrafina when she introduced me to her version.

Arroz con Mariscos is like a much richer paella made with the most intense seafood broth, which clings to the rice like a satin nightslip, and is topped with charred seafood. I've made it my lifelong mission to find good Arroz con Mariscos everywhere I go but, as hard as it is to find a good paella, a good arroz is even harder – especially when you've had it cooked for you by the best. Nieves won restaurant of the year three years running for Barrafina, earning it a Michelin star and making it the first Michelin tapas bar in the UK. So I've had to learn to improvise and now I make a pretty mean one myself. If you're a lover of paella, then please give this a go – I think it's better.

Start by making the shellfish broth. Heat the oil in a large, heavy-based saucepan. Toss in the onion, carrots, fennel, celery, garlic and herbs and sauté slowly for about 20 minutes. This process is really important, as it gives you most of the flavour for your sauce. You want the vegetables to sweat slowly so they get really soft before they start to caramelise, giving you a little colour, but not too much.

Stir in the tomato purée so it coats all the vegetables, then cook for 1 minute to get rid of its raw flavour. Whack up the heat, then add the prawn heads and shells. Sauté until they are bright pink, then douse with the brandy. Blitz the saffron with the stock in a food processor to emulsify the flavour and add to the pan, along with the wine. Now this might seem unorthodox, but at this point I like to add a good few splashes of Worcestershire sauce, as it gives the broth body and roundness. You need the liquid to come above the shells. Add the tomatoes and cook for 20 minutes on a slow boil.

CONTINUED »»

SERVES 6

Preparation time 30 minutes
Cooking time 1 hour 20 minutes

For the shellfish broth
2 tbsp olive oil
1 onion, chopped
2 carrots, chopped
1 fennel bulb, chopped
2 celery sticks, chopped
1 head of garlic, cut in half
2 bay leaves
few sprigs of thyme
few parsley stalks
1 tbsp tomato purée
the heads and shells of 24 raw king prawns (see below)
good slug of brandy or cognac
1 tsp saffron
1.5 litres fresh chicken or fish stock
400ml dry white wine
few splashes of Worcestershire sauce
4 tomatoes, quartered
squeeze of lemon juice

For the rice
2 tbsp olive oil
2 onions, finely chopped
1 head of garlic, cloves peeled and finely chopped
300g paella rice, such as arroz de Calasparra
1 tsp high quality Spanish smoked paprika
400ml dry white wine
1 tsp celery salt
sea salt

For the seafood
good handful of mussels, scrubbed and beards removed
good handful of clams, scrubbed
24 raw king prawns, peeled, deveined and butterflied, heads and shells reserved for stock
1 medium squid, trimmed, wings and tentacles detached, scored all over
2 tbsp olive oil
sea salt
chopped parsley, to serve
lemon wedges, to serve

Pour the mixture through a sieve, collecting the fragrant prawn stock. Squash the shells, particularly the heads, so they release all their juices. Transfer the strained stock to a frying pan, and then boil it gently to reduce the sauce until it starts to thicken and become intense in flavour. This will reduce the volume of liquid by about two-thirds. Finish with a squeeze of lemon juice to cut through the richness and season. Leave the broth to the side while you cook the rest of the dish. You can make this in the morning and finish it at night if you like.

When you are ready to put the dish together, cook the rice. Heat 2 tablespoons of olive oil in a frying pan. Add the onions and soften for 10 minutes until they start to acquire a golden tinge. Next add the garlic and soften for a couple of minutes. Then add the rice and paprika and cook for a few minutes before adding the white wine. Allow this to bubble for a minute or two before adding all the delicious fishy broth. Season with a little salt. Cook this over a low heat for about 20 minutes. You want the rice to maintain a wet, loose viscosity, but still be creamy; it should be cooked through with a little bite.

While the rice is cooking, get your seafood cooked. Whack your oven up as hot as it will go. Spread the mussels, clams, prawns and squid over a roasting tray, toss in the olive oil and season liberally with salt. Once your oven is roasting hot, put the seafood in for 10 minutes. You want it to develop a really nice charred quality while still being tender.

Once the seafood is cooked, remove the roasting tray from the oven, and strain some of the seafood juice into the rice, making sure you don't drown it in liquid. Allow the rice a couple of minutes to absorb this extra goodness before serving. Finish off with a teaspoon of celery salt.

To serve, spread the rice over a large platter and carefully arrange the seafood on top, followed by a generous scattering of chopped parsley and some wedges of lemon.

SLOW • BRAISE

Cheesy Polenta

Polenta is seen as a side dish in this country, but in Italy it's often given a starring role. Real polenta needs a low slow cook – look at it like cornmeal porridge. It takes about an hour and involves a fair bit of work, especially as you come to the end of the cooking process. There are lots of myths about polenta, but in my experience there's not much that can't be fixed by a really good beating with a whisk.

When it comes to serving, the key is to keep both the polenta and the plate as hot as possible so it doesn't start to set on the plate, and you want to serve it with something equally sumptuous, such as a sticky braise – or even alongside a quick stir fry of some bacon, prawns and spring onions. One of my favourite ways to eat polenta is with some charred corn shaved on top. But whichever way you serve it, take the time to make it properly.

SERVES 4

Preparation time 5 minutes
Cooking time 1 hour

2 litres fresh chicken or veg stock
200g polenta, cornmeal or grits
sprig of thyme
80g Cheddar, grated
30g Parmesan, grated
30g butter
pinch of cayenne pepper
pinch of white pepper
sea salt

Put the chicken stock, polenta, thyme and ¼ teaspoon of salt in a medium saucepan and bring to the boil. Allow to simmer over a very low heat for 1 hour. Initially it will resemble murky yellow water, but have patience, it will slowly come together. Keep whisking the mixture, especially during the last 15 minutes of cooking, to prevent the bottom of the polenta scorching. Once you have a nice thick gloopy consistency similar to a well-cooked porridge which pulls away from the sides of the pan and has no bite to it when tasted, mix in the cheeses, butter and peppers. You will notice that the the polenta lightens in colour and becomes lovely and shiny. Season with salt to taste and keep hot until ready to serve.

Dirty Prawns, Spring Onions & Bacon

This is my take on the classic Shrimp and Grits that hail from the southern states of America. Deeply satisfying and savoury, while quick to whip up, this prawn dish is the perfect accompaniment to my luxurious polenta recipe opposite. The main difference between grits and polenta is that Americans traditionally use white cornmeal as opposed to the sunnier yellow Italian cornmeal.

The combination of the sweetness of the prawns and the saltiness of the bacon works perfectly against the mellowness of the polenta. I recommend not being overly cautious with the cayenne or lemon juice, as this really helps to cut through the richness of the dish.

Place the prawns in a bowl with enough olive oil to coat them, add the crushed garlic and allow to marinate while you get everything else ready. This dish cooks fast so have everything prepped and organised before you start cooking.

Heat a frying pan over a medium heat with a slick of oil. Add the bacon and fry until it is starting to crisp and the fat has rendered. Remove the bacon from the pan with a slotted spoon and set aside. In the same pan, melt the butter in the remaining bacon fat. Turn up the heat to high and add the prawns. You want to cook these hard and fast. When they have begun to turn opaque, return the bacon to the pan along with the spring onions, salt, pepper and cayenne. Check for seasoning and give it a generous squeeze of lemon juice before serving alongside the polenta (see opposite).

SERVES 4

Preparation time 15 minutes
Cooking time 15 minutes

16 raw king prawns, peeled with
 tails on, deveined and split down
 the middle to butterfly
1 tbsp olive oil
6 garlic cloves, crushed
100g smoked streaky bacon, cut into
 lardons
1 tbsp butter
4 spring onions, finely chopped
½ tsp sea salt
¼ tsp white pepper
good pinch of cayenne pepper
squeeze of lemon juice

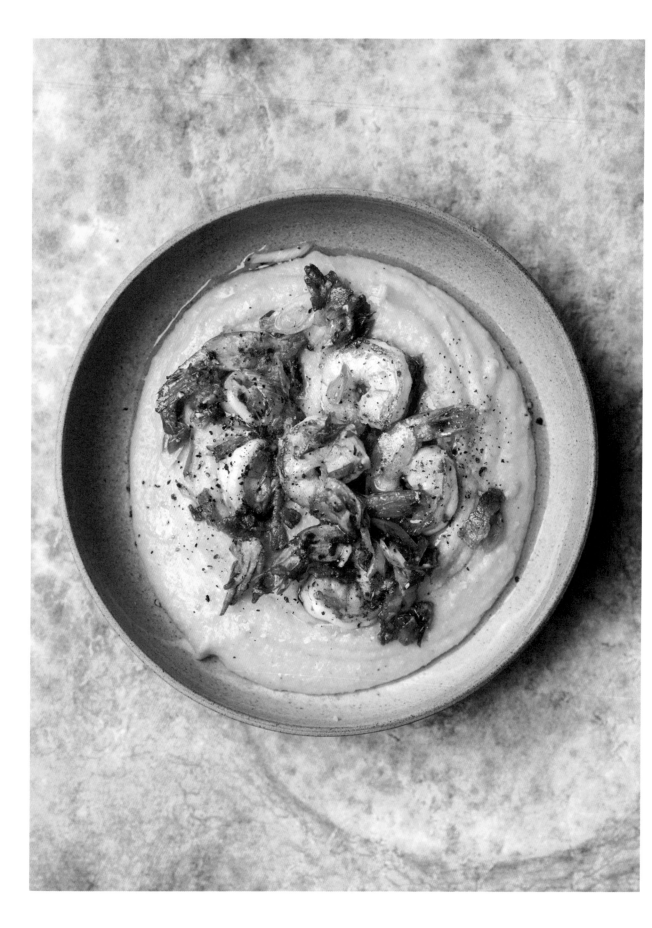

Golabki

My heritage is mostly Scottish, but my mother's father was Polish and we were brought up with the odd Polish treat. Two that I remember really well are ponchki (Polish damson doughnuts) and golabki, which are stuffed cabbage rolls. Many Eastern European cultures have their own variations and in southern Europe and the Middle East you can find something similar wrapped in vine leaves, but golabki rule for me.

They're really easy to make – it's like making little meatballs stuffed with onions, garlic, barley and spices and then wrapping them in cabbage leaves, before baking in a tomato sauce. The acidity in the sauce cuts through the slightly fatty pork perfectly. They're healthy and so tasty – I genuinely find them addictive. Serve them with soured cream and dill and if you can, find some ponchki for pudding.

SERVES 8

Preparation time 45 minutes
Cooking time 1 hour

120g pearl barley
5 tbsp olive oil
2 medium onions, finely chopped
1 head of garlic, cloves finely
 chopped
1 tsp fennel seeds
1 tsp crushed chilli
3 sprigs of thyme, leaves picked
600g pork mince
zest of 1 lemon
handful of parsley, finely chopped
1kg tomatoes, chopped
1 tbsp red wine vinegar
8 Savoy cabbage leaves, blanched
 for 2 minutes and refreshed in
 cold water
sour cream, to serve
handful of dill, to serve
sea salt and freshly ground black
 pepper

First, cook the pearl barley for 15 minutes in a saucepan of boiling salted water. Drain and set aside. Heat 1 tablespoon of the oil in a pan, and sweat the onions, 5 garlic cloves, the fennel seeds, chilli and thyme for 20 minutes until soft and translucent. Add this to a bowl with the pork mince, pearl barley, lemon zest and parsley and season generously with salt and pepper. Mix everything together thoroughly with your hands to ensure that all the ingredients are evenly dispersed.

In a separate saucepan, heat the remaining 4 tablespoons of oil and the rest of the garlic. Once it starts to soften, add the tomatoes, vinegar, salt and pepper. Cook over a medium heat for 30 minutes. Once reduced, transfer to a food processor and blitz until smooth.

Now you are ready to construct the golabki. Take a cabbage leaf, pat it dry and measure out 2–3 tablespoons of the meat mixture. Using a spoon or the palm of your hand, mould the mixture into a patty about 8cm long. Put this at the stalk end of the cabbage leaf, and roll up the leaf carefully, folding the ends under to make a little parcel. Repeat this with the rest of the cabbage and meat mixture.

Pour the tomato sauce into a heavy-based casserole to cover the base. Tightly arrange the cabbage parcels on top. Cover with a lid and cook over a gentle heat for 30 minutes. Serve two golabki per person, with some sour cream and dill on top.

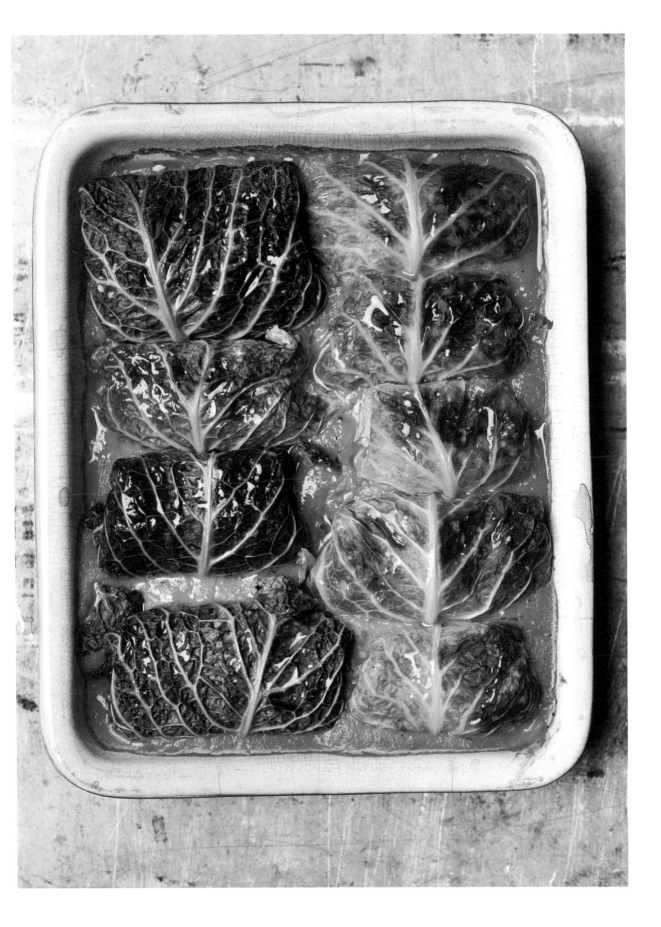

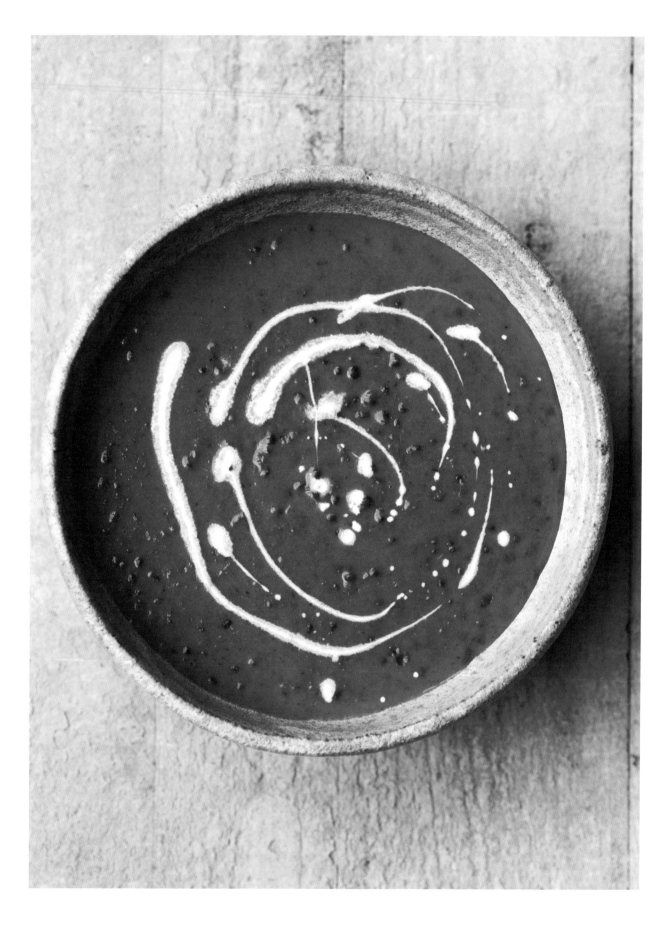

Makhani – Proper Butter Masala

If you've ever eaten that wonderful Black Dhal they serve at Dishoom, you will know the extreme deliciousness of this dish. I have never heard of anyone who has come out of that restaurant and not shouted about this being one of the standout dishes in the whole of London. I felt the same way the first time I tried Butter Chicken, but only a few years ago I realised that my beloved Butter Chicken, that I bought weekly from Khans in Westbourne Grove as a teenager, was of the same descent. You see, Makhani dishes are all finished with a healthy dose of butter and a slick of double cream, in the very same way that Butter Chicken and the Dishoom Black Dhal is. This is a brilliant base that can be tweaked to work with poultry, dhal or paneer.

Heat the ghee in a medium-sized casserole over a medium-low heat and add the onions. Soften for about 20–30 minutes, being careful not to let them catch by stirring regularly. Next add the garlic and ginger and soften for a further 10 minutes. Add the spices and allow to cook for a couple of minutes, then stir in the tomato purée and cook for another minute or two. Pour in the blitzed tomatoes and bring everything to the boil, then reduce the heat and cook slowly for 40 minutes until thickened and reduced and full of flavour, making sure to give the sauce a good stir every so often.

At this stage add the cashew nuts, salt and coconut sugar. Reduce for a further 10 minutes before transferring to a food processor. You want a really smooth creamy texture, so allow the sauce to blend for at least a minute. Check for seasoning. Now you have your sauce base!

SERVES 8

Preparation time 20 minutes
Cooking time 1 hour 20 minutes

For the base
4 tbsp ghee
4 onions, finely chopped
6 garlic cloves, finely chopped
large thumb-sized piece of ginger,
 peeled and grated
1 tsp chilli powder
½ tsp garam masala
1 tsp fenugreek seeds
1 tbsp ground cumin
2 bay leaves
1 tbsp tomato purée
1kg tomatoes, blitzed in a food
 processor
50g cashew nuts
1 tsp salt
1 tbsp coconut sugar
sea salt and freshly ground black
 pepper

CONTINUED »»

Makhani Dhal

Place 300g black lentils (traditionally urid beans) into a saucepan of cold water, bring to the boil and cook for 30 minutes. Drain, reserving 100ml of the cooking water and add this and the lentils to the sauce base. Allow to cook together for a further 30 minutes. Finish off the dish by stirring through 50g butter and 200ml cream to achieve that quintessentially rich, decadent finish. Add another swirl of cream and serve with 2 tablespoons of toasted flaked almonds and half a bunch of chopped fresh coriander.

Butter Chicken

Add 50g butter and 200ml cream to the sauce base, then a portion of chicken with Tandoori Marinade (see page 157). Cook in the sauce for 5 minutes, then add another swirl of cream and serve with 2 tablespoons of toasted flaked almonds and half a bunch of chopped fresh coriander.

Paneer Makhani

Add 50g butter and 200ml cream to the sauce base. Fry 250g paneer cheese until it starts to crisp up and go golden. Add to the sauce and allow to cook for about 5 minutes before adding another swirl of cream and serving with 2 tablespoons of toasted flaked almonds and half a bunch of chopped fresh coriander.

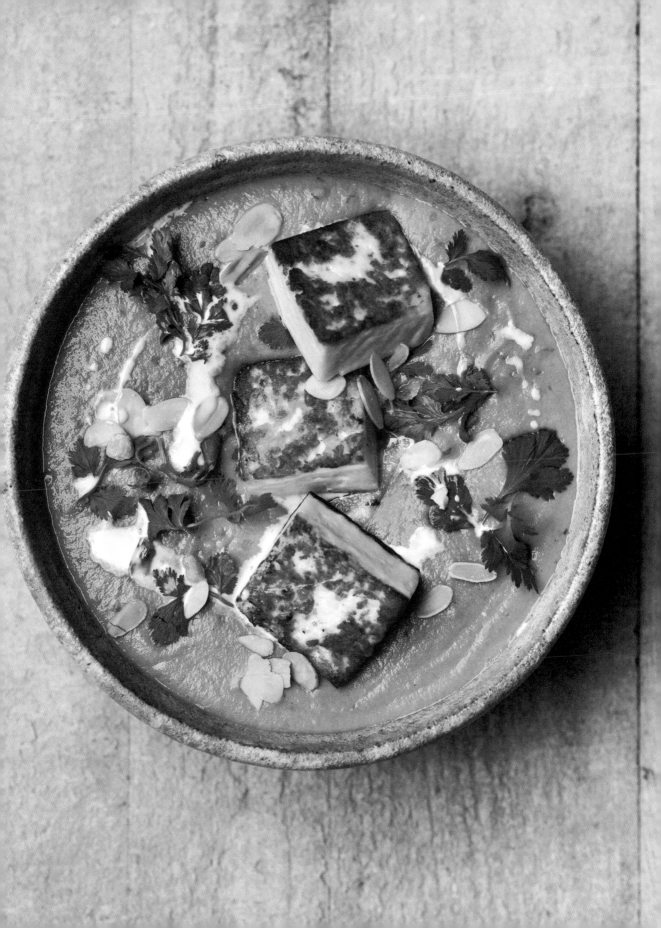

Braised Lamb Mince

As a child, when everyone else was eating shepherd's pie, I would more often than not be having braised mince and either mash or boiled potatoes – sometimes served on toast cooked in the fat of the lamb. I thought this was entirely normal, but there was a huge hoo-ha on the internet recently about whether mince should be served on toast or separately from its pie topping – and apparently it's not completely normal if you're English.

I'm a Scot; both my parents are Scottish (although my mum's half Polish), and it has taken me pretty much until this year to realise that I'm in a minority about how to serve braised mince. So if this feels weird, this is what we do in Scotland and it's just as delicious as any English version. Sometimes I crave the simplicity of a good, minted, buttery, waxy Jersey Royal instead of the richness and crust of a potato pie topping. If you want to turn this into a pie; make a kilo of Maris Piper mash with plenty of butter, milk, salt and pepper and nutmeg, top with Cheddar and bake at 200°C/180°C fan/gas mark 6 for 30 minutes, but always, always serve with Braised Sour Red Cabbage (see page 87).

SERVES 8

Preparation time 30 minutes
Cooking time 2 hours 30 minutes

4 tbsp olive oil
2 onions, finely chopped
2 celery sticks, finely chopped
2 carrots, finely chopped
2 leeks, finely chopped
1kg lamb mince
1 heaped tsp plain flour
1 tsp tomato purée
300ml white wine
1 litre fresh chicken stock
2 bay leaves
2 sprigs of rosemary
few sprigs of thyme
sea salt and freshly ground black
 pepper

Heat 2 tablespoons of the oil in a heavy-based casserole over a medium heat, add the onions, celery, carrots and leeks and sweat gently for 15 minutes until nicely softened. Meanwhile heat the remaining oil in a frying pan over a high heat, and fry the mince in two batches until well browned.

Next add the flour and tomato purée and cook for a couple of minutes before adding the wine, stock, bay leaves, rosemary and thyme. Bring to the boil, season well and cover with a lid. Cook very slowly over a low flame for 2 hours 30 minutes, stirring every so often.

Once the time is up, check the seasoning and serve. I think this works fantastically with my braised red cabbage as the vinegar cuts through the lamb perfectly and lifts the whole dish. Also, you simply have to have boiled new potatoes (a waxy variety), seasoned liberally with salt and covered in plenty of butter and finely chopped fresh mint leaves.

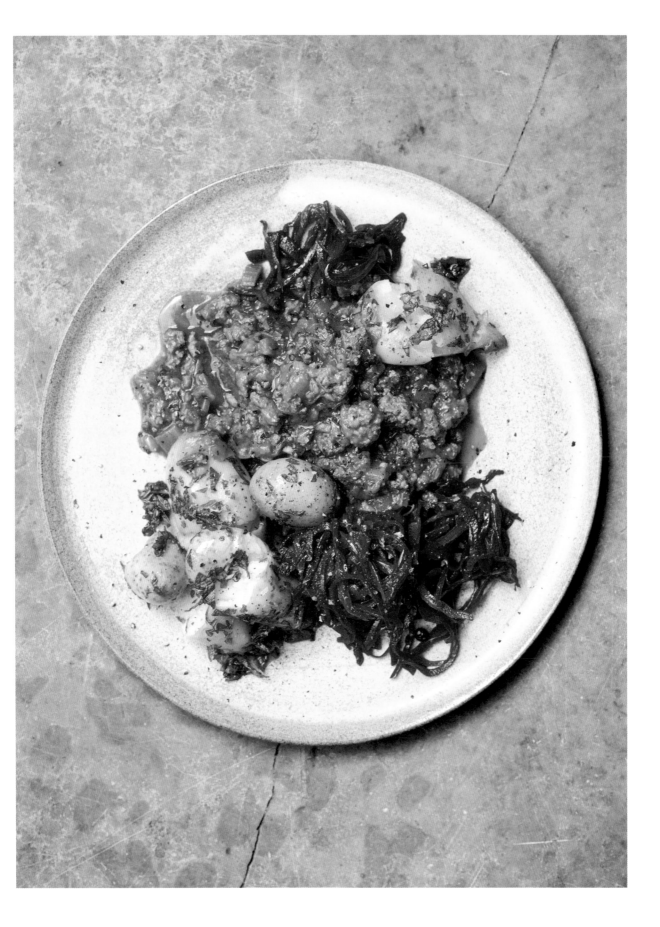

BAKE

Baked Kale, Spinach & Ricotta Stuffed Conchiglioni

This is my take on the classic cannelloni. Its origins stem from a happy accident when, as a teenager, I set my sights on learning how to cook the perfect version but couldn't find any cannelloni shells. My mum rooted around in the cupboard and produced a bag of conchiglioni, and a tradition started. Turns out the Venetians have been doing this for years, so I'm not as clever as I thought! What really lifts this is the green chilli and lemon, which add zinginess.

SERVES 4

Preparation time 40 minutes
Cooking time 30 minutes (plus
 1 hour 45 minutes if making
 tomato sauce from scratch)

250g kale, stalks removed
100g spinach leaves
1 green chilli, roughly chopped
handful of parsley, leaves picked
2 tbsp olive oil
250g ricotta
50g Parmesan, grated
½ nutmeg, grated
zest of 1 lemon
200g conchiglioni
750ml Slow Cooked Tomato Sauce
 (see page 240)
125g mozzarella
sea salt and freshly ground black
 pepper

Bring a large saucepan of salted water to the boil. Blanch the kale for 2–3 minutes, then remove from the water with a slotted spoon and refresh immediately in a bowl of ice-cold water. Repeat the process with the spinach, but reduce the cooking time to 30 seconds. It's important you don't overcook your leaves as not only will that destroy all their nutrients, you will also lose their vibrant green colour.

Once all your leaves are blanched, squeeze out any water. Throw the spinach, kale, chilli and parsley into a food processor and whizz for a few seconds. Scrape out the green goodness into a bowl and add the oil, ricotta, 30g of the Parmesan, the nutmeg, lemon zest, salt and pepper. Mix together until everything is well combined, and taste for seasoning. Transfer the mixture to a piping bag, squeezing the mixture towards the nozzle so it is nicely compacted and ready to pipe. This might seem a bit cheffy, but trust me it makes life so much easier.

When you're ready to assemble the bake, preheat the oven to 220°C/200°C fan/gas mark 7. Bring a large saucepan of salted water to the boil, and cook your pasta shells for 10 minutes. Don't fully cook the pasta – the shells should retain a good amount of bite (a little more than the standard 'al dente'), as the remaining cooking will be done in the oven. Drain and allow to cool until you can handle them.

To fill the pasta, cup a shell in one hand with the piping bag in the other, and with your thumb open up the shell and squeeze about a tablespoon of filling into the cavity. Repeat until all the pasta and filling is used up.

Take a medium ceramic baking dish (about 26cm square) and pour in the tomato sauce. Then arrange the filled pasta shells on top, packing them in tightly and pressing them down a little into the sauce. Tear the mozzarella and scatter over the top, followed by the remaining Parmesan. Bake in the hot oven for 20 minutes until the cheese is delicious and bubbling and serve with a simple green salad.

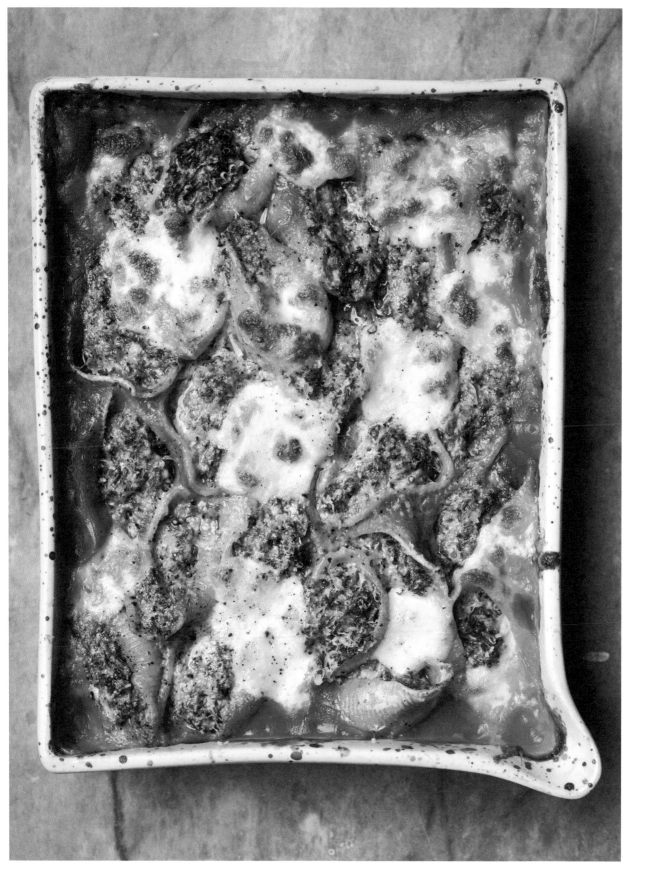

Bangers, Bacon & Beans

This started as a cassoulet recipe and while cassoulet is a classic for a reason, I felt that the combination of sausage, duck *and* pork belly or bacon was a bit much… even for me! It seemed to work with only the pork and sausages – it's just as delicious and becomes more so after a day of maturing.

Toulouse sausages work best, but you need to buy them from a specialist, so don't break your back to find them; other sausages will do. But you do need a thick slice of smoked bacon and for that you'll need to pop to your butcher. The most marvellous thing about this recipe is that it has gone from being the most French dish in the world to the most wonderfully British; bangers, bacon and beans. What could be better!

SERVES 4

Preparation time 40 minutes
Cooking time 3 hours

4 tbsp olive oil
2 onions, finely chopped
4 garlic cloves, finely chopped
pinch of dried chilli
2 sprigs of rosemary
few sprigs of thyme, leaves picked
2 bay leaves
4 tomatoes
300ml white wine
700ml chicken stock
300g cannellini beans, soaked
 overnight
4 Toulouse sausages
1 x 400g slice of smoked streaky
 bacon (about 2.5cm)
juice and zest of ½ lemon
large handful of parsley, chopped
sea salt and freshly ground black
 pepper

Preheat the oven to 180°C/160°C fan/gas mark 4. In a medium flameproof casserole, heat 2 tablespoons of the oil and add the onions. Sweat the onions over a medium heat for a good 15 minutes until they are nice and soft and beginning to go golden. Add the garlic, chilli and herbs and cook for a couple more minutes.

Blitz your tomatoes into a smooth purée in a food processor and add to the onions and garlic. Allow to reduce down before adding the wine. Let this bubble for a couple of minutes and then add the stock. Cook this out slowly for an hour, blitz, and then add in the beans.

While the base of the sauce is coming along, brown your sausages. Heat the rest of the oil in a frying pan over a high heat, add the sausages and brown until they are a good colour on all sides (this usually takes 8–10 minutes). Transfer the sausages to the casserole. Return the frying pan to the heat and brown the bacon slice on all sides, again making sure it has a good colour all over.

Tuck the bacon in with the rest of the stew. Season well with salt and pepper, cover with a lid and place in the oven for 1 hour 30 minutes. After this time remove the lid and return to the oven for a further 30 minutes to reduce the sauce a little.

Finally, before serving remove the sausages and stir through the lemon juice, zest and parsley. Return the sausages to the casserole. Check for seasoning; beans need a lot of salt and I like to make it quite peppery. Serve straight away, cutting the bacon slice into pieces and sharing them out equally.

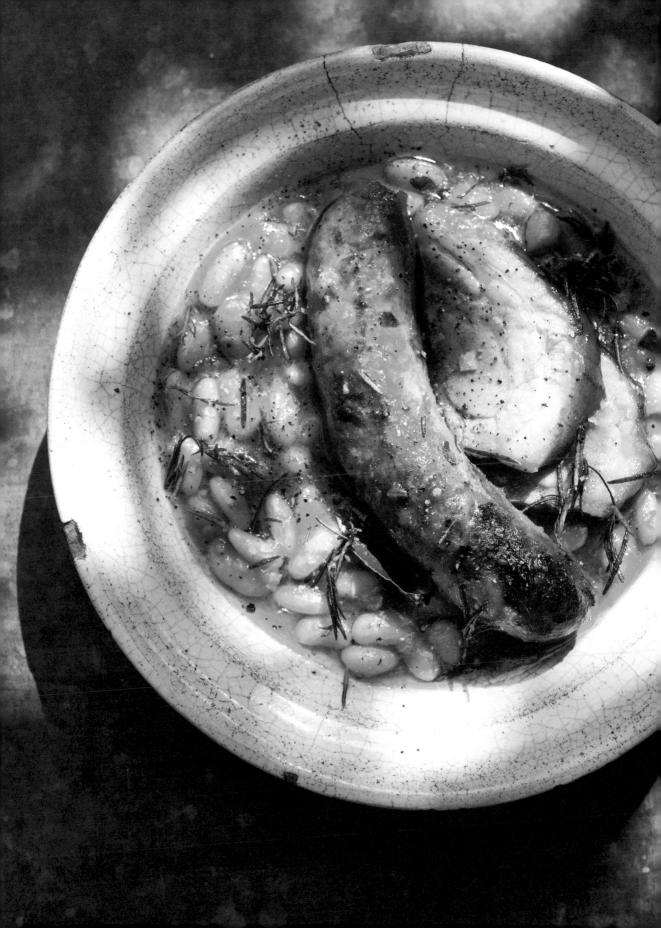

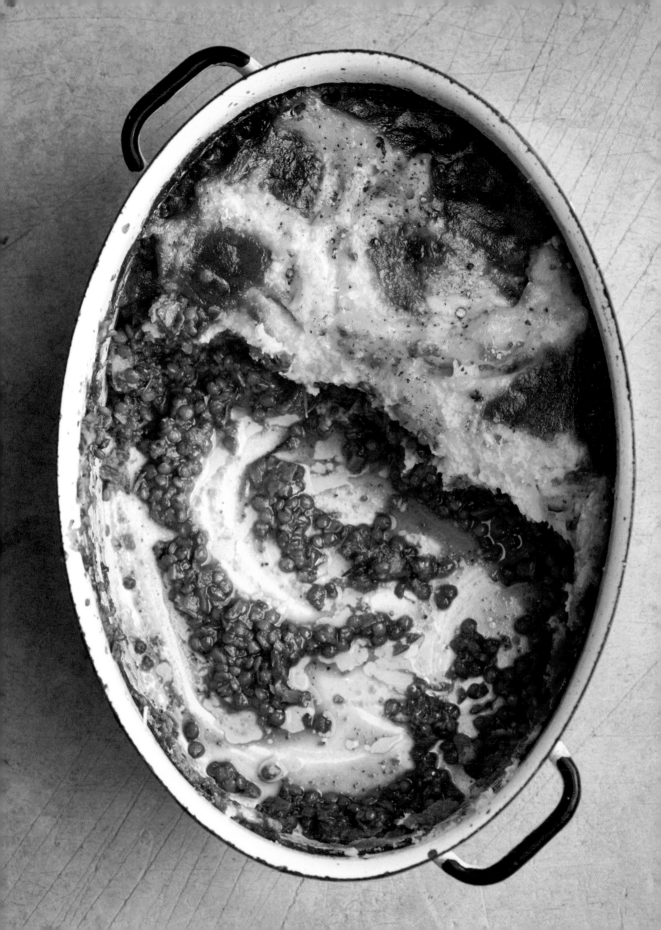

Mushroom & Lentil Shepherd's Pie with Root Veg Mash

I've been trying to eat less meat over the last few years and, although I've found it easy with some dishes, there are times when removing meat from your diet can leave you feeling a little short-changed flavour-wise. Here I've used dried mushrooms, mushroom stock and Marmite, which are all rammed with umami flavours and bring that meaty equilibrium back to the dish. I suggest using meat stock if you're not veggie or vegan, because they have the right viscosity to them, but vegetable stock is still super. This intensely flavourful stew is balanced really well by the root vegetable mash.

First, place the dried porcini mushrooms in a bowl and pour the boiling water over them. Set aside for at least 20 minutes to rehydrate. Next, heat 2 tablespoons of the oil in a deep casserole over a high heat. Add the minced fresh mushrooms and fry for about 5 minutes, or until the water that seeps out has evaporated and they're browned. Remove from the pan with a slotted spoon.

Add some more oil and then fry the onions, carrots, celery and leeks and cook slowly for 10 minutes, or until they have softened and started to go golden. Add the garlic and cook for a further couple of minutes. Add the tomato purée and ramp up the heat. Caramelise the vegetables in the purée for about 1–2 minutes.

Add the wines and cook for 5 minutes before adding the fried mushrooms back in with the bay leaf and sprig of rosemary as well as a small pinch of ground cloves. Remove the porcini mushrooms from the soaking water and finely chop them. Add these, along with the water you rehydrated them in (strain the water to discard any sediment at the bottom), the lentils, the stock and the Marmite. Cook over a low heat for 1 hour, or until the sauce has reduced and the lentils are cooked and plumped up. Season, place in a pie dish and allow to cool, overnight if you can.

Preheat the oven to 200°C/180°C fan/gas mark 6. To make the mash, pop all the root veggies into a saucepan of cold water. Bring to the boil, then simmer gently for 20 minutes, or until completely cooked through. Drain, and then allow the vegetables to steam in the colander for 5 minutes. Mash with a potato masher or ricer. Add the butter, milk, nutmeg and seasoning.

Pick out any stray herbs from the lentil mixture then top with the root veg mash. Top with the cheeses and bake for 25 minutes, or until golden and piping hot.

SERVES 6

Preparation time 25 minutes, plus cooling time
Cooking time 1 hour 25 minutes

30g dried porcini mushrooms
300ml boiling water
3 tbsp rapeseed oil
5 field mushrooms and 4 shiitake mushrooms, pulsed in a food processor until as finely ground as mince
2 onions, finely chopped
3 small carrots, finely chopped
2 celery sticks, finely chopped
2 leeks, finely chopped
3 garlic cloves, finely chopped
1 tsp tomato purée
300ml red wine
100ml port (optional)
1 bay leaf
sprig of rosemary
pinch of ground cloves
350g dried puy lentils
750ml fresh vegetable stock (or chicken or beef if you're not veggie)
1 tsp Marmite

For the root vegetable mash
½ small celeriac, cut into small cubes
1 parsnip, cut into small cubes
2 medium carrots, cut into small cubes
1 medium swede, cut into small cubes
2–3 tbsp butter
2 tbsp milk or cream
grating of nutmeg
35g Cheddar, grated
35g Parmesan, grated
sea salt and freshly ground black pepper

Flageolet, Anchovy, Rosemary & Confit Garlic Gratin

I wanted to name this recipe Flageolet Dauphinoise but I thought it wouldn't be fair on the classic Dauphinoise. Normally nothing comes close to Gratin Dauphinoise, so I can understand if people are sceptical when I say this is just as good, but it really is! I grew up eating leg of lamb with Dauphinoise and really delicious flageolet beans with a slick of rosemary-infused confit garlic oil and lamb jus – and this gratin combines them all. Have it with roast lamb at the weekend or even with pink lamb cutlets or chops in the week. This really is my kind of food.

SERVES 6 AS A SIDE, OR 4 AS A MAIN

Preparation time 10 minutes
Cooking time 15 minutes, plus
 45 minutes if using dried beans

350g dried flageolet beans, soaked
 overnight (or 800g cooked flageolet
 beans, drained)
1 head of Confit Garlic (see page
 64)
4 tbsp garlic oil (from cooking the
 Confit Garlic)
300ml cream
splash of whole milk
8 anchovy fillets
white pepper
good grating of nutmeg
2 sprigs of rosemary
40g Gruyère cheese, grated
sea salt

To cook the flageolets place the soaked beans in a large saucepan with plenty of unsalted water. Bring to the boil and cook for 30–45 minutes. Check the beans regularly. They should be toothsome to bite but completely cooked through. Flageolets can cook quite quickly, so make sure you keep watch. Drain and leave to steam in a sieve for 10 minutes.

Preheat the oven to 220°C/200°C fan/gas mark 7. Spread the beans neatly in a large, shallow 25cm oval gratin dish. In a separate bowl, mix together the garlic, oil, cream, milk, anchovies, pepper, salt and nutmeg. Check the seasoning. Lay the rosemary sprigs across the beans (the flavour will infuse the gratin), pour over the creamy mixture and level out. The beans should be generously suspended in the sauce. Sprinkle the cheese over the top and put in the oven for 15 minutes until the cheese has melted and gone a charred golden brown.

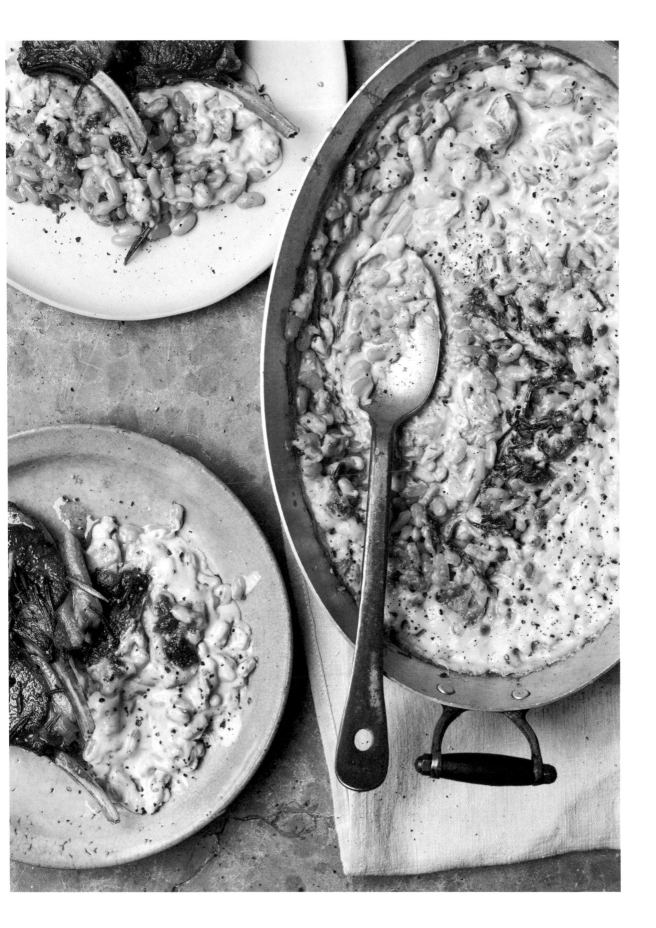

Chicken, Buttermilk & Wild Garlic Pie

To me, chicken pie is comfort food personified. Lifting a big golden pie out of the oven and bringing it to a table of hungry mouths evokes warmth, family and cosiness. Here I have updated the much-loved classic with the addition of buttermilk, which adds a great tanginess that lifts the dish into something more complex. The inclusion of wild garlic (fast becoming a favourite ingredient of mine and increasingly widely available) not only provides a delicate sweet garlic note, but also turns the filling a vibrant, pleasing green. Available from the end of winter until early May, wild garlic is really worth seeking out. This pie is a great way to celebrate the verdancy of springtime, but is equally delicious at any time of year.

Heat the oil in a frying pan over a high heat. Brown the chicken thighs until they are deep golden in colour. It's best to do this in two batches. Remove from the pan and set aside.

Put the butter into the pan and once melted add the leeks and gently sweat for 10 minutes, until they are nicely softened but not coloured. Next add the flour and cook for a couple of minutes. Pour in the white wine and allow to bubble for a few minutes, followed by the chicken stock. Simmer gently to reduce for about 20 minutes then add the buttermilk. Continue to reduce for a further 20 minutes until the meat is falling apart and the sauce is well thickened. At the end stir through the wild garlic purée and Parmesan, grate in the nutmeg and season well. Transfer the filling to a bowl and leave to chill in the fridge for at least an hour, or preferably overnight.

To make the pastry, put the flour, butter, cheese, cayenne and salt into a food processor and blitz until you achieve breadcrumbs. Add a little water at a time until the pastry just forms a ball. Be careful not to make it too wet. Tip the mixture on to a floured surface and bring together, making sure not to handle it too much. Cut into two pieces, two-thirds of the pastry for the base and the other third for the top. Wrap each half in cling film and place in the fridge to chill for at least 30 minutes.

When you're ready to make the pie, dust the work surface with flour, then roll out the larger portion of pastry until it is the thickness of a pound coin. Dust the rolling pin with flour, and carefully fold the pastry over it. Roll the pastry off the rolling pin and

CONTINUED »»

SERVES 4

Preparation time 40 minutes, plus at least 1 hour 30 minutes chilling time
Cooking time 35–40 minutes

For the filling
1 tbsp pomace oil
8 boneless, skinless chicken thighs
30g unsalted butter
3 leeks, thinly sliced (including the green)
30g plain flour
1 glass dry white wine
500ml fresh chicken stock
250ml buttermilk
1 bunch of wild garlic (about 30 leaves), blitzed to a purée with about 50ml water
30g Parmesan, grated
good grating of nutmeg
sea salt and freshly ground black pepper

For the pastry
420g plain flour, plus extra for dusting
250g ice-cold unsalted butter, cut into cubes
60g Parmesan, grated
1 tsp cayenne pepper
1 tsp salt
1–2 tsp ice-cold water
1 free-range egg, beaten

over a 23cm pie dish. Carefully line the base, pressing the pastry into the sides of the dish, but do not trim the edges at this stage. Fill the pie with the fridge-cold filling. Using a pastry brush, glaze the edges of the pastry with the beaten egg.

Roll out the smaller portion of pastry to make the top. Using the rolling pin, place the pastry lid on top of the pie. Use a sharp knife to trim off the excess pastry to make a neat edge. You can push down the edges with a fork to seal them tightly, but I prefer to use the crimping method, pushing down with one finger towards the outside of the dish on the pastry edges. Pinch around that finger with the finger and thumb of your other hand to create a scalloped edge.

Roll out any excess pastry and using a cutter of your choice make a decoration for the lid of the pie (I went for wild garlic leaves). Brush with the beaten egg glaze and return to the fridge to chill for 30 minutes.

Meanwhile preheat the oven to 190°C/170°C fan/gas mark 5. Glaze the top of the pie once more, then bake for 35–40 minutes, or until the pastry is golden brown and cooked all the way though. Delicious served with buttery mash and spring greens.

Salt Baking

Salt has been the elemental cornerstone of our relationship with food for thousands of years. And although salt baking has become pretty trendy in the food world in recent years, it is by no means new. This is one of the most modest, humble and ancient methods of cooking there is, not to mention versatile. It's a technique used all over the globe, throughout the annals of culinary history, from the ancient Hakka people's salt-baked chicken (which originated in China more than 2,000 years ago) to centuries old Mediterranean salt-baked whole fish.

This process has stood the test of time for good reason. The science is simple; encasing fish, meat or vegetables in a salt crust creates a kiln-like cocoon effect, which prevents moisture – and therefore flavour – escaping. It also protects and intensifies what lies within, while providing a perfect, even cooking environment.

Salt baking is simplicity itself. You need just two ingredients, salt and egg white, which combine to create a cement-like paste and, when put in a hot oven, harden to form a brick-like case around whatever you choose to cook. Every time I cook in this way I experience child-like excitement in anticipation of cracking the hard shell to reveal its contents. A whole salt-baked fish, such as my sea bass recipe on page 133), is nothing short of impressive when brought to the table, and the ceremony of breaking into the salt crust to find succulent, moist, perfectly seasoned fish is a real joy.

You may worry that all the salt will make what's inside taste unbearably salty, but in fact the crust lends only the smallest amount of seasoning to what you're cooking, and is really subtle. When I was trying to come up with a recipe for the perfect baked potato (see page 134), salt baking provided the answer, ensuring that the potatoes had smooth and creamy insides while also bringing out the skins' true flavour.

The other great advantage of salt baking is that you don't need to buy any fancy equipment to achieve pretty sophisticated and refined cooking. I urge you to give this a go; it's a fantastic technique to have up your sleeve and you can use it for myriad dishes.

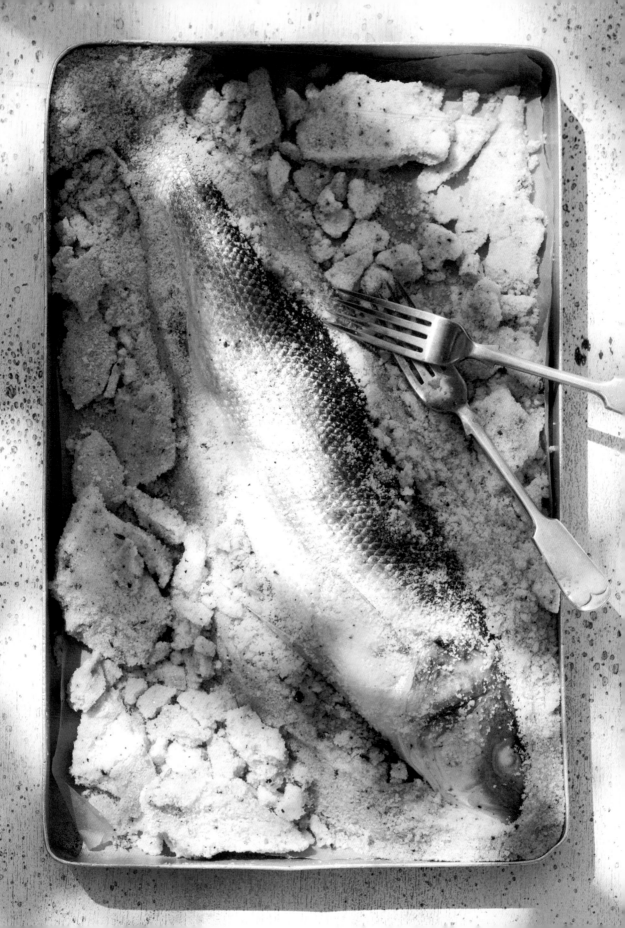

Salt Baked Sea Bass

I've really fallen for salt baking. A little late in the game! But it's such a great way to cook; the salt crust insulates the food inside, preventing it drying out, but also helps to create a gentle and even cooking environment, which is why it's such a perfect method of cooking fish. Look for wild sea bass as it is more sustainable, but if you can't find any just cook two smaller farmed bass, reducing the cooking time by eight minutes. In this recipe I added flavours from woody herbs and lemon to the salty 'meringue' crust, which is not very traditional but the flavour that permeates the fish is very satisfactory.

When the fish comes out of the oven, crack the salty meringue casing and peel it away to leave perfectly cooked, juicy fish. Remove the fillets and serve them with olive oil and whatever accompaniments you fancy – I'd go for buttered and herbed new potatoes and creamed spinach.

Preheat the oven to 230°C/210°C fan/gas mark 8. Lightly whisk the egg whites for a few seconds, then add the salt and mix to form a thick paste. Grate in the lemon zest and add the leaves of 4 thyme sprigs. Pile one third of the mixture on to a baking parchment-lined baking tray a little larger than the fish. Lay the fish on top of the salt.

Stuff the cavity of the fish with the lemon slices and lots of thyme. Pack the remaining half of the salt paste over the top of the fish so it is completely covered. Bake in the oven for 25 minutes. Once the time is up, the crust should be golden and you may hear a little hissing inside, which tells you it's cooked. Take the fish out of the oven and let it rest for 5 minutes.

You can make the theatrical cracking open of the salt crust at the dinner table a ceremonious occasion. Carefully crack open the salt crust – some use a hammer, but I bash mine with a rolling pin – and carefully peel away the rest of the salt crust from the fish. You will reveal perfectly cooked, moist fish with the bright fragrance of lemon and thyme.

SERVES 4

Preparation time 15 minutes
Cooking time 25 minutes

4 free-range egg whites
1.4kg fine salt
zest of 1 lemon
2 lemons, sliced
large handful of thyme sprigs, leaves
 picked
1 x 1.2kg wild sea bass, gutted

Ultimate Salt Baked Potato

There is nothing more comforting than a baked potato. I was looking for a way to elevate its status and, through my research into salt baking, discovered that this is a brilliant method to achieve the ultimate baked potato. The salt crust allows the potato to retain the maximum moisture, leaving you with really waxy, buttery insides with a delicious concentrated flavour. I like these as a side with grilled fish or steak and slathered in butter or sour cream (or both...) but with the right filling they can also be a fantastic dish in their own right. I've provided recipes for two delicious fillings overleaf but they also work really well with my Boston Beer Baked Beans (see page 23), Gingered Coronation Chicken (see page 47) or filled with my Braised Lamb Mince (see page 112) and topped with a mash made from the potato innards to create a filled potato skin version of a shepherd's pie.

SERVES 2

Preparation time 10 minutes
Cooking time 2 hours 30 minutes

2 free-range egg whites
350g fine sea salt
2 baking potatoes

Preheat the oven to 180°C/160°C fan/gas mark 4. Lightly whisk the egg whites for a few seconds and then add the salt and mix well to form a paste. With your hands, pack a quarter of the salt mixture on one side of the potato and place it on a baking tray. Pack another quarter of the salt mixture around the top of the potato and smooth it around the sides so that it is well covered. Repeat with the rest of the mixture and the second potato. Bake in the oven for 2 hours 30 minutes and you're ready to go.

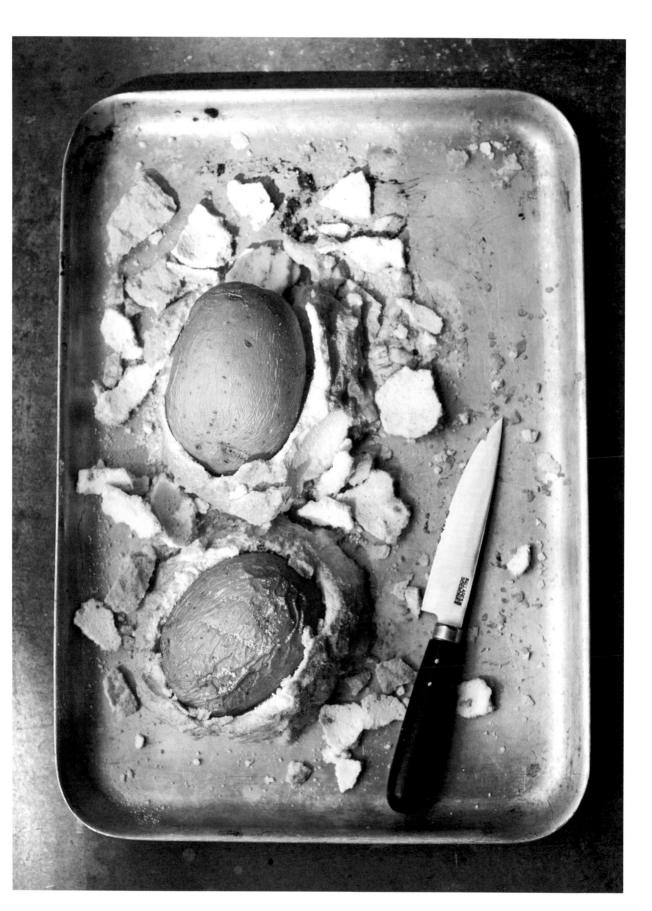

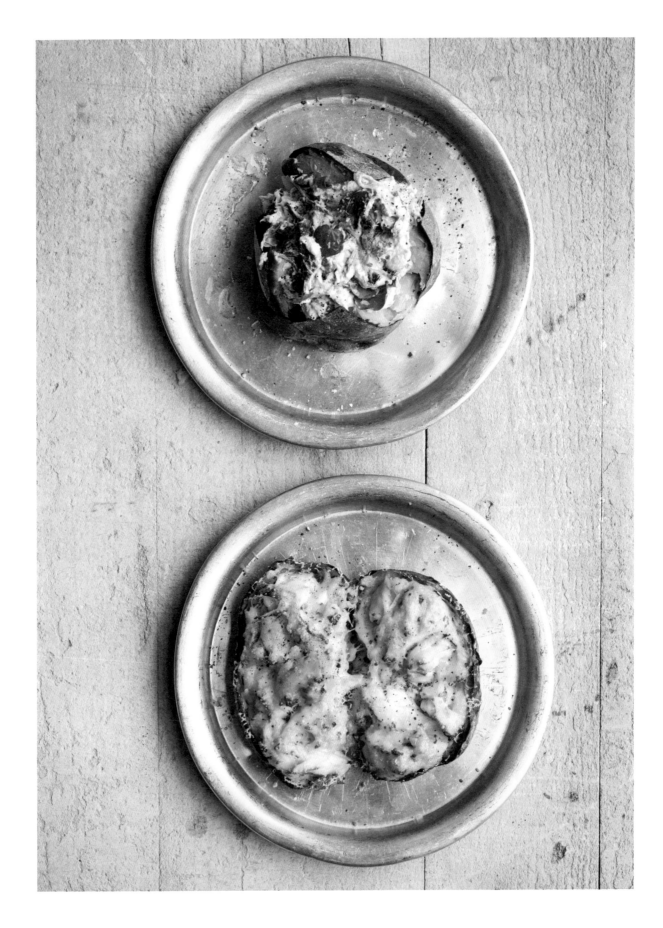

Smoked Mackerel, Beetroot and Horseradish

This is a slightly lighter option than some of the others, as it's really fresh and quick.

Flake the mackerel into a mixing bowl and gently stir through the yoghurt, horseradish sauce, spring onions, watercress, lemon juice and cayenne pepper and season with salt and pepper. Add the beetroot just before you are ready to eat to prevent it bleeding too much colour. Divide the mixture between the two potatoes.

SERVES 2

Preparation time 10 minutes

2 fillets of smoked mackerel
1 tbsp Greek yoghurt
1 tbsp horseradish sauce
2 spring onions, finely chopped
handful of watercress
squeeze of lemon juice
decent pinch of cayenne pepper
2 cooked beetroot, cut into bite-size
 pieces
2 baked potatoes
sea salt and freshly ground black
 pepper

Smoked Haddock Mornay Jacket Potato

This has all the flavours of a fish pie and tastes really luxurious.

Preheat the oven to 220°C/200°C fan/gas mark 7. Pour the milk into a medium saucepan and carefully add the haddock. Bring the milk to the boil and then turn off the heat under the pan. Allow the fish to sit in the warm milk for 5 minutes, which will gently cook it through.

Put the scooped out potato flesh in a separate saucepan and whisk with the butter. Add 100ml of the milk you steeped the fish in and half the cheese, and whisk again until smooth. Remove the fish from the milk and add to the mixture. Fold in the fish carefully so as not to break it up too much; you want large flakes. Gently mix in the mustard, salt, the peppers and herbs. Spoon half the mixture into each potato skin, sprinkle the remaining cheese over the top and bake in the oven for 10 minutes.

SERVES 2

Preparation time 10 minutes
Cooking time 10 minutes

300ml whole milk
260g undyed smoked haddock
2 baked potatoes, flesh scooped out
1 tbsp butter
100g Cheddar
1 rounded tsp wholegrain mustard
1 tsp smoked salt
pinch of cayenne pepper
pinch of white pepper
2 tsp finely chopped chives
2 tsp finely chopped parsley

Lamb Hotpot

The original incarnation of this stew would have used mutton in place of lamb, so if you can find it, please don't hesitate to use that instead. To get the best out of mutton, you have to cook it really slowly, so this is the perfect recipe for it, but lamb neck also works well, and the stew benefits from the extra fat you find in younger lamb. The first recipes for hotpot can be traced back to the mid-nineteenth century, when few people would have had their own oven, so it's likely that this was cooked in clay pots in the communal bread oven as it cooled. Despite this dish's rustic origins, this recipe takes the cheaper cuts of lamb and transforms them into something really rather beautiful. This goes perfectly with my Braised Sour Red Cabbage (see page 87).

SERVES 6

Preparation time 30 minutes
Cooking time 3 hours

4 tbsp rapeseed oil
900g mutton or lamb neck fillet, cut into 9 pieces (about 3 large neck fillets, each cut into 3 pieces)
300g lamb kidneys, sinew removed, cut in half lengthways
300ml red wine
4 onions, thinly sliced
2 bay leaves
3 sprigs of rosemary
bunch of thyme sprigs
1 tsp plain flour
500g good-quality fresh beef stock, the more gelatinous the better
1 tsp redcurrant jelly
550g waxy potatoes, peeled and very thinly sliced, ideally with a mandolin
sea salt and freshly ground black pepper

First brown the meat. Heat 2 tablespoons of the rapeseed oil in a heavy-based pan over a high heat and brown the lamb neck and kidneys in two batches until they are a deep colour. Set aside. Pour the wine into the pan to deglaze it, scraping all the nice meaty bits off the bottom with a wooden spoon.

While you are deglazing the pan, heat the remaining oil in a heavy-based casserole over a medium heat, add the onions and cook for about 25 minutes until well softened, throwing in the herbs half way through. Once they are nice and soft, stir in the flour and cook it for a minute.

Transfer the meat to the casserole, add the stock, cover with a lid and cook over a medium heat for 2 hours. Then stir in the redcurrant jelly and season liberally. Some people may query why I stew rather than casserole in the oven. I think you have more control over the whole process this way. Slow casseroling can leave quite an intense aftertaste. Also, I like my stew to be quite liquid with lots of gravy. Don't forget that the potatoes will soak up quite a lot of the juice and the richness you would normally achieve by reducing will happen later when you bake it with the potato slices.

Preheat the oven to 180°C/160°C fan/gas mark 4. Carefully layer the potatoes over the top of the stew. Take your time with this, and make it beautiful, until the meat is totally covered in potato slices. Cover with a layer of baking parchment followed by foil. Find a small ovenproof pie dish that you can use as a weight to press the whole thing down and place in the oven for 30 minutes. Then remove the weight, foil and parchment and return to the oven for a further 30 minutes to allow the potatoes to brown and the excess liquid to evaporate.

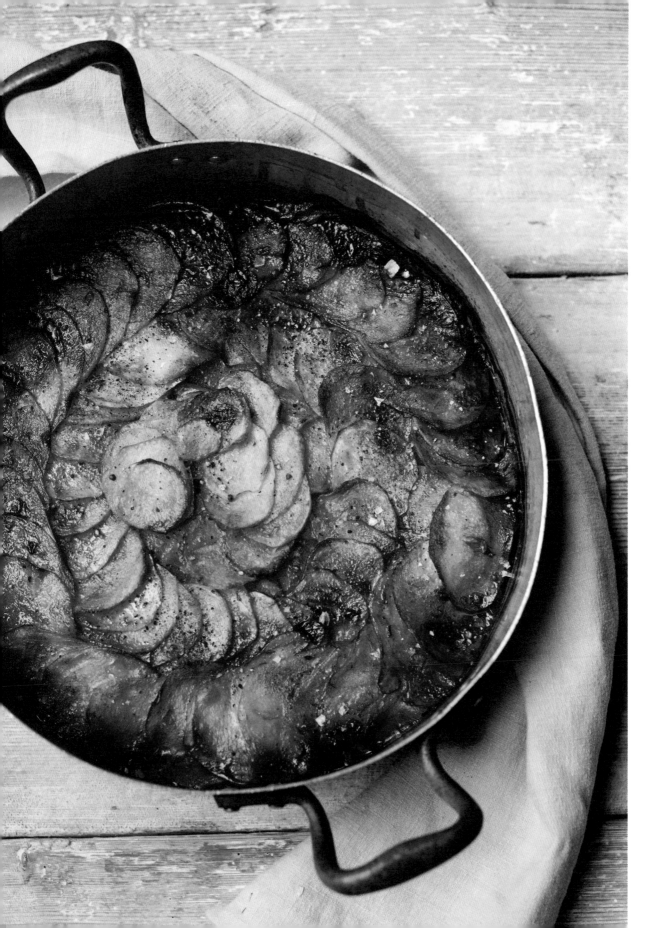

Vegetable Lasagne

Lasagne alla Bolognese has been adopted by this country as one of our ultimate comfort foods. Who doesn't love it? But what many people don't know is that in Italy most regions have their own version of lasagne, with fillings ranging from meatballs and boiled eggs in Naples, to leeks and lard in Tuscany. So there are fewer hard and fast rules than you might think, legitimising this vegetable version all the more! This is a wonderful way to draw attention to the simple, vibrant flavours of the Mediterranean: tomato, courgette, aubergine – and, of course, basil. I'm always looking for ways to reduce my meat intake, and while this is a lighter incarnation of the classic, it is still wholly satisfying. The ragu can also be simply stirred through cooked pasta if you are looking for something a little quicker to make.

Preheat the oven to 240°C/220°C fan/gas mark 9. Place the peppers on a baking tray and roast them for 25–30 minutes, or until they are still firm but blistered on the outside. Remove from the oven and allow to cool, and then pull out the stalks and remove the seeds. Flatten each pepper into large pieces, then slice into 1cm squares.

Heat 4 tablespoons of the olive oil in a frying pan to shallow fry the aubergines and courgettes. You will need to do this over a high heat so that they are nice and caramelised on the outside and soft in the middle. It's best to do this in two batches so that you can achieve a good colour. Add more olive oil with each batch and season with a little sea salt each time. Remove from the pan with a slotted spoon and drain on kitchen paper to soak up any excess oil.

Next, pour the tomato sauce into a saucepan and stir in the courgettes, peppers and aubergines. Add a pinch of chilli flakes, check for seasoning and cook over a medium heat for 5 minutes. You can cook it more, but the more it cooks the more broken down the veg will be and I like a little bite in the sauce. Tear the basil leaves and stir through the sauce until they have wilted. Set aside while you get on with the béchamel.

To make the béchamel sauce, warm the milk, bay leaf and nutmeg in a saucepan. Remove from the heat and leave to infuse for 10 minutes, then discard the bay leaf. Melt the butter in a saucepan, then whisk in the flour. Allow the flour to cook for

CONTINUED »»

SERVES 8

Preparation time 40 minutes
Cooking time 1 hour 10 minutes

200g fresh lasagne sheets (or 1 batch of fresh pasta, rolled out very thinly into 8 sheets 25 x 10cm), blanched for 30 seconds and refreshed in iced water
50g Parmesan, grated

For the vegetable ragu
6 peppers (a mixture of red, yellow, green and orange)
10 tbsp olive oil
2 aubergines, cut into 1cm cubes
3 courgettes, cut into 8mm cubes
700ml Slow Cooked Tomato Sauce (see page 240)
pinch of dried chilli flakes
1 large bunch of basil
sea salt and freshly ground black pepper

For the béchamel
500ml milk
1 bay leaf
generous grating of nutmeg
50g butter
50g flour
1 x 250–300g ball of mozzarella cheese (don't bother with buffalo mozzarella as it'll get lost in the sauce), cut into small cubes
sea salt and freshly ground black pepper

a couple of minutes, and then slowly add the infused milk, whisking as you go to maintain a smooth sauce. Continue until all the milk is combined and the sauce looks glossy. Bring the sauce to the boil slowly, making sure you keep scraping the base of the pan. Beat the mozzarella into the sauce, allowing it to melt slowly. Season to taste with salt and pepper and a bit more nutmeg.

Ideally you should chill the vegetable ragu to make it easier to handle when building your lasagne, but it's not essential. When you are ready to construct your lasagne, preheat the oven to 180°C/160°C fan/gas mark 4. Take a large ovenproof dish (about 40 x 20cm) and lay 2–3 lasagne sheets to cover the bottom. Add 2–3 ladles of the vegetable ragu on top and smooth it down with the back of the ladle. Lay another layer of pasta on top and repeat this process twice more, finishing with a final layer of pasta. Cover the pasta with the béchamel sauce and finish by sprinkling the grated Parmesan over the top.

Bake in the oven for 35–40 minutes until the sides are bubbling and the top is perfectly golden.

Rye Bread Sauce Gratin

A creamy bread sauce makes the perfect gratin. The sauce should be nice and loose and, depending on what you're serving it with, should be boosted with a healthy dose of Parmesan cheese. This rye bread version, with the nuttiness of the grain and the sourness of the natural yeast, is a perfect accompaniment for roast game and poultry. As bread sauce goes, this has to be the ultimate indulgence, but won't need selling to any bread sauce lover.

Put the milk, butter, onion, cloves, peppercorns and bay leaf into a saucepan and bring to the boil, then turn down to a simmer. Cook gently for 5 minutes, then take the pan off the heat and leave the milk to infuse for 1 hour.

Strain the liquid and return to the pan. Add the breadcrumbs and simmer for 3–4 minutes. Stir in the cream or mascarpone, add the spices and season. The sauce is ready when it's a thick pouring consistency and full of spicy flavour. Now stir in the extra 50ml of cream and check for seasoning. You can make this in advance – it will thicken up a bit, but can be loosened with more milk and reheated ready to serve.

Preheat the oven to 240°C/220°C fan/gas mark 9 or heat the grill to maximum. Pour the bread sauce into a small gratin dish. It should be a little looser than normal. Cover with Parmesan and bake it in the searingly hot oven for 10–15 minutes or grill for 5 minutes until the top is bubbling and the cheese is a little browned and scorched.

SERVES 8

Preparation time 5 minutes, plus
 1 hour infusing
Cooking time 20 minutes

600ml milk
50g butter
1 onion, roughly chopped
6 cloves
6 peppercorns
1 bay leaf
100g rye breadcrumbs
4 tbsp double cream or mascarpone
¼ tsp ground ginger
¼ tsp freshly grated nutmeg
¼ tsp allspice
¼ tsp ground cloves
50ml double cream
30g Parmesan
sea salt and freshly ground black
 pepper

Lemon Sherbet Meringue Pie

I've tried making all kinds of meringue pies; rhubarb and grapefruit have both made the grade, but there is something about the acidic tang of citrus that just can't be beaten. Lemon by itself tastes great, but in balancing the lemon with some orange and lime, you get a sherbet-style finish, like eating the perfect sour sweets. This is still lemon meringue pie but with added va va voom.

MAKES 8 SLICES

Preparation time 20 minutes, plus
 30 minutes resting and 10 minutes
 cooling
Cooking time 1 hour 10 minutes

For the pastry
225g plain flour
pinch of salt
1 tbsp caster sugar
170g ice-cold butter, cut into small
 cubes
1 free-range egg whisked with 1 tsp
 ice-cold water

For the filling
300ml lemon juice
100ml lime juice
100ml orange or tangerine juice
50ml water
240g caster sugar
1 tsp salt
zest of 1 grapefruit
4 tbsp cornflour
100ml gin
170g butter
6 free-range egg yolks plus 2 whole
 eggs

For the meringue
350g golden caster sugar
4 free-range egg whites
1 tsp vanilla extract

First make the pastry. Put the flour in a food processor with the salt and sugar and whizz for a few seconds (this is a great way to ditch the process of sifting flour). Add the butter and whizz again for about 20 seconds, or until the mixture resembles breadcrumbs. Turn out into a fridge-cold mixing bowl, and with a cold knife, slowly add enough of the whisked egg and water to bind the mixture together, being careful not to make the dough too wet. Bind the pastry into a ball. Kneading will make it tough, so try to handle it as little as possible. Lay the pastry on a baking sheet and roll out to flatten a little. Cover with cling film and leave in the fridge to rest for 30 minutes, or until needed.

Once you are ready to make the pie, preheat the oven to 190°C/170°C/gas mark 5. Dust the work surface with flour and roll out the pastry until it's the thickness of a 50 pence piece. Very carefully line a 24cm deep tart tin. Let the pastry overhang the edge of the tart dish so you can trim it once it has been blind baked. Place the lined tin in the freezer for 10 minutes and then line the raw pastry with baking parchment filled with baking beans and blind bake it for 20 minutes.

Remove from the oven, take out the baking beans and baking parchment and pop it back for a further 10 minutes. Take out and leave to cool. Lower the oven temperature to 140°C/120°C/gas mark 1. When the pastry is cool, carefully trim the pastry edges away with a knife, carving off the excess against the side of the tin, then brush away any crumbs with a pastry brush.

While the pastry bakes, prepare the filling. Put the juices, water, sugar, salt and zest in a saucepan and bring to the boil. Mix the cornflour with the gin to form a smooth paste and whisk this into the juice mixture. Keep whisking and it will start to thicken. Lower the heat and add the butter, whisking until it has all melted. Now take the

CONTINUED »»

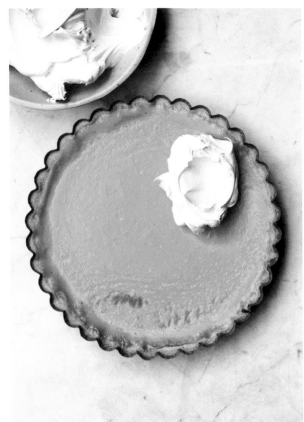

pan off the heat and stir in the eggs, beating furiously until you have a lovely smooth consistency. Leave to rest covered with some cling film touching the surface of the sherbet curd to stop a skin forming while you wait for the base to bake and cool.

When you are ready to fill the tart, strain the filling into the tart case to ensure a perfectly silky consistency. Level it out carefully with a spatula and return to the oven for 30 minutes.

To make the meringue, put the sugar in a saucepan and add 4 tablespoons of water and the vanilla. Turn on the heat and bring to the boil until the sugar is melted, but do not stir as this will crystallise the sugar syrup. Whisk the egg whites into soft peaks so they fall down on themselves and, keeping the whisk going, slowly pour in the sugar syrup until it is all incorporated.

With a metal spoon, top the tart with the meringue, creating lovely peaks as you go. Turn the oven up to 180°C/160°C fan/gas mark 4 and cook the pie for 10 minutes until golden brown on top. Remove from the oven and leave to cool for an hour before serving.

SLOW • BAKE

Chocolate Pavlova with Poached Pears, Salted Caramel & Chocolate Sauces

There are two classic Erskine puddings that my mum made when wanted to treat us but was feeling a strain on her purse strings. One was sliced bananas, cream and chocolate flakes and the other tinned pears, vanilla ice cream and a basic chocolate sauce made from cocoa powder, sugar and water. The joy of being little is that you have no idea that your parent worries that a pudding like this is as cheap, simple and basic as it gets; as a child you thinks it's as swell a pudding as you could eat.

Pears and chocolate are a terrific combination and in adulthood I can swank it up a little and make it into a chocolate pavlova and drench it with a real chocolate sauce – plus a further layer of salty bitter caramel. I could even finish it off with a handful of roasted hazelnuts and have the kind of show-stopping pudding my mother wanted for us, but then again, some days I just want to be that kid again and eat these poached pears with chocolate sauce and some too sweet, cheap and foamy vanilla ice cream and be at my happiest.

Start by making the meringue. Preheat the oven to 200°C/180°C fan/gas mark 6. Line a deep roasting tray with baking parchment, pour in the sugar and put it in the oven for about 5 minutes until the edges are about to melt. Heating the sugar helps to create a more stable, glossy mixture. Put the egg whites in a large bowl and whisk slowly, allowing small bubbles to form, then increase the speed gradually until they form stiff peaks.

Turn the oven down to 110°C/90°C fan/gas mark ¼. While you whisk at speed, add the hot sugar to the egg whites one spoonful at a time. Once you have added all the sugar, continue to whisk for a further 5–7 minutes, until the sugar has dissolved and the mixture is smooth, stiff and glossy. Sprinkle over the cocoa and stir through with a metal spoon without fully combining it so you create a marbled, swirly effect.

Line a baking tray with baking parchment (a dab of meringue in each corner can glue the paper down on the tray) and carefully turn out the meringue mixture. With a

CONTINUED »»

SERVES 6

Preparation time 30 minutes
Cooking time 2 hours

For the meringue
300g caster sugar
5 free-range egg whites
2 tbsp cocoa

For the pears
4 ripe pears (preferably William or
 Conference
200ml Sauternes or other medium
 sweet white wine
50ml apple cider vinegar
350ml water
30g runny honey
50g agave nectar
1 vanilla pod, split in half
4 cardamom pods, bashed

To serve
Salted Caramel Sauce (see page 247)
Chocolate Sauce (see page 247)
Whipped Cream (see page 247)

palette knife carefully spread it out into a fat circle approximately 23cm in diameter. Using a spoon, delicately make a shallow well in the centre.

Bake in the oven for 2 hours while you get on with poaching the pears. Peel the pears, but leave the stalk in place. Remove the core from the base using a corer or small melon baller. Combine all the other ingredients in a large saucepan, putting the pears in last. Put the pan over a medium heat until the liquid comes to the boil, then reduce the heat so that it is barely simmering.

The cooking time will vary according to the ripeness of the pears. Very ripe pears only take 5 minutes, less ripe fruit will need up to 15 minutes. As soon as they are cooked, turn off the heat. Transfer the pears with their poaching syrup to a bowl and leave at room temperature until needed or chill in the fridge. Once you are ready to assemble the pavlova, cut the pears into quarters vertically from top to bottom

Once the meringue is cooked, remove it from the oven and cool to room temperature. You don't want to leave it anywhere too cold, so you can cool it by leaving the oven door open if you think your kitchen is too chilly.

Assemble the Whipped Cream and the Chocolate and Salted Caramel Sauces. Now you are ready to put together the pavlova. Spoon the cream into the well of the meringue and spread it out evenly with a palette knife. Arrange the pears carefully on top and then drizzle the Chocolate Sauce all over them. Do the same with the Salted Caramel Sauce, using about 4–5 tablespoons, but by all means be generous!

ROAST

Sausage, Roasted Squash & Potatoes with Pancetta & Chilli

SERVES 4

Preparation time 15 minutes
Cooking time 45 minutes

5 tbsp olive oil
5 garlic cloves, skins on, but bashed
2 sprigs of rosemary
good pinch of dried chilli flakes
½ tsp fennel seeds, bashed in a pestle
 and mortar
8 good-quality pork sausages (I like
 Italian fennel sausages)
700g potatoes, peeled and cut into
 bite-size pieces, parboiled and
 shaken to roughen their edges
2 small squashes (I used red kuri and
 acorn) or ½ large butternut squash,
 peeled and cut into wedges and
 skin left on
100g sliced pancetta
Maldon sea salt, to serve

For the onion gravy
2 onions, thinly sliced
1 tbsp vegetable oil
1 tbsp plain flour
500ml fresh brown chicken or beef
 stock (from the chiller cabinet)
1 tbsp Worcestershire sauce
sea salt and freshly ground black
 pepper

There is nothing better than a baking tray full of juicy sausages, crackly roast spuds, sweet caramelised squash and salty pancetta. Although the chilli, rosemary, fennel and garlic are Italian flavours, I'm a gravy fiend and as British as you can be when it comes to bangers, so I serve this with a simple onion gravy. You can strain out the onions for a more refined sauce, but the truth is, when a sausage is involved, refinement goes out of the window in favour of hearty rib-sticking methods!

Preheat the oven to 200°C/180°C fan/gas mark 6. Pour the oil into a roasting tray and heat in the oven for 5 minutes. Add the garlic, rosemary, chilli flakes and fennel seeds and swish them around the tray to release their flavours.

Add the sausages, parboiled potatoes and squash and toss in the hot oil. Pop in the oven and roast for 30 minutes, turning once after about 20 minutes.

Take the roasting tray out of the oven and top with the pancetta slices, then roast for a further 10 minutes. You want the potatoes to be super-crisp and the squash, sausages and pancetta to be golden. Remove from the pan with a slotted spoon, drain and then place on a serving plate and sprinkle with Maldon sea salt to serve.

To make the gravy, fry the onions in a pan with the oil for about 5–8 minutes, or until they are golden brown. Add the flour and stir for 1 minute, then slowly stir in the stock. Add the Worcestershire sauce and bring to the boil. Reduce until the flavour is full and intense and then season to taste.

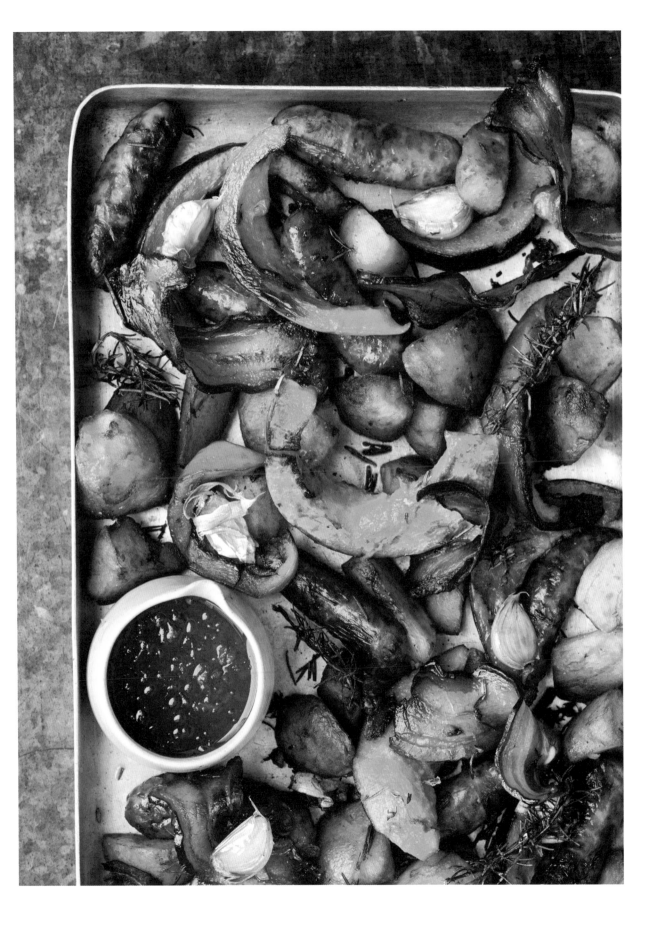

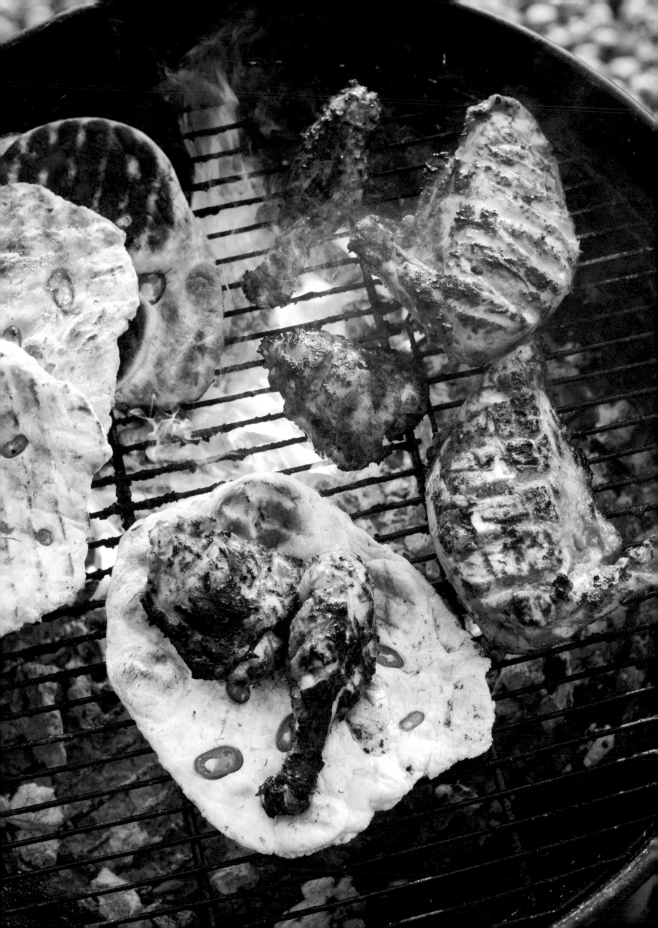

Tandoori Marinade

Tandoori involves two processes. First the long slow marinade followed by the short sharp cooking time. This combination creates really tender, moist meat, full of fragrant spiced flavour. I have used chicken in this recipe, but the marinade is very versatile and works brilliantly with other poultry, such as guinea fowl, and is equally great with firm white fish or prawns – you just need to adjust the marinating and cooking times. You can add this chicken to my Makhani Sauce base (see page 109), but it's also delicious as it is, alongside a kachumber salad and some chapattis.

Put all the marinade ingredients into a food processor and whizz until smooth.

Make two deep slashes in each chicken piece to help the marinade penetrate the meat even further. Pour the marinade over the chicken pieces and allow to marinate for a minimum of 1 hour.

Preheat the oven to 240°C/220°C fan/gas mark 9. It's important to make sure your oven is roasting hot, as you want the chicken pieces to be nicely charred. Wipe off any excess marinade and place the chicken pieces on a baking tray. Place in the oven for 20 minutes until the chicken is cooked through and has begun to char at the edges.

SERVES 6

Preparation time 10 minutes, plus 1–3 hours marinating (but ideally overnight) for poultry or 1 hour for fish
Cooking time 20 minutes for poultry; 10 minutes for fish

1 whole chicken, cut into 6 pieces, skin removed

For the marinade
1 medium onion, roughly chopped
1 head of garlic, cloves peeled
50g fresh ginger, peeled
200g natural yoghurt
3 tbsp lemon juice
2 tbsp tomato purée
1 tbsp ground coriander
1 tsp ground cumin
1 tsp turmeric
1 tsp garam masala
¼ tsp mace
¼ tsp grated nutmeg
¼ tsp ground cloves
¼ tsp ground cinnamon
2 tsp salt
¼ tsp black pepper
1 tsp cayenne pepper
1 tsp natural red food dye (optional)

Roast Duck with Blood Orange Gravy

This is a British-style roast duck with all the brilliant spicy notes of Chinese five-spice, served with a gravy that gives a nod to its French counterpart Duck à l'Orange, but has its own twist. The gravy is made with a lot of blood orange juice that's been spiked with a cheat's gastrique sauce. You make a gastrique sauce by reducing sugar and vinegar together and it is the basis of the sauce in Duck à l'Orange. I use gastrique sauces a lot in cooking but they can be syrupy and sweet, so by using only a little here we get a more balanced and savoury sauce, which I think complements the duck so much better.

SERVES 4

Preparation time 25 minutes
Cooking time 1 hour 45 minutes,
 plus 30 minutes resting

1 x 2kg free-range duck
2 tsp Chinese five-spice powder
2 tsp salt
freshly ground black pepper
1 blood orange, segmented

For the gravy
duck neck, chopped into 4 pieces,
 and gizzards (if available)
1 onion, chopped
1 tbsp plain flour
1 bay leaf
100ml blood orange juice
1 tbsp sherry or red wine vinegar
1 tbsp caster sugar
1 litre good-quality fresh jellied
 chicken stock

Preheat the oven to 220°C/220°C fan/gas mark 7. Score the skin of the duck breast in a crosshatched pattern and prick the rest of the skin all over. Mix the five-spice powder with the salt and a little pepper and rub all over the skin of the duck. Place the duck, breast side up, on a roasting tray with a wire rack or trivet. Roast in the oven for 20 minutes, then turn down the heat to 180°C/160°C fan/gas mark 4 and cook for another 40 minutes for perfectly pink breasts.

At this stage take the duck out of the oven and allow it to rest for 30 minutes covered with foil. After 15 minutes take the breast bone off and pop the legs back into the oven to roast for another 30 minutes. If you are not fussed about having pink breast meat and want a better cooked duck, then turn the whole duck upside down and roast for another 45 minutes.

Make sure you rest the duck over a plate or dish to collect the juices. Meanwhile, place the roasting tray over a lowish heat and make the gravy. Brown the neck and gizzards, then add the onion and cook for 4 minutes, or until a little soft and golden. Next add the flour and the bay leaf and scrape away at the bottom to lift all the burnt bits and juices. Pour in the blood orange juice and whisk like crazy; it will fast become a murky red gunge. Add the vinegar and sugar and keep cooking. The sugar will make the sauce glossy. Now pour in the stock slowly, whisking as you go until it is combined. Bring the gravy to the boil and reduce until the flavour is intense and almost syrupy and it's a good pouring consistency.

Carve the duck and serve with the blood orange gravy poured over the top, together with the orange segments.

Poultry

We eat a lot of chicken in this country; it accounts for almost half the meat consumed every year, but up to 90% of chickens produced in the UK are reared in intensive farming systems, bred to grow unnaturally fast and be large enough to slaughter at six weeks. Kept in overcrowded, dark sheds, these chickens are prone to a multitude of health problems, with welfare standards at the bottom of the priority list. My mum and I have an annual fight on the topic because it's totally frustrating that an ethically-farmed chicken costs five times as much as an intensively reared one. How can I suggest to the average family that they should be eating a chicken costing £20–£25, which everyone can appreciate tastes better and is better for you, when the cheaper chicken is still tasty and feeds a family?

What I try to explain is that slow-raised chickens are much larger, and not pumped full of water so they go much, much further. I know the idea of buying an expensive, ethically-farmed chicken is still hard to commit to, so I would lastly suggest to you that chicken, like all meat, should be considered a treat.

Finding the best chicken
• Buy free-range; I always buy free-range chicken. This means that the chickens will have spent part of their lives outside and more exercise leads to leaner meat with a better flavour. Currently, only 3% of the chicken sold in the UK is free-range, compared with more than 40% in France, so we need to do better!
• Buy organic. No chemical fertilisers or pesticides are used in organic production and the animals are fed on natural feed and looked after to higher welfare standards.
• Buy chickens with the Freedom Food label. This label means that the producer meets the RSPCA's welfare standards.
• Look for the Red Tractor logo. This is awarded to UK

producers who follow 'rigorous' production standards and whose poultry is traceable.
• Other options such as 'farm fresh' or 'barn-reared' don't really mean anything. These terms are just marketing tools, and don't denote a healthy, happy chicken. As ever, the best way to guarantee the best-quality, tastiest produce is to shop at a reputable butcher, who will be able to tell you where the meat has come from.

What to look for when buying chicken
• Fresh chicken should be odourless.
• The breast should be pale pink with very little fat.
• The legs and thighs should be a bit darker with some fat.
• The skin should have a slightly yellowish tint.

Preparing poultry
• Always store raw poultry in the bottom of the fridge, keeping it separate from any food that may be eaten raw.
• Do not wash raw chicken as splashed water can contaminate surfaces.
• Wash hands, utensils and any surfaces that have been in contact with raw chicken.

Cooking poultry
• Cooked chicken should not be pink inside.
• The best way to test whether a chicken is cooked is to cut through the thickest part of the leg; the juices should run clear.
• Some poultry may retain a pinkish colour, so if you are unsure use a meat thermometer. It should read 73.9°C when it is safe to eat.
• The dark meat has a higher fat content so these joints are tastier and better suited to longer cooking times, as they are less likely to dry out than the leaner breast meat.
• Always allow chicken to rest for 15 minutes after removing it from the oven, to allow the juices to be reabsorbed, ensuring tastier, moister meat.

Roast Chicory, Ham & Parmesan Gratin

This Belgian classic is traditionally made with Comté cheese and Parisian ham, but we also have fantastic ham in this country – some of the best in the world in my opinion – and this deserves celebrating! I'll always also vote for the less traditional Parmesan over Comté as I'm an umami hound, and I prefer its deeper saltiness. This rustic dish evokes an element of nostalgia for me, as it is the kind of food my mum would cook for me and my sisters when we were small so it's reminiscent of the flavours I grew up with.
It's a brilliant example of how to transform a few simple ingredients into something rather beautiful. I love the bitterness of the chicory against the creaminess of the Parmesan béchamel.

SERVES 2 AS A LUNCH OR 4 AS A SIDE DISH

Preparation time 20 minutes
Cooking time 20 minutes

2 chicory heads, halved lengthways
120g best quality air-dried roast ham slices (2 wafer thin slices or 1 slightly thicker slice per chicory head)
sea salt and freshly ground black pepper

For the béchamel
20g unsalted butter, plus extra for greasing
20g plain flour
400ml whole milk
30g Parmesan, plus extra for topping
good grating of whole nutmeg
pinch of cayenne pepper
pinch of white pepper
sea salt

First make the béchamel. Melt the butter in a saucepan and then add the flour. Allow the flour to cook for a minute or two over a medium heat before adding a little of the milk. Whisk together to form a smooth paste. Continue this process until all the milk has been combined and you have a lovely smooth sauce. Grate in the Parmesan and season with the nutmeg, salt and the peppers. Leave to one side while you prepare the chicory.

Preheat the oven to 200°C/180°C fan/gas mark 6. Place the chicory halves in a shallow gratin dish greased with a little butter and season with salt and pepper. Roast in the oven for 10 minutes. Remove from the oven and allow to cool enough to handle before wrapping the ham around each head of chicory.

Pour over the béchamel and grate over a little more Parmesan. Whack the oven up to 240°C/220°C fan/gas mark 9 and cook for 10 minutes. Remove from the oven when it is bubbling and golden.

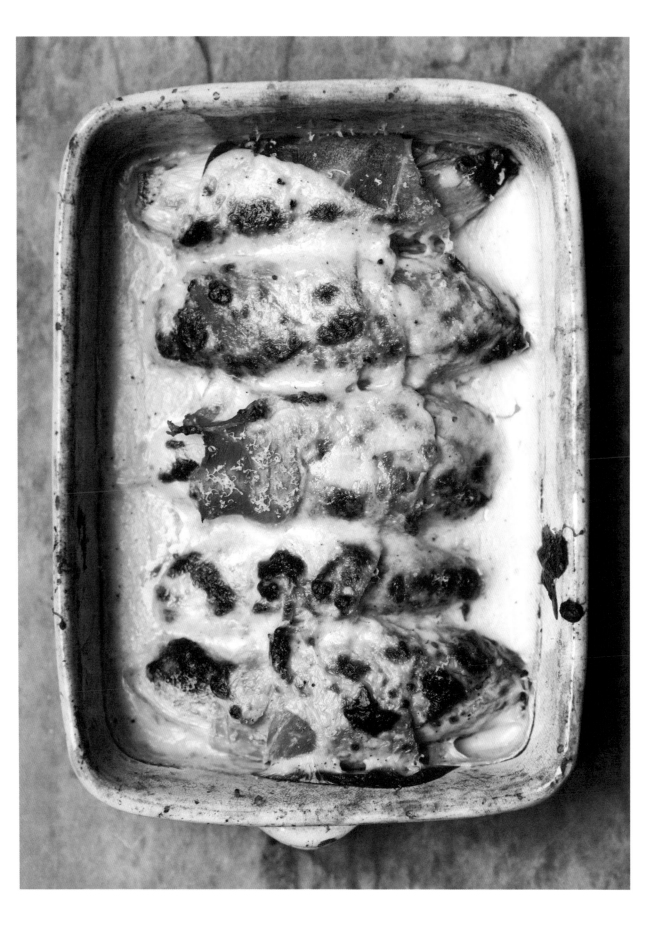

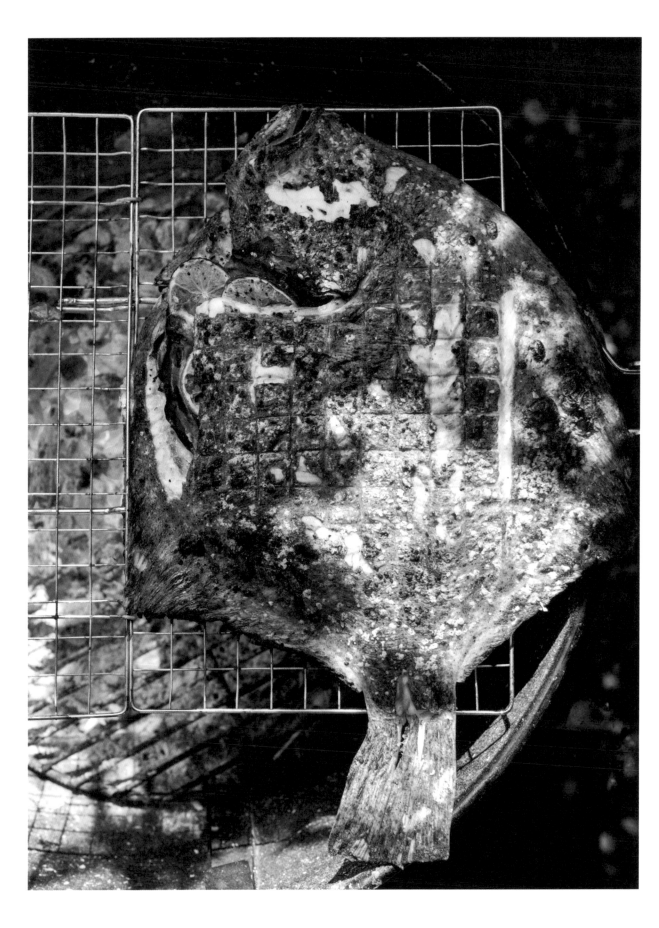

Grilled Turbot

Many chefs and cooks have waxed lyrical about turbot being the 'King of the Sea' and if you've ever eaten it you will know why. Turbot harbours the type of gelatine we're used to seeing in slow cooked oxtail, ox cheek and even sticky pig skin. Gelatine is something we rarely see in other fish, and it means that turbot can withstand more aggressive cooking and robust flavours.

The Chinese and other Asian countries love turbot too – some steam it, but often it's grilled and served with light, salty sauces. Sadly, due to widespread trawl fishing many turbots are badly damaged when they are caught, which has resulted in their extortionate price tag. They are only considered sustainable if line-caught or farmed.

Strangely it's actually better not to eat a really fresh turbot. I learned this when I was in Korea. The Koreans eat their fish very, very fresh; it is often killed minutes before serving, but the fish never tastes of much and can also be really chewy. In Japan, it's often hung for a good few hours – even for a few days when it comes to some flat fish – in order to develop its flavour and achieve the tenderest flesh. By the time we buy turbot in the UK it will be fine to eat but, unlike other fish, it can improve with a day or two in the fridge.

After accosting my mate Nathan Outlaw, I was persuaded to test grilled turbot in a variety of ways: over coals in my big green egg barbecue, under the grill and also in a very hot wood fire. They all gave a very good result, and took about the same time. Because the turbot's skin is heavy and thick and contains lots of gelatine it can take quite a lot of charring when you're cooking it on the bone. The thick skin and deep flesh keep the fish moist and you're left with meaty but juicy flesh, with a smoky tinge. However, I prefer to remove the skin before serving.

I've given you two options for accompaniments; one is a modern take on its classic pairing, Hollandaise, and the other a fresh Thai sauce that reminds me of the eight years my mother worked between London and Thailand and my sisters and I got to go on the best Thai holidays.

CONTINUED »»

SERVES 4

Preparation time 10 minutes
Cooking time 15 minutes, plus
 5 minutes resting

1 x 2–2.5kg turbot (ask your
 fishmonger to gut it)
2 tbsp olive or rapeseed oil, to cover
 the skin
2 tbsp white wine vinegar
2 tsp Maldon sea salt

Before you cook your turbot you need to heat your cooking equipment to temperature. If you're grilling over coals they should be white hot, or if cooking under a grill, get it as hot as it will go, but move your tray a little lower than normal. If you're using a wood fire make sure it has been burning for a good 40 minutes so it is roaringly hot.

Take your turbot out of the fridge and unwrap it. Turbots are extra slimy; this doesn't freak me out, but it may bother some people. Wash it under a cold tap to rinse off the slime and then pat it dry it with kitchen paper. Mix together 2 tablespoons each of oil and vinegar. Rub the turbot with as much as you need of this, then rub it all over with salt. The oil stops the fish sticking, while the vinegar dries the skin a little, and the salt is for seasoning.

The easiest way to cook it is in a fish grill basket because it makes the fish easy to flip. Put the fish into the basket or on a tray and cook for about 5–8 minutes on one side before flipping it over and cooking the other side for a further 5–8 minutes. It's ready when the skin has completely blistered and charred and gives when pushed at its thickest point. Set the fish aside and allow to rest for 5 minutes over a plate as it will collect a fair bit of juice.

To serve, snip off the rim of fine bones that runs along the fillets (called the frill) using scissors. Then remove the skin. Next carve along the central bone that runs along between the two fillets. I like to serve the fish on the bone. If you're serving with Thai sauce, cover it in sauce now and serve. Alternatively serve alongside a richer dolloping sauce such as hollandaise.

Thai Sauce

Heat the oil in a small saucepan and add the garlic. Fry gently for 2 minutes until it starts to soften. Add the ginger and cook for another minute, or until they both start to take on a golden tinge (not brown – which means you've overcooked them). Add the lime leaves, chillies, sugar, fish sauce and lime juice and bring to the boil. Boil for 3 minutes, or until thickened. Taste; it should be as the cliché says: salty, sour, spicy, sweet in perfect balance. Add the coriander and white pepper and boil for another minute. Pour over your cooked, rested and trimmed fish and then top with the crispy shallots.

Preparation time 10 minutes
Cooking time 10 minutes

2 tbsp rapeseed, coconut or
 groundnut oil
4 garlic cloves, very thinly sliced
4cm piece of ginger, peeled and
 thinly sliced into matchsticks
8 lime leaves, (fresh or frozen are
 best, stalk removed and
 thinly sliced)
2 red Thai chillies, thinly sliced
3 tbsp coconut sugar
3 tbsp Thai fish sauce
3 tbsp lime juice
small bunch of fresh coriander, very
 finely chopped
¼ tsp ground white pepper
100g Crispy Shallots (see page 245)

Hollandaise Sauce

To make the reduction, place all the ingredients in a small saucepan and bring to the boil. Continue boiling until you have only 2 tablespoons of liquid left, then strain into a cold bowl. This is your reduction and the base flavour of your hollandaise.

Whizz the egg yolks in a food mixer or bowl with an electric hand-held whisk, with a pinch of salt. Pour in half the reduction. Add the melted butter very, very slowly – 1 teaspoon at a time if need be. Treat making hollandaise like making mayonnaise, adding only a little fat at a time to incorporate it all without splitting and to ensure it gets really thick. When half the fat is in you can start to pour the rest of the butter in a thin stream until it forms a thick sauce. Season with more salt and pepper and lemon juice. You can keep the sauce warm over a bain marie. Serve the fish with the hollandaise on the side.

You can pimp this by adding ground nori seaweed with a tablespoon of yuzu and serve your fish with toasted sesame seeds.

Preparation time 5 minutes
Cooking time 10 minutes

For the reduction
1 shallot, very finely chopped
6 tbsp white wine or cider vinegar
3 black peppercorns
1 bay leaf
2 blades of mace

For the sauce
4 free-range egg yolks
225g hot melted butter
squeeze of lemon juice
pinch of sea salt
white pepper

Goat

Goat is a meat central to so many global cuisines, but much ignored in the UK. While working on this book I had the great good fortune of spending an afternoon with James Whetlor, founder of Cabrito, author of the highly recommended book *Goat* and goat afficionado extraordinaire. Seriously, what James doesn't know about goats isn't worth knowing. What followed was an extremely inspiring afternoon learning about the prominence of goats throughout human history, the ethics of goat production – and perhaps most importantly how to get the best out of cooking it!

Cabrito produces and supplies goat kid meat to restaurants all over the country and was inspired by a key issue that I have focused on for years, but through the prism of dairy cow farming. I am a big advocate of eating veal, as I see it as the only sane response to the problem of unwanted male calves which are a by-product of the dairy industry. Dairy farms slaughter male calves within hours of birth, as they have no value for the farmer, unlike female calves which are raised to produce milk. To me this is senseless, wanton wastefulness, and wholly unjustifiable. I consume milk and dairy products, therefore I see it as my responsibility to eat veal.

This problem is exactly the same for goat farms. While goat dairy products are relatively new in this country compared with Spain and France, which have a much bigger, more established goat dairy industry, goats' milk and cheese are growing in popularity in this country year by year. So this feels a key moment to establish ethical, workable practices that respect the animals at the centre of the industry. Enter people like James who have made it their mission to bring our attention to the wonderful world of goat meat!

Until recently I must confess I was ignorant of the ancient relationship humans have had with goats. They were the first livestock animals to be domesticated, the earliest traces of goat herds being found in Western Iran, dating back to 11,000 BC, so we have some serious history with these animals! Their husbandry provided the cornerstone to human evolution from nomadic hunter-gatherer into settled farmers. Why goats? Well first of all, goats are hardy, adaptable creatures able to thrive in a multitude of environments and climates. They are extremely versatile, providing both milk and dairy products, and – importantly – hard-wearing leather. Humans were consuming fermented goats' milk in the form of yoghurt or cheese long before we considered drinking it in its primary form, and before cows were the central providers. Also, crucially, their meat is seriously delicious. The meat that is most like it is of course lamb or mutton, but goat has its own unique qualities, and in my opinion a more complex flavour. I think everyone expects goat to be tough, but just like lamb, different cuts of the animal require different cooking.

I truly believe that we are all implicated in the journeys of the produce we consume, and this is never as important as when we are talking about animal products. I think it is so important to try and expand this approach to all the types of food we eat, wherever possible. We cannot use wilful ignorance as an excuse to avoid responsibility for the impact that the food we consume has on the environment – and on the animals themselves. Reducing waste in all its forms is one of the key issues that needs addressing. OK, I'll get off my soapbox now, but I feel so passionately about this. What's more, if you avoid veal or kid meat, you are really missing out on amazing produce!

Slow Roast Goat Shoulder

This is simplicity itself. If you wanted to, you could treat this like a lamb shoulder and spike it with garlic, rosemary and anchovy, but goat has such a wonderful flavour in its purest form that all you really need is a bit of salt and pepper. As with all slow roasting, this results in tender, melt-in-the-mouth meat. It goes perfectly with the classic roast accompaniments – potatoes, carrots and greens. You can make a classic gravy using a roux and the juices, but I found that just pouring the juices into a saucepan and allowing them to reduce for 20 minutes creates a delicious rich sauce that perfectly celebrates the flavour of the goat.

Goat shoulder provides abundantly more meat than a lamb shoulder, which leaves you with plenty of leftovers to be used in all sorts of ways, such as my Goat 'Shawarma' Wraps (see page 168).

SERVES 8, PLUS LEFTOVERS

Preparation time 5 minutes
Cooking time 8 hours

2 tbsp olive oil
1 goat shoulder, about 2.5–3kg
sea salt and freshly ground black
 pepper

Preheat the oven to 240°C/220°C fan/gas mark 9. Rub the oil all over the goat shoulder and season liberally with salt and pepper. Place in the hot oven for 20 minutes to give it a good colour, remove from the oven and cover tightly with foil. Turn the oven down to 150°C/130°C fan/gas mark 2, bung the goat back in and allow to cook ever so gently for 8 hours until the meat is falling off the bone.

Goat 'Shawarma' Wraps

SERVES 4

Preparation time 15 minutes

4 flatbreads, ideally Lebanese, but
 pittas or tortillas work well too
400g slow-roasted goat meat (fresh
 is ideal, but you can bake leftover
 roast meat with a splash of lamb jus
 covered in foil for 5 minutes)

For the salad
½ cucumber, halved and thinly sliced
1 small red onion, thinly sliced
150g best quality cherry tomatoes,
 quartered
large handful of parsley, finely
 chopped
seeds of ½ pomegranate
2 tbsp olive oil
juice of ½ lemon
sea salt and freshly ground black
 pepper

For the garlic sauce
200g Greek yoghurt
2 garlic cloves, grated
2 tbsp lemon juice
sea salt and freshly ground black
 pepper

To serve
hummus
Turkish fermented chilli sauce
pickled chilli peppers
leftover meat juices

I have referred to shawarma here in inverted commas, as the traditional way to make a classic shawarma involves layering meat on to a rotating spit and grilling slowly for as long as a day. The meat is sliced off as it cooks and put into a flatbread with chilli and garlic sauce, along with a mixture of salad and pickled chillies. This combination is an ideal way to use up the leftover meat from my Slow Roast Goat Shoulder recipe (see page 167), and the meat is so flavoursome that you don't miss out on any of the tastiness achieved by spit-roasting the meat. What you will get is a wrap with a more meaty bite from the lean goat than in a standard shawarma, and I actually prefer this. I think it's nice to lay out all the constituent parts on the table so that everyone can tailor make wraps to their own taste, whether they be spicier or milder.

To make the salad simply throw all the ingredients into a bowl, and mix well. Check for seasoning. This salad benefits from being left for 20 minutes or so.

The same goes for the garlic sauce; just put all the ingredients in a bowl, mix well and set aside for 20 minutes.

When you are ready to construct your wraps, heat a frying pan over a high heat. Put a flatbread in the dry hot pan and warm for 20 seconds on each side. Spread a nice layer of hummus on each flatbread, followed by a healthy portion of meat in a line down the centre. Top with salad, the garlic sauce, chilli sauce and pickled chilli peppers if you like it spicy and douse in the umami goat cooking juices. Wrap it up tightly and eat as a sandwich, or pile the meat and toppings on a piece of bread and eat with a knife and fork!

Goat Dumplings in Broth

This is the best way to use your leftover goat bones after making the Slow Roast Goat Shoulder (see page 167). You'll need to plan ahead to make this dish as the stock takes 4 hours to make and a further 45 minutes to reduce once strained. The dumplings can be made with raw or cooked meat – raw will always be a little juicier, but cooked will save on wastage. Always cook dumplings made with wheat flour separately before popping them into the broth, so the broth stays lovely and clear. Steaming is best, but boiling is good too. The quantities I've given will make enough dumplings for six, but they freeze brilliantly when raw, as long as you store them in airtight containers.

SERVES 2

Preparation time 1 hour 30 minutes
Cooking time 20 minutes, plus
 4 hours 45 minutes if making stock

For the dumplings (makes 30 small
* dumplings)*
150g 00 grade pasta flour
¼ tsp fine salt
1 large egg, beaten
150ml cold water

For the filling
2 tbsp goat fat
1 small onion, finely chopped
3 garlic cloves, finely chopped
400g raw or cooked boneless
 kid shoulder, finely chopped
3 tbsp jellied goat stock
¾ tsp sea salt
½ tsp white pepper
freshly ground black pepper
pinch of ground cloves

For the broth
800ml goat stock
200g cooked kid meat, chopped
1 carrot, halved and cut thinly at a
 sharp angle
10 goat dumplings
2 tbsp chopped dill
sea salt and freshly ground black
 pepper

First make your dumpling dough. You will need a mixer with a dough hook attachment. Tip the flour and salt into the bowl of the mixer. Combine the egg and water, turn the mixer on low and slowly pour in the liquid. Then turn the mixer to high and allow to run for about 5 minutes until you have a smooth, elastic dough. Wrap the dough in cling film and allow to rest in the fridge for about 30 minutes.

While the dough is resting make your filling. In a small frying pan, heat the fat over a medium heat and add the onion. Allow to cook gently until it is lovely and soft and beginning to go golden, which should take about 15 minutes. Add the garlic, turn off the heat and allow the onion to cool a little before putting it into a bowl with the kid meat, stock, salt, white and black pepper and the cloves.

Once the dough has rested, roll it out thinly on a floured surface: you are aiming for a 30cm long rectangle about 2mm thick. Cut the dough into 6cm squares. To fill a dumpling, place a little less than a teaspoon of filling in the centre of the dough square. Pull up two opposite corners and squeeze them together firmly. Do the same with the other two corners, and squeeze together all the edges to form a neat 'X'.

Lightly grease the top of your steamer and carefully put the dumplings in. Steam for 10–12 minutes until the meat is cooked through.

Meanwhile bring the goat stock to the boil. Add the cooked meat and carrot and cook until the stock has reduced and become extra intense. This may take a bit of time but keep boiling it until it's really concentrated in flavour. Season with salt, pepper and the dill. Divide the broth between two bowls, add 5 dumplings to each and eat immediately.

Mallorca Slow Roasted Lamb Shoulder

This is one of the most famous dishes in Mallorca and usually made with very young milk-fed lamb. It's allowed to cook very slowly in delicious juices with lots of vegetables. The trick is to ensure that the joint is tightly covered; if you allow no air to escape, it steam roasts inside the foil at a very low temperature. The end result is deliciously caramelised fat, meat that just falls off the bone and the most wonderful natural sauce made from the cooking juices and the wine. Traditionally, this would be served at the table in the roasting dish it was cooked in but it also works really well as a Sunday roast – simply remove the lamb and vegetables and use the cooking liquid to make a proper gravy.

SERVES 4–6

Preparation time 15 minutes
Cooking time 6 hours

2.25kg high-quality shoulder of
 lamb, bone in
3 tbsp olive oil
1 head of garlic, halved
3 onions, thinly sliced
3 carrots, halved lengthways and
 widthways
2 celery sticks, each cut into 3
1 large leek, trimmed, halved
 lengthways and cut into 3
4 small vine-ripened tomatoes,
 halved
handful of fresh rosemary
2 fresh bay leaves
handful of fresh thyme sprigs
1 bottle Spanish red wine
300ml fresh jellied chicken stock
sea salt and freshly ground black
 pepper

Genuinely this couldn't be easier. Preheat the oven to 230°C/210°C fan/gas mark 8. Rub the lamb with the olive oil and plenty of seasoning and place in a baking dish. Bake for 20–25 minutes, or until the outside is well browned. Remove from the oven and reduce the heat to 160°C/140°C fan/gas mark 3.

Remove the lamb with two forks and set it aside, then place the vegetables and herbs in the dish and replace the lamb on top. Pour over the wine and stock and cover the dish with foil. Make sure there are absolutely no gaps for the air to escape. Pop the lamb into the oven and slow roast it for 6 hours, or until the meat is falling off the bone and the vegetables have shrunk stickily into one another and the sauce is reduced.

I prefer to remove the lamb from the cooking vegetables and strain the veggies out of the sauce, giving you a really delicious lamb gravy to pour over the falling-to-bits lamb, but traditionally the foil is whipped off and everything served together at the table with peeled waxy potatoes that have been boiled with shedloads of salt and drizzled with a bit of olive oil.

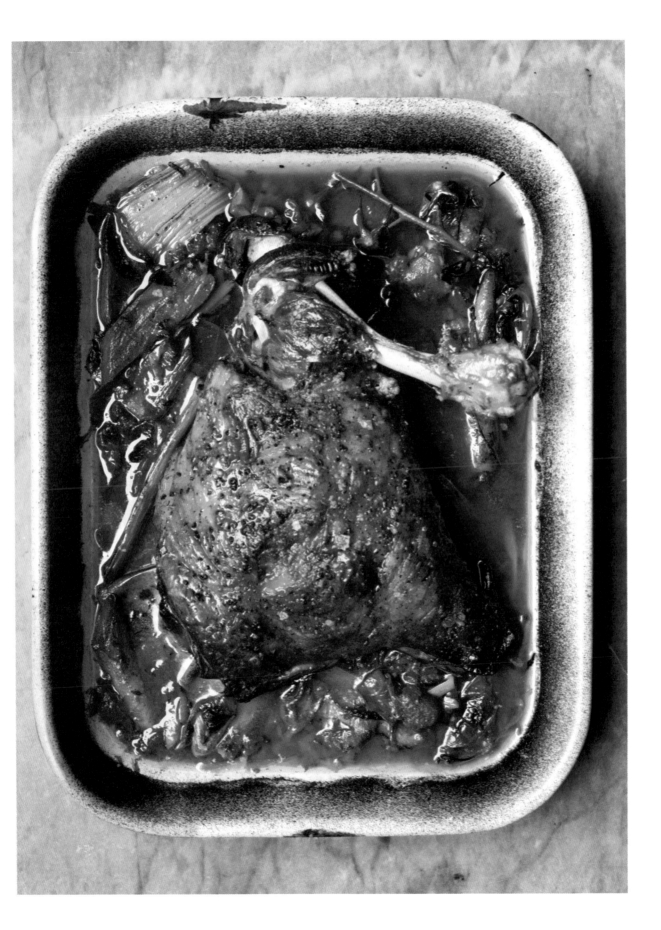

Pork Meatloaf

I am an advocate of the much-maligned meatloaf. It's a mainstay of the American home cook, but I think we really miss out on it this side of the pond. Traditionally meatloaf is made with beef mince combined with a little pork, but here I have only used pork mince, which makes a much lighter loaf. Think of it as a huge sausage! It's really versatile and can be served with my Slow Cooked Tomato Sauce (see page 240) BBQ Sauce (see page 241) or Green Peppercorn Sauce (see page 241) instead.

SERVES 6

Preparation time 20 minutes
Cooking time 1 hour

2 tbsp butter, plus extra for greasing
1 large onion, finely chopped
2 garlic cloves, finely chopped
few sprigs of thyme, leaves picked
 and chopped
2 sprigs of rosemary, leaves picked
 and chopped
700g pork mince
100g fresh breadcrumbs
2 free-range egg yolks
splash of milk
good grating of nutmeg
olive oil, for brushing
sea salt and freshly ground black
 pepper

Preheat the oven to 220°C/200°C fan/gas mark 7. Melt the butter in a frying pan until it starts to foam. Add the onion and sauté gently for about 15–20 minutes until softened and lightly golden. Stir in the garlic and herbs and cook for a further minute or two. Remove from the heat and set aside for 5–10 minutes to cool.

In a bowl, mix together the pork mince, breadcrumbs, egg yolks, milk, the cooked onions and nutmeg and season liberally. You'll be surprised how much salt the mixture can take. There's nothing worse than an under-seasoned meatloaf, and the best way to check is to take a little spoonful of the mixture and fry it up quickly and let your taste buds tell you if it needs more. Trust yourself! Once you're happy, turn out the mixture on to a well greased roasting tray, and with your hands, mould it into a loaf shape. Brush all over with a little olive oil. Put in the oven and roast for 20 minutes to give it some colour, then turn down the heat to 180°C/160°C fan/gas mark 4 and cook for a further 30 minutes until it's cooked through. Remove from the oven, cover with foil and allow to rest for 10 minutes. A healthy dollop of mashed potato is the perfect accompaniment.

Wild Mushroom & Madeira Sauce

Put the roasting tin you cooked the meatloaf in over a medium-high heat and add a teaspoon of butter. Once it starts to foam, throw in 300g seasonal wild or chestnut mushrooms and 150g small fresh porcini or morels, sliced (or the equivalent of rehydrated dried porcini) and fry for 2–3 minutes until they start to go golden, scraping up all the sticky bits from the bottom of the tin. Add 2 finely chopped garlic cloves and sweat for 1 minute, then add a teaspoon of flour and stir to form a thick paste. Pour in 400ml beef stock and a splash of Madeira or Marsala wine, give it a stir and leave to bubble away until reduced by about two-thirds. Next, pour in 100ml double cream and then add a few tarragon leaves and the zest of half a lemon and season with salt and pepper. Continue to cook until the sauce has reduced to a creamy pouring consistency.

Roast Leg Of Lamb with Garlic, Rosemary & Anchovies

Much as I love a slow cooked lamb shoulder, nothing beats a slice of perfectly pink lamb leg. Studding the meat with garlic, rosemary and anchovies might seem a little fiddly, but is really worth the extra effort as you imbue the lamb with so much extra flavour from the get go. In spring if you're lucky enough to find wild rosemary flowers they are also a fabulous addition. Don't be alarmed by the inclusion of anchovies, I promise the meat won't taste remotely fishy; they melt away during cooking, merely adding an extra level of umami. This is ideal with all the classic roast trimmings, but is also an absolute winner the French way, with my new favourite signature dish, Flageolet, Anchovy, Rosemary & Confit Garlic Gratin (see page 124).

SERVES 6–8

Preparation time 30 minutes
Cooking time 1 hour 10 minutes,
 plus 20 minutes resting

For the lamb
1 x 2.4kg leg of lamb
12 anchovies, cut in half lengthways,
 plus their oil
5–6 garlic cloves, cut into slivers
8 sprigs of rosemary, broken into
 24 smaller sprigs
sea salt and freshly ground black
 pepper

For the gravy
1 heaped tsp plain flour
1 glass white wine
750ml fresh chicken or lamb stock

Preheat the oven to 240°C/220°C fan/gas mark 7. Place the lamb in a roasting tin and stab it with a thin, sharp knife, making cuts about 1cm deep into the meatiest part of the leg. Take an anchovy half and push it deep into the meat. You will be surprised how much you can stuff into the cavity if you get your fingers in there. Follow the anchovy with a sliver of garlic and then a sprig of rosemary. Repeat 24 times all over the surface of the lamb. Rub the joint with oil from the anchovy tin, and season with plenty of salt and pepper.

Put any remaining anchovies in the bottom of the roasting tin, under the lamb. Pop the tin into the oven and roast for 20 minutes, then reduce the heat to 180°C/160°C fan/gas mark 4 and cook for 50 minutes so it will be perfectly pink. Remove from the oven and leave the lamb to rest in a warm place for 20 minutes while you make the gravy and cook the vegetables.

To make the gravy, pour away the oil from the roasting tin until 2 tablespoons are left, being careful not to pour out any of the meaty juices. Place the tin on the hob over a high heat, add the flour and scrape the bottom of the tin with a wooden spoon to pick up meaty residue. Let the flour cook for 1 minute, then pour in the wine and mix quickly. Slowly whisk in the stock. When it's all combined allow to bubble slowly over a low heat. Reduce the gravy until it's rich and has a good pouring consistency. Season with plenty of salt and pepper.

Carve the lamb and serve with the gravy and some roasted baby carrots.

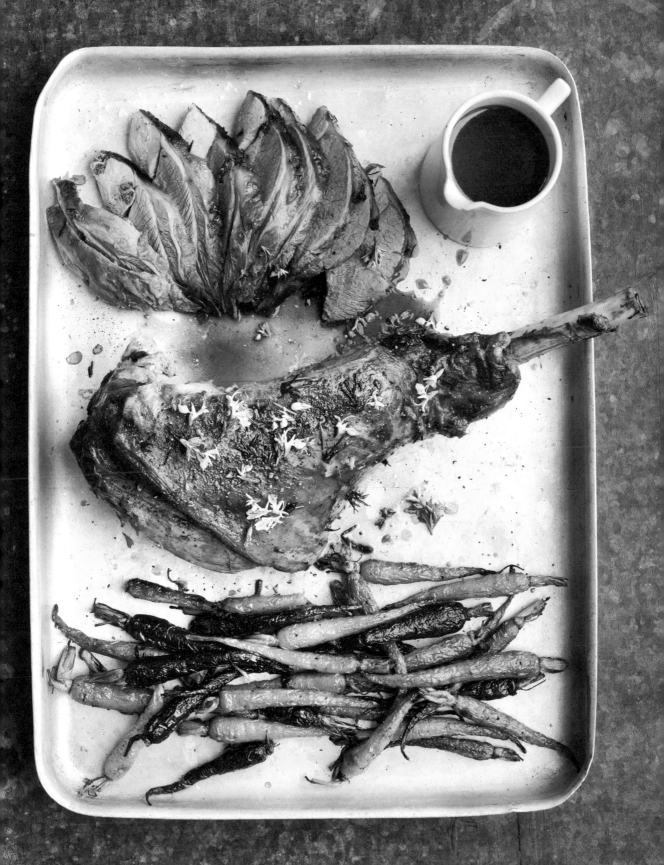

Foolproof Roast Beef Rib & Gravy

There are a few recipes that stand the test of time and this is one of them. This is more a method than a recipe, which has the aim of achieving perfectly cooked, tender beef. The eagle-eyed among you may notice that it has been published before, but I just couldn't omit this one as it's such a classic.

On the ever-dependable advice of my dear friend and meat maestro Neil Rankin, I have opted for the low and slow method here, which allows the meat to cook more evenly and results in juicier, more flavourful meat. When it comes to roast beef, you really don't want to mess around too much; it's all about enhancing the essential flavour of a beautiful piece of meat. I simply suggest creating a well seasoned crust on the beef, then serving with a seriously tasty gravy, made properly. This means that fresh stock is essential so don't even think about using a stock cube! Ask your butcher for a big piece of rib with the rib cap attached – it's expensive, but for special occasions it's pretty unbeatable so really worth the investment. Roast beef is synonymous with Yorkshire puddings and horseradish, so I have included my fail-safe recipes for both. You don't get more British than that.

Choose a roasting tin big enough to hold the rib of beef and preheat the oven to 120°C/100°C fan/gas mark ½. Coat the meat with a generous glug of olive oil and then season very liberally with salt and pepper.

Heat the roasting tin on the hob over a medium heat and slowly render the fat on the rib roast. As the tin fills with fat, pour it into a suitable container and reserve it. Keep cooking until you have 400ml of reserved fat. If you can't cook enough fat off the rib, top it up with vegetable oil. Once this is done, turn up the heat and give the joint some nice deep colour on all sides, seasoning with crushed Maldon salt as you go. Take your time with this, as it will make all the difference to the final depth of flavour.

Once the beef is browned all over, place it in the oven and cook for 2 hours and 30 minutes for medium rare meat. Remove from the oven and leave the meat to rest uncovered for 30 minutes. Collect all the juices and use them for gravy and any of the beef fat for the Yorkshire puddings or potatoes.

CONTINUED »»

SERVES 8-10 WITH LEFTOVERS

Preparation time 30 minutes
Cooking time 2 hours 30 minutes,
 plus 30 minutes resting time

1 x 5kg tied rib of beef with rib cap
 and a thick layer of fat
olive oil
Maldon sea salt and freshly ground
 black pepper

For the mustard gravy
1 tbsp vegetable oil
5 shallots, sliced
1 carrot, diced
1 celery stick, diced
1 tsp plain flour
400ml red wine
450ml Madeira or port
75ml brandy
2 litres fresh beef or brown chicken
 stock, plus tin juices from the roast
3 fresh bay leaves (rip the leaves a
 little to release more flavour)
2 sprigs of thyme
4 black peppercorns
6 garlic cloves, crushed
2 tbsp English mustard
50g butter
salt

To make the mustard gravy, heat the vegetable oil in a saucepan over a medium heat. Throw all the vegetables into the pan and cook until they are nicely caramelised. Add the flour and cook for another minute, then pour in the red wine, the Madeira or port and the brandy and reduce the liquid to half its volume. Pour in the stock and pan juices and reduce it by half, skimming as the stock comes to the boil and then as often as you can as it cooks.

Next add the bay leaves, thyme sprigs, peppercorns and garlic and keep simmering until you have the desired consistency. I don't like my gravy too thick, but on the other hand there's nothing worse than watery gravy! The best way to check is to taste it. You want it to taste rich and full of flavour. Pass the gravy through a sieve to strain out the veg and herbs and return to the pan. Finally, add the mustard, butter and salt to taste, whisking to make sure the butter is emulsified into the sauce.

To carve the joint remove the chine bone and ribs and slice the meat, seasoning each slice with a little salt. Serve with the gravy and horseradish and the same veggies you would serve with the Christmas turkey!

Preparation time 30 minutes

15g freshly grated horseradish
1 tbsp white wine vinegar
pinch of English mustard powder
½ tsp golden caster sugar
sea salt and freshly ground black
 pepper
150ml double cream, lightly whipped

Fresh Horseradish Cream

Soak the horseradish in 2 tablespoons of boiling water and set aside until cool. Drain and mix with the other ingredients. Leave in the fridge to soften for at least 20 minutes.

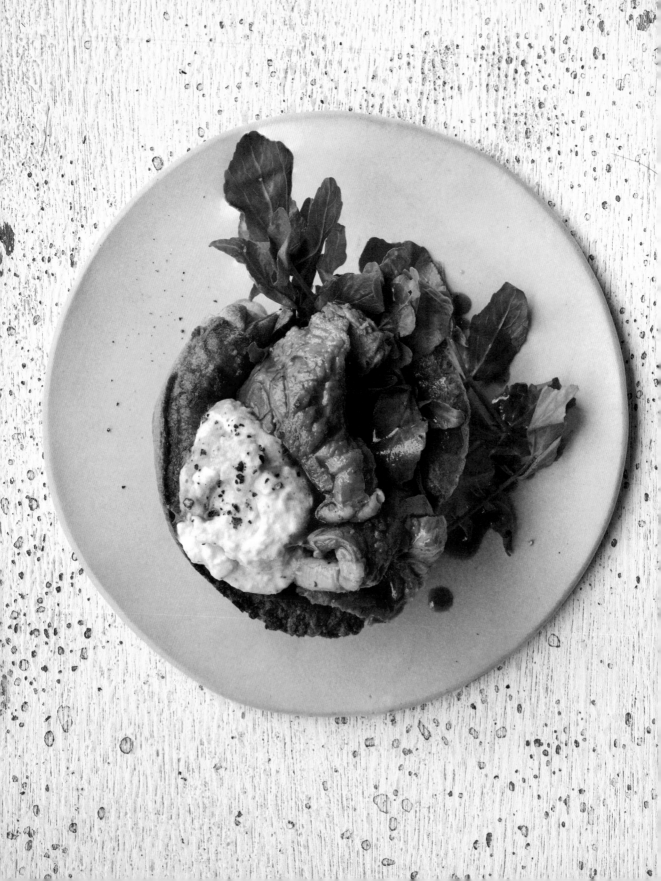

Yorkshire Pudding

There is a secret to the perfect Yorkshire pudding and it's simply this: equal quantities of each of the main ingredients. The way I do it is to crack the eggs into a glass measuring jug before pouring them into a bowl, and then to fill the jug to the same level with flour and then milk. This is a fail-safe method, and you don't even need to bother to get the scales out. However, if you feel a bit unsure, here is the recipe. The other important element is ensuring that you have piping hot oil – there needs to be a sizzle when you pour in the batter – and then get the puddings straight into a hot oven.

Preheat the oven to 200°C/180°C fan/gas mark 6. Place the eggs, flour and milk in a bowl and whisk until smooth and combined. You can do this in a food processor or a mixer if you like. Add the salt and pepper, then leave in the fridge for between 10 minutes and 1 hour to rest.

Divide the oil or fat between the holes of a 9-hole Yorkshire pudding tin (or 9 holes of a 12-hole one), or grease a medium ovenproof dish or frying pan (if making 1 large pudding) and heat in the oven for 10 minutes.

Take the tin out of the oven and place on the hob. To ensure that the oil stays hot, put the burners on underneath, as you want to hear a sizzle when you pour in the batter.

Pour the mixture into the holes in the tin, or into the ovenproof dish or roasting tin, and place in the oven for 30 minutes. The puddings will rise massively and become crisp on the outside, but be fluffy and spongy in the middle. Remove them from the tin, stand them on kitchen paper to drain, then serve immediately.

MAKES 9 SMALL PUDDINGS OR 1 GIANT ONE

Preparation time 5 minutes, plus
 10 minutes–1 hour resting time
Cooking time 30–35 minutes

3 free-range eggs
85g plain flour
150ml milk
½ tsp salt
½ tsp white pepper
3–4 tbsp oil or fat (vegetable or olive
 oil or beef dripping)

Roasted Fennel, Chicory & Shallots in Aged Malt Vinegar

I've only recently discovered aged malt vinegar and it's something of a revelation. It has a similar depth of flavour to sherry vinegar, and really draws the sweetness out of the shallots and fennel. This makes a great accompaniment to a classic roast, or my Salt Baked Sea Bass (see page 133) for something lighter.

(see page 133)

SERVES 6–8

Preparation time 15 minutes
Cooking time 40 minutes

3 tbsp olive oil
3 small fennel bulbs, cut into
 quarters
2 chicory heads, each quartered
 through the stem
10–12 banana shallots, left whole
3 tbsp aged malt vinegar
2–3 tbsp soft light brown muscovado
 sugar
sea salt

Preheat the oven to 240°C/220°C fan/gas mark 9. Put the oil in a large roasting tray and toss the fennel, chicory and shallots in it. Roast in the oven for 20 minutes.

Take out the roasting tray and give the vegetables a gentle stir; you may find it easier not to break them up if you use a spoon to flip them over. Season with a little salt and douse with the vinegar and brown sugar. Place the tray back in the oven to roast for another 15 minutes until soft, sticky and caramelised.

Slow Roasted Butternut Squash

This couldn't be simpler and can be eaten in myriad ways, whether sliced up in a salad, added to a risotto or used as the base of a soup or to add body and sweetness to a curry. Roasting helps to intensify the sweetness of the squash, and adds an extra charred quality which I love. I've made this as a base recipe, which you can add to recipes such as Soy Miso Ramen (see page 13).

Preparation time 5 minutes
Cooking time 1 hour–1 hour
　30 minutes

1 large butternut squash, cut in half
　lengthways
2 tbsp olive oil
sea salt and freshly ground black
　pepper

Preheat the oven to 180°C/160°C fan/gas mark 4. Place the squash on a roasting tray and drizzle both halves with the olive oil. Season well with salt and pepper and bung in the oven. I like to leave mine in for at least 1 hour, if not 1 hour 30 minutes to let the oven work its magic.

Sesame Miso Roasted Red Cabbage

Red cabbage as a stand-alone vegetable doesn't get much air time, other than in the classic format of Braised Sour Red Cabbage (see page 87). Here I've roasted it and then drenched it in a sesame miso dressing. It's the kind of dressing the Japanese use to cure fish. This is great as a side dish or even on its own with some brown rice.

Preheat the oven to 200°C/180°C fan/gas mark 6. Spread out the cabbage wedges on a baking tray, toss with the oil and season lightly. Roast in the oven for 30 minutes.

Meanwhile make the dressing by whisking together all the ingredients. Once the 30 minutes is up, use a pastry brush to coat the cabbage pieces in the dressing then turn the oven up to 240°C/220°C fan/gas mark 9 and return them to the oven for a further 15 minutes until cooked through, caramelised and beginning to get a little crisp at the edges.

SERVES 4 AS A SIDE DISH

Preparation time 5 minutes
Cooking time 45 minutes

1 red cabbage, cut into 8 wedges
2 tbsp rapeseed oil
sea salt and freshly ground black
 pepper

For the dressing
1 tbsp fresh white miso
1 tbsp mirin
1 tbsp sake
1½ tbsp water
1 tbsp sugar
1 tbsp sesame seeds
½ tsp roasted sesame oil

Meat

My attitude to meat has changed and developed throughout my life, and I think it's impossible to ignore the myriad issues around this subject. I admit that I am in the privileged position of being able to afford good-quality meat, and have a number of fantastic butchers within walking distance of where I live, but this hasn't always been the case. I do feel that I would rather not eat meat at all than consume unethical, mass-produced, untraceable meat from animals who have suffered due to poor welfare standards.

Obviously I'm not perfect and I am as susceptible to the occasional late-night burger or kebab as the next person, but I really make an effort to do my best whenever possible. I do believe our attitudes have been evolving in the right direction, especially during the last ten years, and there is far greater awareness and consciousness of the facts about how meat is produced and consumed. But we can always do better.

There's no doubt that global beef production has had a devastating environmental impact for example, so while I am not prepared to cut out meat completely (it's just not realistic for me as a chef), I see it as our responsibility always to buy the best we can afford, to cook it with respect and definitely not eat it as part of every meal. Reducing the amount of meat I consume has become a bigger priority for me over the past couple of years, as not only is this better for the environment, it's no doubt better for our health, too.

However, I am also a firm believer in making the most of every animal, and see eating offal as part of this, which is no sadness for me, as I absolutely love it. Also, if the purse strings are tight, there are so many wonderful cheaper cuts of meat that can offer some of the best eating if treated with a little love and time, illustrated perfectly by my Sticky Oxtail Stew (see page 34) or Steak & Kidney Pudding (see page 69).

When looking for meat, ideally you want it to have a rich, dark red colour. The supermarket has conditioned us to expect to see pale, insipid-looking meat. Most buy underhung, mass-produced meat, which can look anaemic and lacks any real flavour. A deeper, richer colour indicates that the meat has been hung properly and allowed to mature in flavour and texture.

Here are a list of tips and guidelines to tell you what to look out for, and some cooking methods to help you get the very best out of your meat.

How to Buy Meat

• The texture of steak should be very dense and quite dry. If you can distinguish the grain and it feels wet, the meat is not at its best.

• Look for a good marbling of fat throughout the meat, which means that it should have lots of veins of fat distributed through it. The rule with meat generally is that fat means flavour.

• The best fat is aged fat, which is dark yellow in colour and dryer than the paler fat. It's mostly found in older animals but can be manipulated by diet. A good grass-reared animal will have it, as will corn-fed USDA, Kobe or Wagyu beef.

• Fresh meat smells clean.

• Freezing meat is perfectly acceptable, but when it defrosts it loses liquid, which will change the quality, so always use fresh meat when you can.

Beef

The best beef is aged, which means that it has been hung for at least 14 days. The longer meat is hung, the stronger the flavour, as this dries it out and tenderises it at the same time. For really strong flavour, look out for dry-aged meat, when the meat has been left to age in a dry atmosphere so it dries out a bit, thus concentrating the flavour. Unless you're buying from a meat counter or it's clearly indicated on the packaging, you will rarely find dry-aged, well-hung beef in a supermarket, so look locally for a good butcher.

Roasting

• You can brown meat before roasting it by searing it in a little oil in a roasting tin over a high heat.

• Alternatively, heat your oven to its highest temperature for the first 20 minutes of cooking, then reduce the temperature for the latter part. A good browning temperature is 220°C/200°C fan/gas mark 7 and a good roasting temperature is 180°C/160°C fan/gas mark 4.

• Once cooked, rest the meat, covered with foil, for at least 20 minutes before carving, so that the juices can return to the surface and the meat can relax. This also means you have time to make the gravy and cook your vegetables.

Frying, Grilling or Griddling Steak

Cooking a steak properly is really easy, but so many people get it wrong. When you go to restaurants and order steak, they normally use a searingly hot griddle, and this is the key to a good steak. Just heat the pan for a little longer than you think you need over a high heat, until you start to see it smoking. You don't want it to smoke the house out, but there should be some little wisps of smoke visible. This will ensure that you colour the meat well.

• Don't use too much oil or your meat won't brown properly. For great colour, use either a mixture of butter and oil or just butter.

• Make sure you season the meat with lots of salt and pepper just before you cook it. You will be surprised at how much flavour it adds to the meat.

• Don't overcrowd your pan or the meat will boil rather than brown. If this means cooking your steaks one at a time, so be it!

• If the pan is not hot enough to begin with, leave the meat to cook for exactly the same amount of time on both sides.

• Do not move it around; let the meat stick to the pan and caramelise on the outside before flipping it over and doing the same on the other side.

• What you're looking for is a really charred, dark crust and a nicely pink middle. As with all meat, you must leave it to rest; give it at least 5 minutes before serving.

• When it comes to accompaniments, for me it's all about peppercorn or béarnaise sauce, or a good flavoured butter, some fat chips and not much else.

CONTINUED »»

Steak Cuts

There are many different cuts of steak and for some people it comes down to personal preference. All the cuts serve a certain purpose. I'm just going to describe them here and leave it to you to choose what you feel is best.

Fillet Steak: The leanest (and most expensive) of the steaks. Normally thick-cut, it has a delicate flavour because it has very little fat and, as I've said before, fat is flavour. These steaks are so tender they require minimal chewing. I think fillet is best used for dishes that require searing, for example Chateaubriand or Beef Wellington, and need to be cooked rare.

Sirloin Steak: Taken from the middle of the back end of the loin of the animal, a sirloin steak has a fair bit of flavour and is quite an easy, firm cut to cook with. It has more bite than a rib-eye, but is not the firmest of the steaks. Also known as the New York strip or entrecote.

Rib-eye Steak: At the centre of a rib of beef you find the rib-eye. This is a complex piece of meat that has quite a lot of fat, but as it does not do much work it is still a really tender cut. It is by far the tastiest piece of meat you can eat, in my view. A cote de boeuf is a really thick-cut rib-eye steak for two and a real treat. My favourite of all the steaks.

Rump Steak: Once upon a time rump steak was a fairly cheap cut. Nowadays, due to its abundance of flavour, it is getting a spot bit pricier, although still cheaper than sirloin, rib-eye or fillet. I use a rump to make steak sandwiches, and it's great for barbecuing as it holds its shape well.

T-bone Steak: The Desperate Dan steak! This cut is simply a piece of sirloin and a piece of fillet joined together with its natural T-shaped bone. A great cut, as you get a really tender meat and a sturdy, flavoursome piece of sirloin. Fantastic to whip out if you want a bit of wow factor.

Butters for Steaks

A flavoured butter is one of the best things to really bring a steak to life, and is so simple to make. It's just a case of mashing together a combination of ingredients and chilling the butter in the fridge before adding a slice on top of your cooked steak. I've included the recipe for one of my favourites on page 241.

Beef Roasting Cuts

The rib: the prime roasting joint.

The sirloin: delicious and easy to carve. Best cooked as a hot and fast roast.

Topside: the cheapest and most used roasting cut, but I always feel it's a bit tough.

Rump cap: a really underused cut, but growing in popularity. It comes from the top hindquarter of the cow, and has a thick layer of fat attached, which when cooked properly adds a deep flavour to the meat. This is best cooked as a fast roast, much like a sirloin.

Beef Roasting Chart

Always start by browning any joint for 20 minutes at 220°C/200°C fan/gas mark 6, before lowering the oven temperature for the rest of the roasting time.

	Temperature in °C	°C fan	Cooking time per kg
Rare	180	160	30 minutes
Medium rare	180	160	35 minutes
Medium	180	160	40 minutes
Well Done	180	160	50 minutes

Beef Stewing Cuts

Shin: as the legs do so much work and are naturally sinewy, a slow-cooked shin will be gelatinous and melt in the mouth.

Chuck: most of the stewing meat we buy is chuck, and it's great because it doesn't need the really long, slow cooking of that shin does. But then it doesn't quite have its flavour either. Really good mince comes from chuck, and if you're going to ask for it from a butcher ask for a 20 per cent fat version.

Oxtail: the tail of the cow, cut into pieces at each joint. When slow-cooked, the meat is tooth-suckingly good. As it's so close to the bones it has tons of flavour, and it oozes loads of gelatine when cooked, giving a sticky sauce.

DOUGH

Fresh Hand Rolled Pasta

Eating fresh pasta is of the utmost importance in my life! I know all the rules, like a good ragu should always be eaten with fresh pasta but never with spaghetti (I don't always listen, but I know that's a 'thing'). I make a ragu weekly and I eat fresh pasta whenever I can. So it seems a little ironic that making fresh pasta has become the bane of my life. So much so that until I started writing this book, I don't think I'd made it for maybe ten years. (Actually there was one time I 'made' it when I was cooking with Angela Hartnett at her restaurant in Lime Wood, but I think I just came up with the big idea of doing squid ink spaghetti with n'duja and clams and hid when the pasta making was going on.)

I really didn't want it to defeat me and, never having written a fresh pasta recipe before, I decided to include one in this book. But I also wanted to keep it as simple as possible and without all the faff of a pasta machine. This has been one of the most important missions of my life to date. I, like Sofia Loren, feel that I owe this body – all tits and arse – to my beloved pasta and, as pasta has conquered my body, it seems only fair that I learn how to conquer it right back!

Serve with a sauce of your choosing, I highly recommend my Slow Cooked Tomato Sauce (see page 240) or my Venetian Duck Ragu (see page 39).

SERVES 4

Preparation time 15 minutes
Cooking time 3 minutes

300g 00 grade pasta flour
½ tsp salt
3 large free-range eggs (medium eggs
 will make your pasta too dry)
1 tsp olive oil
semolina flour, for rolling

Put the flour, salt, eggs and oil into a food processor and blitz until they form large waxy crumbs. Transfer the mixture to a surface and knead it for about 3 minutes until it becomes a smooth dough. Some recipes say to knead for 10 minutes as you would bread dough. I tested this recipe numerous times and it made no difference. I also made it in a tabletop mixer with the dough hook, but I felt that technology didn't help the process, and that I had more control kneading by hand. The 00 flour is high in gluten and springs back really quickly – and the kneading is quite a fight and the mixture totally unlike bread dough. What you're looking for is a smooth dough that's really firm but on the verge of being both silky and springy to touch. Wrap it tightly in cling film and rest it for an hour outside the fridge. Some people suggest 15 minutes, but for hand rolling it needs more time.

When it's time to make your pasta, dust the work surface with semolina flour. This will stop the pasta drying out or the water getting claggy if you use 00 pasta flour.

This requires some muscle but I've had fights with pasta machines in the past and I recommend hand rolling your pasta. Cut the pasta dough in half and keep one half covered by a tea towel. Warm the dough between your hands before rolling the other half. Lay it on the dusted surface and sprinkle the top with a little more semolina flour. Then just roll. It takes a bit of welly or elbow grease or whatever you want to call it. And sometimes if you stop for a few seconds you will see that it rests again and is easier to roll.

You need to roll it pretty thin – to the thickness of a small coin perhaps. Try to roll it into a neatish rectangle, but you will find that pasta dough has a mind of its own, or at least it does in my case. Roll it out until it's about 50 x 30cm, then roll out the other half to the same shape and size. Cut each rectangle in half, and lay all 4 pieces on top of one another. Trim the edges to neaten them. Then you can roll them all up tightly and begin to cut the roll into thin strips that look like linguine, fettuccine, tagliatelle or pappardelle (see pictures overleaf).

To cook the pasta bring a large saucepan of very salty water (about 1–2 tablespoons of salt per 10 litres) to the boil. Drop the pasta in and cook for a minute, or until it rises to the top. It should be firm to bite, but make sure it's cooked through too. Now you're ready to toss it in your chosen sauce. Reserve a little of the pasta cooking water in case your sauce is too dry.

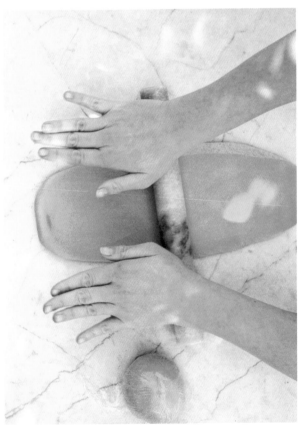
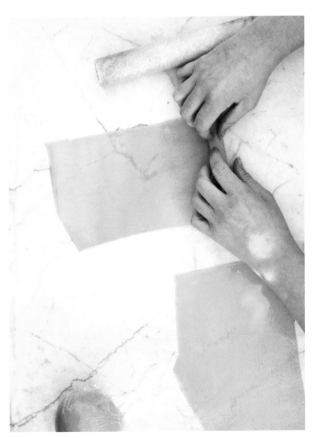

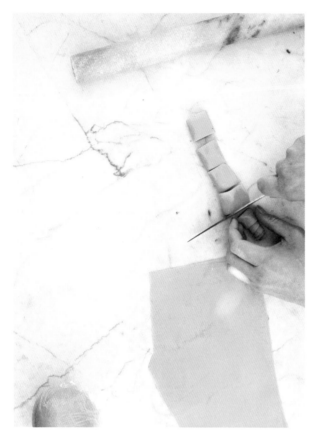
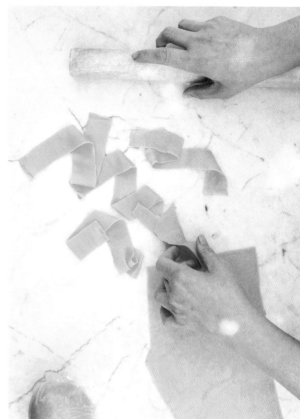

Pierogi Dumplings

Pierogi are Polish dumplings. They are poached and then sometimes crisped up in a little burnt butter. You serve them with soured cream and something a little sweet and sour, such as apple sauce, sauerkraut or pickles. What makes pierogi dough different from regular dumpling dough is that it has a tang from the sour cream and is just a fraction thicker and spongier than other dough. You can fill your pierogi with whatever you like – the most classic filling is potato and cheese (see overleaf), but you can pretty much fill them with anything.

MAKES 24 PIEROGI

Preparation time 15 minutes, plus
 10 minutes resting
Cooking time 5 minutes

250g pierogi or 00 grade pasta flour
1 medium free-range egg, whisked
100ml sour cream
½ tbsp baking powder
pinch of salt
vegetable stock, for boiling
1 tsp vegetable oil

Mix the flour, egg, sour cream, baking powder and salt together in a bowl. Tip on to a floured surface, knead the dough until firm and elastic, then cover with a bowl and allow to rest for 10 minutes. You want the dough to be soft and springy.

On your floured surface, roll the dough to the thickness of a 50 pence piece and cut into circles with an 8cm scone cutter (or an upside-down pint glass).

Pop 1 teaspoon of your chosen filling into the middle of each circle, fold in half and seal by pinching the edges together with your fingers. Spoon your pierogi, a few at a time, into a big saucepan of simmering vegetable stock with 1 teaspoon of oil. Simmer for 5 minutes, stirring gently with a wooden spoon to stop any sticking, until the pierogi are cooked through. Once cooked, remove with a slotted spoon.

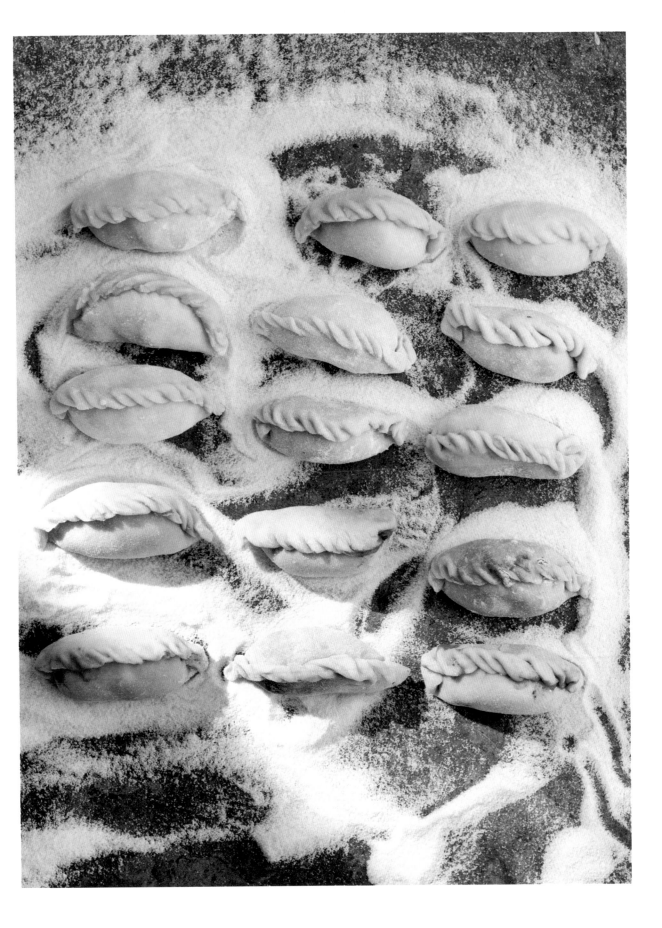

Beetroot & Horseradish Pierogi with Sour Cream, Brown Butter, Paprika & Braised Sour Red Cabbage

This is my favourite way to make pierogi. The beetroot and horseradish go together perfectly and the red cabbage is a naturally happy little accompaniment.

SERVES 8 AS A STARTER; MAKES 24 PIEROGI

Preparation time 15 minutes, plus 20 minutes for dough
Cooking time 1 hour 15 minutes

For the filling
200g beetroot, scrubbed but with the skins left on
small pinch of allspice
small pinch of ground cloves
small pinch of cayenne pepper
sprinkling of sea salt
1 tbsp horseradish, finely grated (or from a jar if you can't find fresh)
sea salt and freshly ground black pepper

For the dumplings
1 portion pierogi dough (see page 200)
2 litres vegetable stock
1 tsp sunflower oil

To serve
oil, for frying
30g butter
squeeze of lemon juice
Braised Sour Red Cabbage (see page 87), warm or cold
1 tbsp sour cream
pinch of paprika

First make the filling. Preheat the oven to 180°C/160°C fan/gas mark 4. Wrap the beetroot in foil and bake for 1 hour, or until soft. Leave to cool, then peel and pop the beetroot and spices into a blender, pulsing gently so they retain a bit of texture. Add the spices and season as required, stir in the horseradish and leave to one side.

On a floured surface, roll out the pierogi dough to the thickness of a 50 pence piece and cut into circles with an 8cm scone cutter (or an upside-down pint glass).

Pop 1 teaspoon of the filling into the centre of each circle, fold the circles in half and seal them by pinching the edges together with your fingers. Heat the vegetable stock in a large saucepan until it is simmering, add the oil, then spoon in a few pierogi at a time. Simmer each batch for 5 minutes, stirring gently with a wooden spoon to stop them sticking, until the pierogi are cooked through. Once cooked, remove with a slotted spoon and set aside on an oiled plate.

Heat a splash of oil in a frying pan and when it's really hot add the butter. Let it foam and start to brown and go nutty and then add the pierogi. Fry them until they are golden and a little crisp, then remove with a slotted spoon. Squeeze the lemon juice into the frying pan and whisk to make a little sauce – there won't be much.

Serve each person 3 pierogis accompanied by a generous scoop of braised red cabbage, a blob of sour cream, a slick of the nutty butter and a sprinkling of paprika.

Potato & Cheese Pierogi

Swap the beetroot and spices for 200g mashed baked potato and 80g grated mixed cheese. I like mozzarella, Cheddar and Parmesan. I also love lots of nutmeg in there.

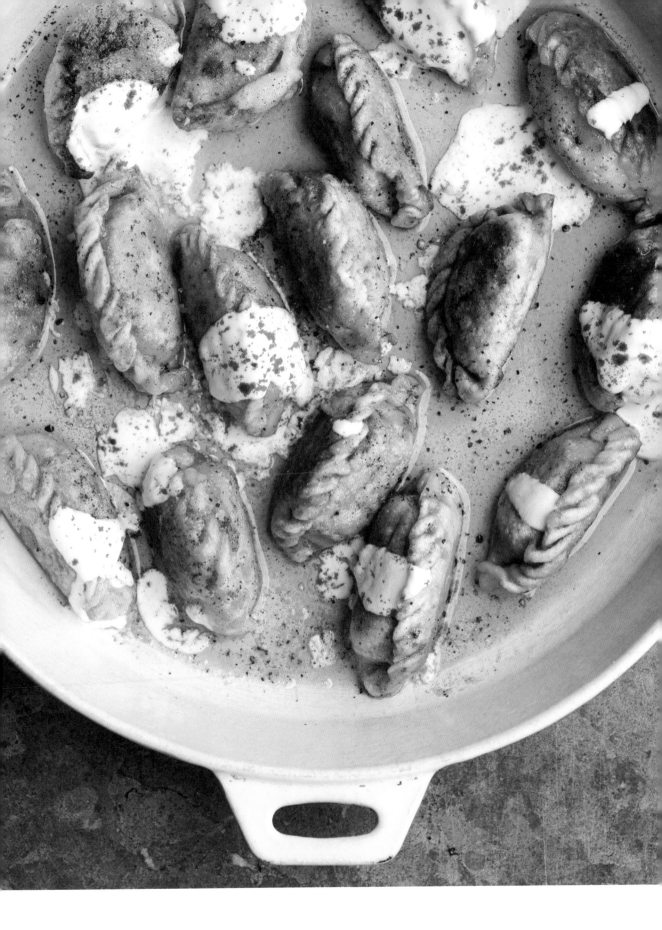

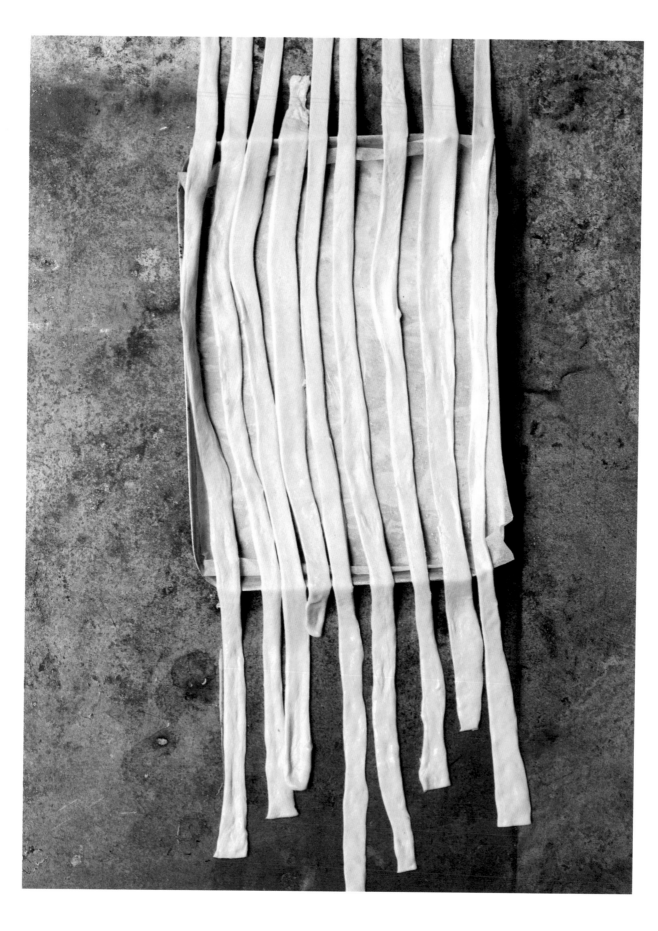

Sichuan Hand Pulled Noodles

Don't worry about evenness or straight edges because they don't matter. You don't have to try too hard here; the noodle stretches out naturally and gravity will pretty much do the job for you!

Set up a tabletop mixer with a dough hook. Put the flour, salt and water in the mixer bowl and start mixing on low, then gradually increase the speed to high, kneading for 5–6 minutes altogether. The dough will feel rough and a bit dry to begin with, but as the flour absorbs water and the gluten starts to develop it will become extremely smooth and elastic. It is ready when you can pull out a 30–40cm length without it breaking. Cover the bowl with cling film and let rest for at least 30 minutes and up to 1 hour.

Before starting to make the noodles, oil and line a large baking sheet or chopping board with baking parchment or cling film and set aside. Put a small bowl of oil for greasing your hands to the side. Oil your hands well, then transfer the dough to an oiled surface. Roll out into a 1cm thick rectangular shape, and then cut into 10 long strips. Separate and lightly oil the strips so they don't stick to each other.

Take 1 strip and lay it flat on the counter, then pound the strip outwards with an oiled palm into a long, wide and flat noodle. Pick up both ends of the noodle, lift it and gently tap it on the counter while stretching it out slightly. This is pretty easy as the gluten in the dough is so stretchy. Lay the noodle flat without folding it on the parchment-lined baking sheet. It should be as thick as a good papardelle noodle and if you can see through it, you've pounded it too thin. Repeat with the rest of the strips, and lay a second piece of baking parchment over the top of the first if you run out of space.

When you're ready to cook the noodles, bring a large saucepan of salted water to the boil. Drop the noodles in one by one. They are ready when they float to the surface, which should only take a minute or two.

SERVES 4

Preparation time 40 minutes, plus
 1 hour resting time
Cooking time 2 minutes

440g strong white 00 pasta, Chinese
 dumpling or bread flour
½ tsp salt
280ml water
oil, for shaping

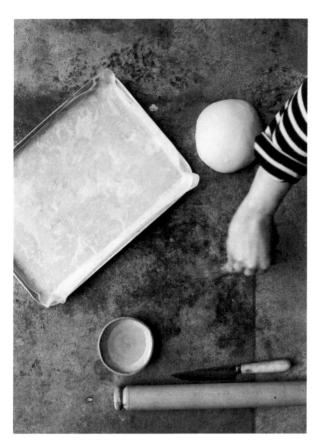
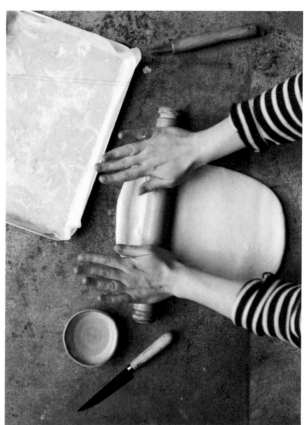
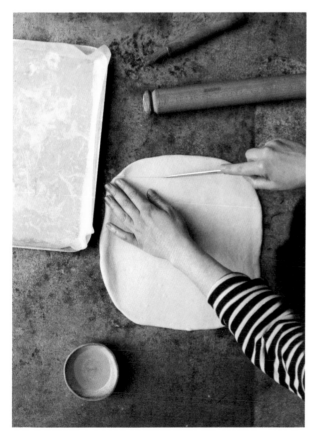
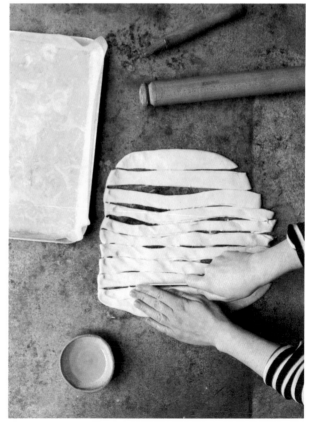

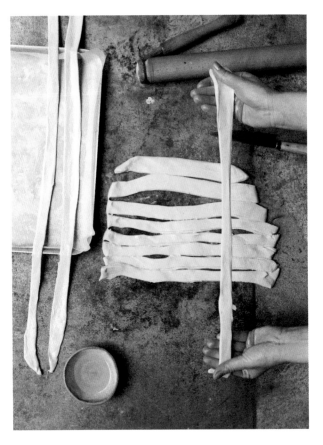
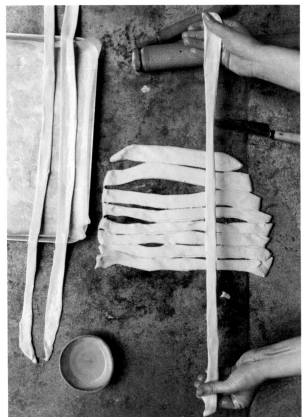
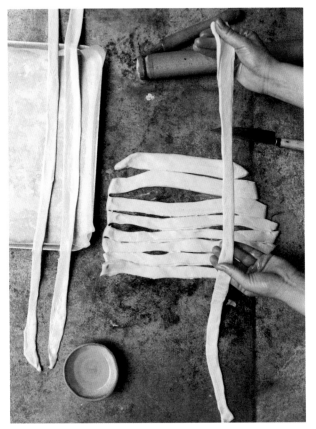
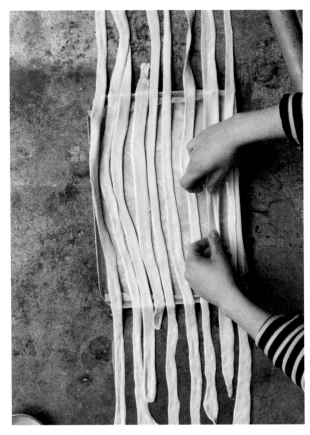

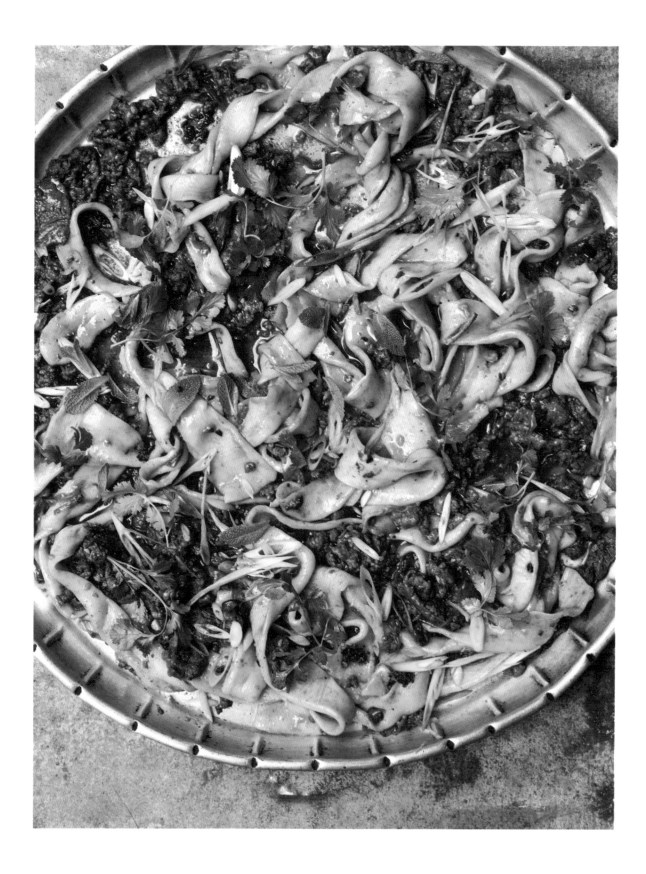

Xian Lamb & Cumin Hand Pulled Noodles

I was first made aware of this dish by social media. Suddenly everyone on my feed was waxing lyrical about these amazing lamb noodles, so naturally I had to find out where I could get my hands on them. My investigations led me to Xi'an Impression in Highbury, which specialises in street food from the Shaanxi province, and as soon as I opened the door, sure enough it was full of bloody chefs!

Shaanxi cuisine is similar to Xianjing cuisine, as they both come from the north-west of China, but Shaanxi is more meat dominated. Highly spiced, savoury flavours are the cornerstone of Shaanxi food. They make their own hand pulled noodles, both thinner, spaghetti-esque strands and the thicker, wider variety which resemble pappardelle (the ones we use here), sometimes referred to as belt noodles. The sauce clings perfectly to the large noodles, much as a ragu would.

This recipe is a wonderful illustration of quintessentially Shaanxi flavours. You get the warmth of the spices, the richness of the lamb, the umami from the soy and the fragrance of the herbs, followed by the powerful, almost mouth-numbing heat of the chilli – this is food to really ignite your senses. Also, please don't be alarmed at the inclusion of MSG (monosodium glutamate). I am not afraid to use it sparingly once in a while; it is authentic in this cuisine and it really does enhance the dish. If you're really not keen, feel free to omit.

We tested this recipe three times: with just lamb neck, just lamb mince and a combination of both. We decided that our favourite was a combination of both, as it delivered a more interesting texture, but it's up to you.

Cumin is one of the heroes of this dish, so begin by toasting the cumin seeds. Heat a dry frying pan over a high heat and add 2 tablespoons of cumin seeds. Toast for a few minutes, keeping the seeds moving so as not to burn them. They will begin to release their aroma and darken slightly in colour, which is a sign they are ready. Transfer to either a pestle and mortar or a spice grinder and grind into a fine powder. You use this in both the marinade and stir fry paste.

CONTINUED »»

SERVES 4

Preparation time 40 minutes, plus
 2 hours marinating
Cooking time 20 minutes

300g lamb neck, very thinly sliced,
 plus 300g lamb mince, or 600g of
 either
1 portion Hand Pulled Noodles (see
 page 205)
rapeseed oil, for frying
1 medium red onion, sliced
4 spring onions, thinly sliced into
 matchsticks
large handful of coriander, leaves
 picked
small handful of mint, leaves picked
1 tbsp toasted peanuts
Sichuan chilli oil

For the marinade
2 tsp coarsely ground cumin seeds
1 tbsp light soy sauce
2 tsp cornflour
1 tsp dark soy sauce (the Chinese
 variety has a deeper flavour and
 adds colour)
1 tsp ground coriander
½ tsp chilli flakes
1 tsp toasted sesame oil
¼ tsp garlic powder
¼ tsp ground white pepper
⅛ tsp ground Sichuan peppercorns

There are quite a lot of ingredients, so I recommend being methodical and organising yourself from the outset. In separate bowls, mix together the ingredients for the marinade, the stir fry paste and finally the stir fry sauce so you have everything to hand when cooking. Although this recipe requires quite a lot of prep, as with most Chinese cuisine, the cooking barely takes any time at all.

Mix the lamb with the marinade ingredients, using your hands to massage the flavours into the meat. Allow to marinate for at least 2 hours in the fridge.

Bring a large saucepan of salted water to the boil to cook the noodles. Once the water has come to a rolling boil, add the noodles one by one. You'll know they're cooked when they float to the top, which should only take a couple of minutes. Drain them and refresh them in a bowl of iced water. It's best to do this before you start frying everything else as you need to move fast once you get going.

For the stir fry paste

4 tbsp vegetable, groundnut or rapeseed oil
4 garlic cloves, very finely chopped
2 tsp grated ginger
1 large Asian red chilli (not spicy), diced
1½ tbsp coarsely ground cumin seeds
1 tsp ground coriander
1 tsp ground black pepper
½ tsp ground white pepper
good pinch of ground Sichuan peppercorns

For the stir fry sauce

4 tbsp soy sauce
2 tbsp rice wine or sake
2 tbsp rice wine vinegar
½ tsp white sugar
½ tsp MSG (optional)
¼ tsp salt

Heat a large frying pan or wok over a high heat. Add 2 tablespoons of oil to the marinated lamb to lubricate it, then put in the hot pan and spread out evenly. Allow to caramelise for 30 seconds without moving, then fry for a couple of minutes until no longer pink. Add the red onion and fry for a few minutes until it start to soften. Remove the lamb and the onion with a slotted spoon and set aside on a plate.

Next heat 3–4 tablespoons of oil in the same pan over a high heat and add the stir-fry paste. Move it around the pan for a few minutes so it starts releasing fragrant aromas, but be careful not to let it burn. Return the lamb and onion to the pan and move them around for a minute or two.

Now pour in the stir fry sauce and cook for 5 minutes until the meat is cooked through and tender. Follow with the noodles and spring onions. Keep stirring to make sure everything is well coated and combined. Finally, mix through the herbs, peanuts and a teaspoon of the chilli oil. I am a big chilli fan but I recommend a bit of caution with chilli oil: I think it may be best to allow everyone to spice their noodles themselves to avoid blowing their heads off! Serve immediately.

Making Pastry

Pastry can be a real test of confidence for even the most seasoned cook. There are a couple of pitfalls that can undo you and leave you with pastry that's either dry and crumbly and a nightmare to work with, or too wet, which leads to chewy tough pastry when cooked. What we are aiming for here is a really light, crisp and buttery texture. For me the breakthrough came when I swapped the standard ice-cold water for whisked egg yolk, which helps to ensure the right level of snap when cut, while also making the pastry easier to roll. The trick is to be vigilant when adding the egg – do it little by little as you may find you don't need to add all the egg. Stop adding liquid just as you see the pastry start coming together. If you follow these steps you should never have to worry about failed pastry again! This recipe can also be used as a perfect foundation for sweet, herb or cheese shortcrust, the additional ingredients for which I've listed below.

Here are a few tips to guide you before you start.

• The most successful pastry is achieved in a cool environment, which means cool surfaces, utensils and hands. Chilling the mixing bowl and knife in the fridge before starting can help with this.

• Use a food processor; it makes light and speedy work of pastry and means you can avoid warm hands.

• Measure out all your ingredients carefully before you start. Pastry making is an exact science and it's important to work quickly, so being prepared is key.

• Butter is a key ingredient in pastry so the better quality your butter, the tastier your pastry will be.

• If a hole or two appears when lining your tart case, don't panic! Just patch it with a little leftover pastry; no one need ever know!

• Always preheat the oven before baking, to prevent the butter melting before cooking and making the pastry greasy. Cold pastry should go straight into a hot oven, otherwise it will be soggy.

Lining a Tart Case and Baking Blind

Preheat the oven to 180°C/160°C fan/gas mark 4. Remove the pastry from the fridge and leave to sit for a minute or two. Roll out on a well floured surface and to about the thickness of a 50 pence piece. Keep turning the pastry as you roll to ensure you get an even circle. Fold one end of the pastry over the rolling pin and quickly transfer it to a 22cm tart tin. You don't need to line the base of the tin with baking parchment as it's unlikely to stick because of all the butter in it, but you're welcome to do this if you want to take extra precautions.

Gently ease the pastry into the corners of the tin and leave any excess pastry hanging over the edge. I leave the excess pastry folded over the edge of the tin and bake it like this, as trimming off the edges once the tart has cooked gives a neater finish. Leave for 30 minutes in the fridge, as resting helps to prevent the pastry shrinking during baking.

To bake blind, line the raw pastry case with a sheet of baking parchment. I find it helps to scrunch up the parchment into a ball first, to make it more malleable. Fill with either ceramic baking beans or dried pulses. Bake in the oven for 25 minutes until the pastry has cooked through but is only just beginning to colour. Remove the baking parchment and baking beans, return to the oven and cook for a further 5 minutes to crisp up a little and guarantee a good snap.

Leave the tart case to cool for 20 minutes on a wire rack, after which time use a sharp knive to make a neat edge against the rim of the tart case. Do this very carefully to prevent the pastry crumbling or breaking, using the edge of the tin as a guide. Now you're ready to fill the tart case with the filling of your choice.

Shortcrust Pastry

Put the flour and salt in a food processor and whizz for a couple of seconds to remove any lumps. Add the butter and blitz for about 20 seconds until the mixture resembles breadcrumbs.

Turn out into a fridge-cold bowl. This helps prevent the butter melting, a key principle in making good pastry. With a cold knife, mix in the egg, little by little, working quickly. Stop as soon as the mixture binds together.

With your hands, bind the pastry into a ball. Do not knead as this will make the pastry tough. Another key element to pastry making is to handle it as little as possible. Put some cling film on a flat surface, put the pastry on top and flatten it out a little with a rolling pin, as this makes it easier to roll out later. Wrap it up in the cling film and leave to chill in the fridge for at least 30 minutes, or until needed.

• For sweet pastry add 1 tablespoon of icing sugar to the flour.

• For herb pastry add 1 tablespoon of puréed fresh herbs with the egg at the breadcrumb stage.

• For cheese pastry add 30g grated Parmesan and a pinch of cayenne pepper to the flour at the beginning.

MAKES ENOUGH TO LINE A 22CM TART TIN

Preparation time 10 minutes, plus
 30 minutes resting time

225g plain flour
pinch of salt
120g ice-cold butter
1 free-range egg, whisked

Leek, Bacon & Cheese Quiche

The much-maligned quiche is definitely due for a comeback. In recent years, it has been pushed aside in favour of its allegedly more elegant relative, the tart, although as far as I can tell the only difference between a tart and a quiche is that a tart can be both sweet and savoury whereas a quiche is always the latter. Perhaps people are put off by memories of heavy, stodgy pastry with tasteless eggy filling, but when made well, a quiche can be really refined, and requires just as much finesse as tart making.

This is like a classic Quiche Lorraine, with the happy addition of leeks. They bring an extra level of sweetness to the dish, work brilliantly with the cheese and bacon, and cut through what could otherwise be quite a dense filling. The end result is really short, light pastry and a beautiful rich, creamy filling – but be careful not to overbake; you want the filling to have a slight wobble as you take it out of the oven. If you want to make a meat-free version, this recipe would work just as well if you swapped the bacon for peas, asparagus or other summer vegetables. Pair it with a crisp green salad and this makes a dream lunch.

MAKES 6–8 SLICES FOR A MAIN COURSE

Preparation time 45 minutes
Cooking time 1 hour 20 minutes

1 portion Shortcrust Pastry (see page 215) made with Parmesan and a pinch of cayenne pepper
1 tbsp unsalted butter
1 large onion, finely chopped
1 leek, finely shredded – do use the green parts
2 sprigs of thyme, leaves picked
200g smoked streaky bacon, chopped into small lardons
3 free-range eggs, whisked
300ml double cream
generous grating of nutmeg
30g Parmesan, finely grated
30g Cheddar, finely grated
30g Gruyère, finely grated
30g extra mixed cheese to sprinkle over the top before cooking
sea salt and white pepper

First make the pastry following my recipe with the additions specified, blind bake it, allow it to cool and trim the excess pastry into a neat edge (see page 213).

Now prepare the filling. Heat the butter in a pan over a medium-low heat and gently sweat the onion for 20 minutes, at which point add the leek and thyme leaves.

Meanwhile, fry the bacon for 10 minutes in another pan over a medium heat until it is nice and golden. Once cooked, mix with the onions and leeks and set aside.

Preheat the oven to 180°C/160°C fan/gas mark 4 and whisk together the eggs and cream in a measuring jug. Sprinkle over a generous grating of nutmeg and then season with salt and pepper before adding the cheeses.

Place the tart case on a baking tray and put the the bacon, onion and leeks in the bottom, making an even layer. Pour over the liquid using a circular motion to avoid bubbles. The mixture will come quite high up the tart case. Sprinkle the extra cheese over the top. Place the quiche carefully on the bottom shelf of the oven. Bake for 20–25 minutes until the top begins to turn golden. You want it to still have a little wobble, but it should not be runny. Remove from the oven and leave to stand for 5–10 minutes before serving.

Lemon Surprise Tart

This is my Mum's recipe via Robert Carrier. It's similar to a lemon surprise pudding but in a tart case. It's quite a weird one to make, in that it's surprisingly wet and it seems a little difficult to mix the egg whites in, but just fold it in and all will be fine, I promise. Always serve this warm and with pouring cream – nothing fancy required.

Preheat the oven to 190°C/170°C fan/gas mark 5. To make the pastry, place the flour in a food processor with the salt and sugar and whizz for a few seconds, which avoids having to sift the flour. Add the butter and whizz again for about 20 seconds, or until the mixture resembles breadcrumbs. Next, gradually add the egg and water mixture and mix until the pastry starts to form large clumps.

Turn this out on to a board and bind the pastry into a ball, handling it as little as possible. Roll it out and line a 24 x 2.25cm tart case with the pastry and leave to it rest in the fridge for a good 30 minutes.

Once it's rested, line the raw pastry case with baking parchment (you can get it into the corners more easily if you crumple the parchment first). Fill with either ceramic baking beans or dried pulses. Blind bake in the oven for 25 minutes, or until the pastry is cooked through but has only a little colour. Remove the beans and parchment lining and bake for another 5 minutes to guarantee a good snap when the pastry is cut. Remove from the oven and make the filling.

Turn the oven down to 180°C/160°C fan/gas mark 4. Cream together the butter, sugar and egg yolks until light and fluffy. Mix in the flour and salt, followed by the milk, lemon zest and juice. In a separate bowl whisk the egg whites until stiff. Fold them into the lemon mixture with a large metal spoon. Pour this combined mixture into the blind-baked pastry case and bake for approximately 45 minutes.

SERVES 6–8

Preparation time 30 minutes
Cooking time 1 hour 20 minutes

For the pastry
225g plain flour
pinch of salt
1 tbsp caster sugar
140g unsalted butter, very cold and
 cut into 1cm cubes
1 large free-range egg mixed with 1
 tbsp iced water.

For the filling
50g butter
170g sugar
3 free-range eggs, separated
35g plain flour
pinch of salt
280ml whole milk
grated zest of 2 lemons
juice of 3 lemons

Puff Pastry

There's no beating about the bush – making puff pastry is a painstaking task. When I was taught how to make it at catering school I was told that it took a whole day to make. It's an intensive process because the pastry dough has to be rested and at a similar temperature to the butter you're rolling into it to create the layers of gluten in the détrompe (pastry dough). The point is to make lots and lots of layers of butter that run perfectly between the layers of the détrompe. You have to fold and roll the pastry six times to create the right number of layers and, as the détrompe and the butter are rolled thinner and thinner, you have to be very careful not to let the butter peek through. This probably sounds like a right royal pain in the arse, especially when you can buy good puff pastry, but here's hoping that at least a few of you are interested in giving it a go. It's really fun and it gives you a great sense of achievement.

Personally I think the best way to make this is with a food processor; it also eradicates the necessity to sift the flour. Put the flour and salt into a food processor along with the butter or lard and whizz for about 15 seconds until the mixture forms a breadcrumb texture. Next add tablespoons of iced water one at a time – between 6 and 8 tablespoons in total – to bring the flour together.

Use your fingers to pull out clumps of moistened flour and form them into a ball, kneading as little as possible to create a soft, smooth dough. It's really important not to overwork the dough, as it will form too much gluten so the pastry will become tough. Flatten out the pastry a little and wrap it in cling film. Leave it to rest for about 30 minutes to allow the gluten to relax.

Meanwhile, lay a sheet of baking parchment on a flat surface and place the block of butter on top, followed by another layer of parchment. With a rolling pin, bash the butter to flatten it and then roll it out into one thin sheet about 5mm thick. Make sure that the butter is not so cold that it breaks, but also not so warm that it becomes oily. You want it to be the same texture as the détrompe.

Flour the flat surface and roll the pastry into a rectangle double the size of the butter. Pull the parchment off the butter and lay the butter on one half of the pastry, allowing a 1cm margin of pastry around the edge. Remove the other sheet of parchment, fold the edges around the butter, then fold the other half of the pastry over the top to encase the butter.

MAKES 550G

Preparation time 3-4 hours, including resting

225g plain flour
3 pinches of fine salt
30g butter or lard
6–8 tbsp ice-cold water
200g unsalted butter, removed from the fridge for about an hour, or until pliable

Roll out the pastry out with 2 rolls of the rolling pin. Fold the top third of the pastry down and the top third up to make a parcel, like a business letter. This is what we in the trade call 1 roll and fold! Repeat this once more before rewrapping the pastry in cling film and allowing it to rest in the fridge for 10–15 minutes.

Be careful to prevent the butter breaking through the pastry. If this happens it means that it has become too soft, so wrap up the pastry immediately and allow it to cool in the fridge until the butter firms up a little.

At this stage, unwrap the pastry, flip it over and rotate it by 90 degrees. Repeat the roll and fold process a further 4 times to make 6 times in total. If streaks of butter show through the pastry you can give it 1 further roll and fold, but no more or you will make the layers too thin.

Once you have completed the rolls and folds, wrap the pastry up again in cling film and allow to rest in the fridge for another 30 minutes.

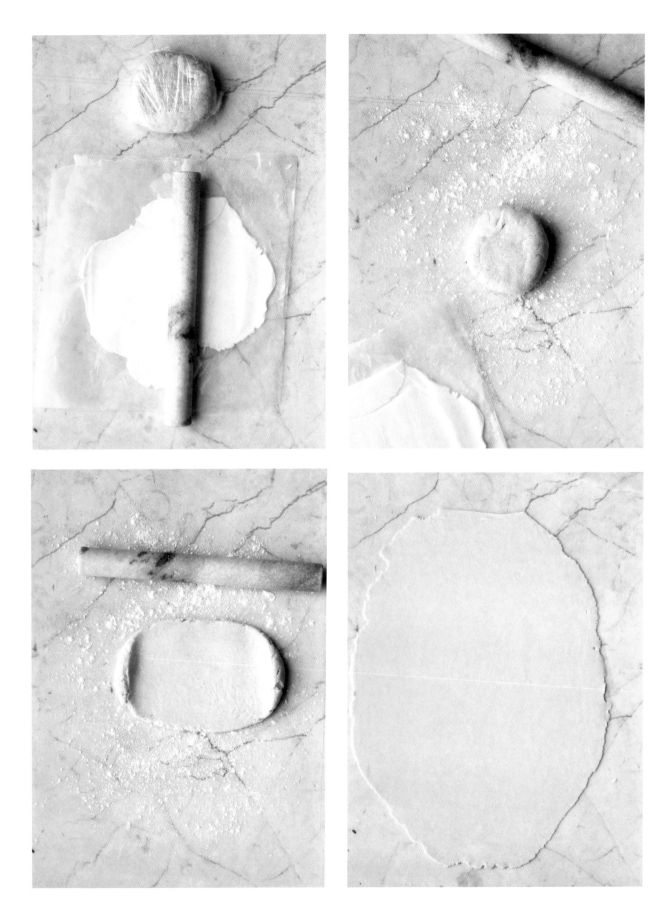

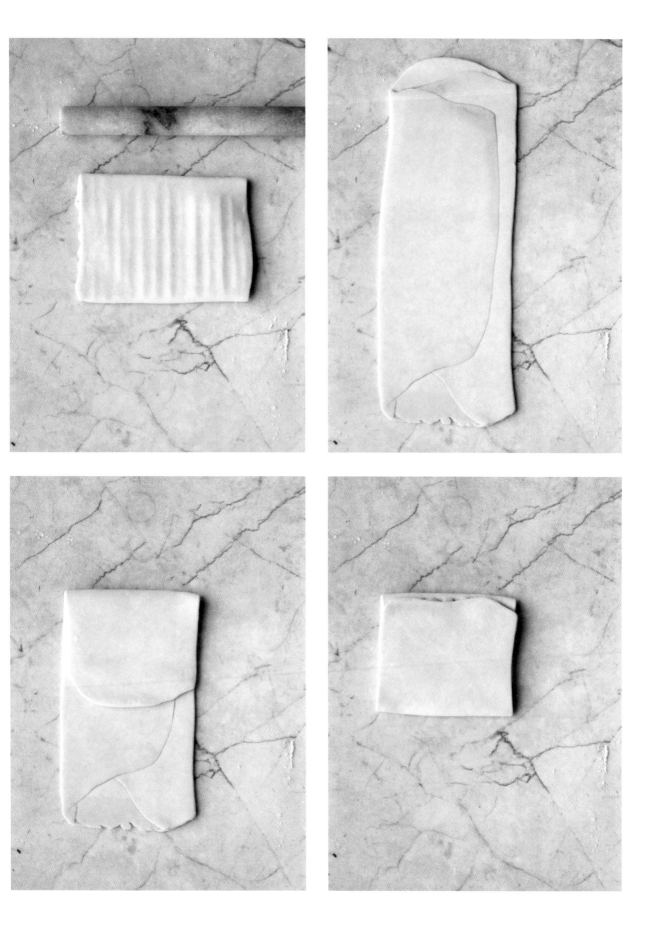

Rosemary Salted Caramel & Apricot Tarte Tatin

The truth is, I've always been a bit rubbish at making tarte tatin. Cooking the caramel to the right point, the fruit to the right firmness and then making sure the pastry is baked all the way through without all the fruit juices going everywhere is tough. You've got to work fast and trust your judgement. Making a dry caramel in a pan and using soft stone fruits really helped me, and also working fast with the pastry, tucking the edges into the pan with the back of a spoon handle and cooking at a high heat. If you've also had a bit of a dodgy time making tarte tatin, try it this way and it should work out better. I serve it with vanilla ice cream.

SERVES 6

Preparation time 20 minutes
Cooking time 20 minutes

120g caster sugar
1 sprig of rosemary
¼ tsp salt
30g unsalted butter, roughly chopped
10 apricots, halved and pitted
1 portion Puff Pastry (see page 222)
 or 1 x 375g sheet of ready-made
 all-butter puff pastry

Preheat the oven to 240°C/220°C fan/gas mark 9. Heat the sugar for a few minutes in a 24cm diameter frying pan until it starts to caramelise. Swirl the pan occasionally, but do not stir as this will make the sugar crystallise. Add the rosemary and salt, give the pan another swirl and add the butter. Neatly place the apricots skin side down in the caramel and take off the heat.

On a floured surface, roll out the pastry to the thickness of a £1 coin and use a large dinner plate as a template to cut a perfect circle. Make sure the pastry circle is a little larger than the frying pan, and place it on top of the apricots. Tuck in the edges of the pastry carefully and quickly (I use the end of the spoon). Make a couple of little incisions in the pastry to let the air escape, and then put straight in the oven.

Bake the tart for 15–20 minutes until it is puffed up and golden. Turn out on to a plate, but be very careful as the caramel will be dangerously hot. Cut into slices and serve with lashings of double cream or vanilla ice cream.

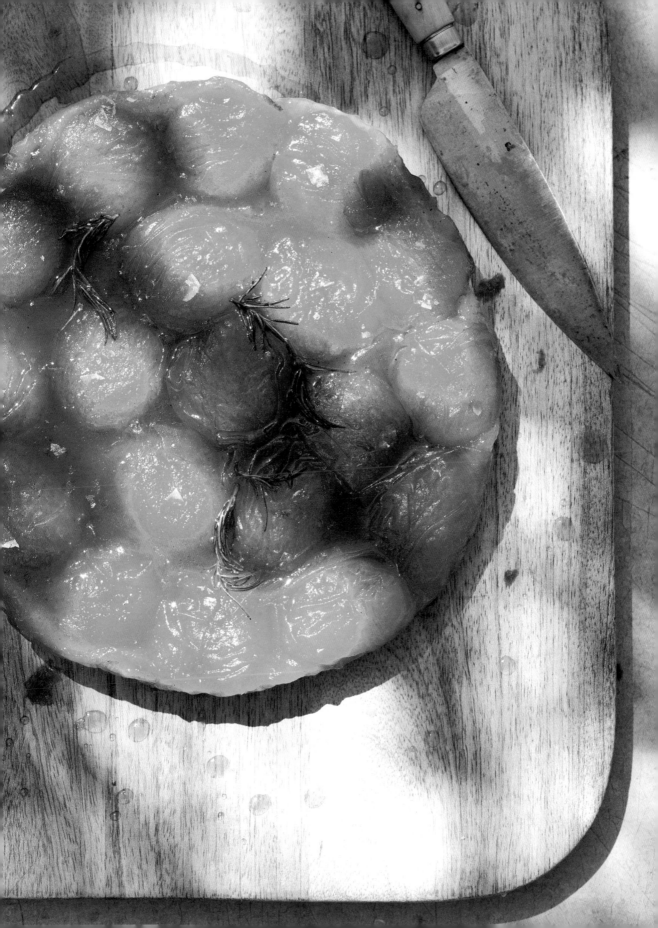

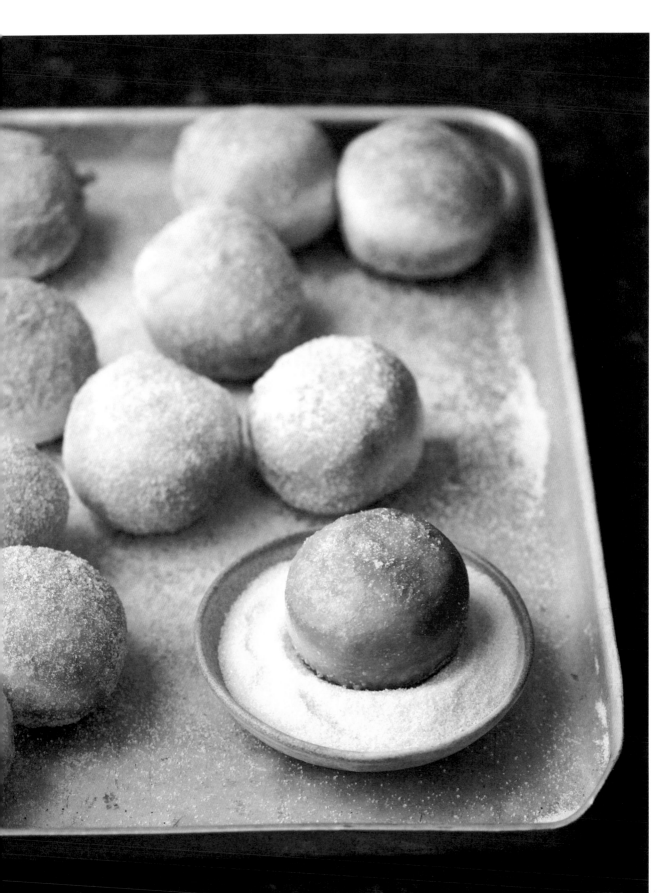

Rhubarb & Custard Doughnuts

The doughnut has been elevated to great heights in recent years and a number of brilliant companies have popped up offering a wide variety of fillings, such as salted caramel, hazelnut praline and banana cream, to name just a few – so I thought it was high time I got involved!

These doughnuts really do need to be rested overnight, and then given a second rise to develop a truly rounded, yeasty flavour and to ensure a beautifully light and fluffy dough. This will give you an enriched dough almost like brioche; it's that good. Trust me, it's really worth investing the time.

Here I have suggested two of my favourite flavours to fill them. I can never decide between a custard or a fruit doughnut, so I guess I'll just have to have both! It's a bit tricky to fill the doughnuts with both fillings, but if you have any leftover filling you can dip your jam doughnut into the custard or vice versa to achieve that classic flavour combination.

First make your dough. You will need an electric mixer with a dough hook. Put all the dough ingredients apart from the eggs and the butter in the bowl of the mixer and give them a good whizz. With your mixer at a medium speed, add the eggs and allow them to become incorporated before pouring in the butter. Beat the mixture for about 8 minutes until it starts to come away from the sides of the bowl and form a ball. Cover the bowl in cling film and leave it in a warm place to prove.

As this is an enriched dough it will take longer to prove than a normal bread dough; it is more like a classic brioche dough. Be patient as you want it to double in size. This should take about 5–6 hours.

At this stage knock back the dough and give it a bit of a knead to squeeze out any extra air. Put the dough back in the bowl, cover with cling film and leave to chill in the fridge overnight.

The next day, take the dough out of the fridge and cut it into 50g pieces. (You can freeze the pieces at this stage as long you keep them separate and in airtight containers and you can keep them in the freezer for up to 6 months.) Roll the pieces

CONTINUED »»

MAKES 20 DOUGHNUTS

Preparation time 25 minutes,
 plus proving time (5 hours, then
 overnight, plus a further 4 hours)
Cooking time 8 minutes

For the dough
650g strong white flour
60g caster sugar
15g dried yeast
1 tbsp fine salt
150g water
4 free-range eggs, whisked
125g melted butter

For the crème patissière
250ml whole milk
1 vanilla pod
10g plain flour
10g cornflour
50g caster sugar
4 free-range egg yolks
200ml double cream

To cook and serve
2 litres sunflower or rapeseed oil
caster sugar, for tossing
400g Rhubarb & Blood Orange Jam
 (see page 248)

into smooth, taut, round buns and place them on a baking tray lined with baking parchment, leaving space between them as they will grow in size and you don't want them to stick together. Cover in cling film and allow to prove in a warm place for about 3–4 hours until they have doubled in size. (When cooking the doughnuts from frozen leave them to prove for 6 hours at this stage.)

To make the crème patissière, pour the milk into a saucepan. Scrape the seeds out of the vanilla pod and add them to the milk. Heat the milk over a medium flame, but don't let it boil. Meanwhile mix together the flours and sugar in a large bowl and whisk in the egg yolks to form a smooth paste. Once the milk is warm, slowly pour it into the egg mixture, whisking as you go. You will find that it quickly thickens. Once all the milk is incorporated you may want to pass it through a sieve to ensure that you have a really smooth, silky crème. Leave to cool completely. In a separate bowl, whisk the double cream until it is relatively stiff but not overwhipped. Mix this thoroughly into the cooled vanilla custard, until they are well combined.

Once the dough has risen for the second time you are ready to fry the doughnuts! Pour the oil into a heavy-based saucepan to just under halfway up the sides. Heat the oil to 170˚C, checking the temperature with a high-quality cooking thermometer. Use a spatula to carefully remove the doughnuts from the baking tray, making sure you keep their nice round shape and that you don't deflate them. Lower 4 or 5 at a time into the oil. Fry for about 4 minutes on each side until they puff up and bob on the surface of the oil. Turn them over carefully with a metal spoon; you are aiming for a lovely even golden colour all over. These doughnuts benefit from being fried more slowly than you might expect.

Lay some kitchen paper on a baking tray and transfer the cooked doughnuts on to it to absorb any excess oil and to cool a little. Pour some caster sugar on to a plate and roll the doughnuts so they are covered in sugar. It's best to do this when they are still warm as the sugar sticks to the doughnut better then.

Now you are ready to fill your doughnuts. I like to fill half with crème patissière, and half with rhubarb jam. Fill two nozzled piping bags with the crème patissière and rhubarb jam respectively. Use a sharp knife to make an incision into the centre of the doughnut, being careful not to pierce it all the way through. Insert the nozzle deep into the doughnut and firmly squeeze the bag to ensure that you inject a healthy amount of filling. There's nothing worse than a meanly filled doughnut!

BASICS

Slow Cooked Scrambled Eggs

Writing a recipe for scrambled eggs may seem a bit pointless as it's probably the one dish we are all taught before leaving home but I'm pretty opinionated about how we should eat them, so this is it.

My assistant Rose and I agree on everything, but she likes her eggs firmly scrambled, whereas I like mine very, very loose – and by that I mean eggs so gently cooked in butter and milk that they are immersed in a silky, almost thickened sauce. The French term for this perfect scramble is *baveuse*, which translates as 'baby dribble', and might explain why some people can't stand them! However I can't emphasise enough that, even if the idea doesn't appeal, the more you cook the eggs the more they taste of sulphur so when you overscramble your eggs, it results in a much eggier tasting scramble.

I've recently noticed a trend for eggs so heavily scrambled they can be moulded into the shape of a rose. That is not scrambled eggs, it's a flower-shaped omelette.

If you are someone who thinks I'm insane for liking my scrambled eggs loose like this then you have a lot of great chefs to answer to. Ask Escoffier how he liked his eggs and I can assure that you that he liked his the way I like mine. You can't argue with Escoffier. If you've been put off trying them like this then please give them a go – just this once, humour me. I promise you, just like the first time you realised that a medium rare steak tasted better than an overcooked one, you will thank me.

SERVES 2–3

Preparation time 1 minute
Cooking time 10 minutes

1 rounded tbsp butter
6 large free-range eggs at room
 temperature, beaten
splash of whole milk or cream
 (impossible to measure but about
 1 tbsp)
very generous pinch of salt

In a small saucepan heat the butter over a low heat. Meanwhile, whisk the eggs, milk or cream and salt together. When the butter starts to foam gently pour your eggs into the pan. Using a wooden spoon, gently scrape the base of the pan while stirring to effortlessly lift the setting eggs away from the base of the pan. This process takes time and the more you stir the more you will notice that the eggs start to thicken and create an emulsified sauce around the flakes of set egg. Keep scrambling until they are cooked to your liking. For me, that's when you can draw the spoon through the scramble and it stays parted, but the eggs are still very loose.

I serve my scrambled eggs in numerous ways, but the best is either on hot buttery, Marmitey sourdough toast or – as the ultimate indulgence – covered in very thinly sliced white truffles.

Stock Making & Broths

A true cook understands the importance of really good stock. Stock is the base of so many dishes and many of them, particularly slow cooked food, would be much less delicious without it. Recently, the health benefits of making your own stocks have become clearer. I have no time for sodium-dense and lacklustre stock cubes and you shouldn't either. What real stock brings to a dish is a meaty body that makes up the skeleton of everything from stews to soups to gravies. But that's not all; it also supplies gelatine – tooth-sucking, lip-smacking gelatine. And that represents the main difference between the quality of home cooking and that of restaurants.

I'm pretty militant about stocks. I don't care whether you call them bone broth, and I don't stress the importance of clarity, which was key to the old-school way of making stock. And, while I'm not generally a fan of 'boiling your bones' – I always err on the side of the long simmer – sometimes robust cooking really extracts the marrow from the bones. I also think that there is a lot of scaremongering about overcooking stock, although there does come a point at which you've extracted as much flavour as you're going to get, after which they become acrid. What I do care about is flavour – deep, meaty flavour. And the best way of getting this is through the long, slow cooking of good-quality bones that still have some meat on them and are filled with marrow. I also prefer the flavour of a stock which has been left to cool overnight with the bones, before being brought back to the boil and then strained.

You don't need vegetables and herbs, although they add sweetness, aroma and a different flavour balance. They're not vital though, so feel free to leave out any you don't have to hand or are allergic to. Stock freezes well, but you can also store it tightly sealed in the fridge for about ten days. I would never use a stock cube or one of those gel tubs (which are gel because of thickening agents, not gelatine), but if your freezer and fridge are bare you can buy fresh stock in the meat chiller section at supermarkets. My favourite is made by a company called TrueFoods.

CONTINUED »»

White Chicken Stock

Place all the ingredients in a large, deep cooking pot and cover with cold water. Slowly bring to the boil, skimming off the scum that rises to the surface with a large metal spoon, along with any fat. This helps to ensure a lovely clear stock. Turn the heat down and let it simmer gently for 3 hours. It's important to make sure that it doesn't boil at this stage, or the bubbles will knock away at the bone marrow and make the stock cloudy. While it's simmering, skim the scum from the top, especially for the first 30 minutes of the cooking time.

As the stock cooks it will begin to reduce. If the water level falls below the ingredients, add more cold water, which will also reveal any scum hiding at the bottom of the pan.

When the 3 hours are up, place a fine sieve over a large saucepan or bowl and pour the stock through it, collecting all the flavoursome liquid. Squeeze all the juice out of the veggies and through the sieve. If you taste the stock at this stage it may not have much flavour; you need to reduce the liquid to condense the flavour. Pour the stock into a clean saucepan, bring to the boil and slowly allow the liquid to reduce. Taste it every so often as it gently boils, and once you have the right intensity of chicken flavour you can stop. Do not season your stock as you may want to reduce it more when making gravies which will make it too salty.

Either use the stock straight away or let it cool, transfer to a container and keep it in the fridge. A good chicken stock will have a really chickeny essence to it and, once refrigerated, will turn to jelly.

This is the basic recipe for all stock making. Below are variants for Dark Chicken Stock, Beef or Veal Stock, Roast Meat Stock, Fish and Veggie Stock.

Dark Chicken Stock

For a richer stock that's great with gravies and meat stews, roast the chicken carcasses or wings and vegetables in a very hot oven for 30 minutes, or until they have become golden and caramelised. Be careful not to burn them, or this will impart an acrid, charred flavour to your stock. Then follow the steps in the standard stock recipe above.

MAKES 1.5 LITRES

Preparation time 10 minutes
Cooking time 3 hours 15 minutes

3 chicken carcasses (freeze carcasses after roasts until you have enough or buy 3–4 raw carcasses from the butcher) or 2 kg chicken wings, jointed, or a mixture of both
2–3 onions, quartered
1 head of garlic, halved
2 carrots, chopped into 3 pieces each
2 leeks, chopped into 3 pieces each
2 celery sticks, cut into 3 pieces each
2 bay leaves
few parsley stalks
fresh thyme
8 black peppercorns

Beef or Veal Stock

This produces a dark stock. Swap the chicken carcasses for 2kg beef or veal shin bones and cook in the same way as the Dark Chicken Stock. It's really important to roast your bones to develop a deep, rich flavour. Cook the stock for longer than chicken stock – about 4 hours.

Roast Meat Stock

This recipe is ideal for using leftover roasting bones, especially the goat bones from the Slow Roast Goat Shoulder (see page 167).

Use the same procedure as when making the Beef Stock, but use 2kg leftover bones from the roast goat. The bones from the roast shoulder recipe will give you almost exactly 2kg. Remove all the excess fat, but leave any hard-to-remove meaty bits for extra flavour and cook in the same way as the Beef or Veal Stock. You can make this stock extra strong by adding any leftover gravy or meat from the roast.

Fish Stock

Swap the chicken carcasses for the carcasses of 3 large white fish, or 1kg fish bones, excluding the heads. Salmon or tuna don't make nice stock, so look for sea bass, halibut or haddock. Follow the recipe for White Chicken Stock, but only cook the carcasses for 20 minutes before straining. Don't cook it for too long or it will become muddy and rancid.

Veggie Stock

Leave out the chicken carcasses and double the quantity of vegetables in the White Chicken Stock recipe, adding 2 parsnips and some of the outer leaves of a cabbage. Cover with cold water and cook gently for 20 minutes. As with fish stock, vegetable stock is much more delicate than chicken or beef stock, and it will develop a school dinner-like stewed veg smell if cooked too long!

Gizzi's Slow Cooked Tomato Sauce

There is always one recipe that, no matter how hard you try to adapt it, will always end up being the same, because the quality of the ingredients and the way it's cooked are what make it gold. This is that recipe for me. I use it as a base for lots of things, but I also eat this with pasta a few times a week. I use fresh tomatoes when possible because when they're good there's no beating them. If you are not convinced by the quality of the tomatoes available, then use passata or jarred plum tomatoes – not tinned. You can also add a teaspoon of sugar to the tomatoes to balance the sweetness. I don't use onions in this sauce so it becomes multi-purpose; a lot of the dishes I use it with include onions anyway.

SERVES 6

Preparation time 15 minutes
Cooking time 1 hour 45 minutes

3 tbsp olive oil
1 head of garlic, cloves finely
 chopped
2kg tomatoes (a mixture of varieties
 – plum, vine and cherry)
2 tbsp sherry or red wine or white
 wine vinegar
large bunch of basil leaves
sea salt and freshly ground black
 pepper

Heat the olive oil in a heavy-based casserole over a medium heat and gently fry the garlic for about 10 minutes until lightly golden. This stage is important because if you cook the garlic too fast it will be scorched but still raw. Let the garlic heat up in the oil and watch it cook gently. You want to see it go from raw, to softened, to only just beginning to go golden.

Meanwhile blitz the tomatoes into a purée in a food processor and add to the garlic in the pan. Season well, add the vinegar and then cook the tomatoes very slowly for about 1 hour 30 minutes to reduce them so they have a really wonderful concentrated flavour. Once the cooking time is up, I like to blitz the sauce again to blend the tomato seeds and garlic into the sauce. Transfer back to the casserole, check the seasoning and then tear up the basil leaves and add them to the sauce.

Green Peppercorn Sauce

MAKES 500ML

Preparation time 5 minutes
Cooking time 25 minutes

240ml brandy
3 tbsp green peppercorns in brine,
 drained and chopped
480ml fresh jellied beef stock
240ml double cream
30g butter
small bunch of chopped parsley
salt
squeeze of lemon juice (optional)

Put the brandy and green peppercorns in a small saucepan and bring to the boil. Let it bubble for 5 minutes, or until the brandy has reduced by half. Add the beef stock and continue to simmer for 10–15 minutes, or until the sauce has reduced by half. It should be really intense in flavour. Whisk in the double cream and cook for a further 3 minutes before whisking in the butter. Add the chopped parsley and season to taste. You may want to add a spike of acidity with a squeeze of lemon juice.

Garlic and Herb Butter

MAKES ABOUT 100G

Preparation time 5 minutes
Chilling time 2 hours

100g unsalted butter, at room
 temperature
1–2 small garlic cloves, finely grated
50g chopped mixed herbs (I would
 use parsley, tarragon and thyme)
sea salt and freshly ground black
 pepper

Place the butter in a bowl and mash together with the rest of the ingredients. Put between two sheets of cling film or baking parchment and roll into a tight sausage shape. Store in the fridge for 2 hours before using.

BBQ Sauce

MAKES 500ML

Preparation time 5 minutes
Cooking time 10–15 minutes

150ml tomato ketchup
300ml chicken stock
120ml cider vinegar
4 tbsp soft brown sugar
2 tbsp hot sauce (Tabasco Chipotle
 has a wonderful smokiness which
 works brilliantly)
1 tsp ground cumin
1 tsp smoked paprika
½ tsp salt
freshly ground black pepper

Combine all of the ingredients together in a saucepan over a medium-low heat and let them bubble away for 10-15 minutes to thicken up a little. Taste for seasoning and allow to cool. Easy as pie!

Apple Sauce

Simply does it here. It's all about the Bramley apples, which are essential because you need the apples to break up and become a little puréed. I use lemon juice to stop the apples browning and a little cider vinegar for sharpness. This sauce is really for pork, duck or goose, but if you have any leftovers it is delicious hot with pouring cream.

SERVES 8 AS AN ACCOMPANIMENT TO A ROAST

Preparation time 10 minutes
Cooking time 15 minutes

550–600g (about 2) Bramley apples
3 tbsp sugar
1 tbsp cider vinegar
1 tsp lemon juice
1 tbsp butter

Peel, core and roughly chop the apples. Place them in a small saucepan with about 50ml water, the sugar, cider vinegar and lemon juice and ramp up the heat. When the mixture starts boiling, turn down the heat. There won't be much liquid in the pan and the idea is to cook the apples slowly enough for them to soften until they almost explode with fluffiness and turn into an ambrosial mulch of stewed apples. This will take about 10–15 minutes.

The best apple sauces have a puréed texture with some slightly more toothsome bits bobbing about. At this stage whisk in your butter. Serve at room temperature with roast pork – or anything porky – and fatty poultry.

Pickled Pears

The salty fattiness of ham cries out for something acidic to cut through it, making piccalilli the obvious choice for an accompaniment. This is something a little different. A classic recipe of my mum's, these pears work whether the ham is hot or cold. They are best made two weeks in advance to give the spices a chance to infuse the pears, and you can store them unopened anywhere cool for at least 2 months. Once opened, keep chilled and eat within 2 weeks.

Put all the ingredients except the pears, rosemary and bay leaves into a large, heavy-based saucepan over a low heat. When the sugar has dissolved turn up the heat and bring to the boil. Add the pears and simmer for 10 minutes. Add the rosemary sprigs and bay leaves and cook for a further 5 minutes.

Using a slotted spoon remove the pears, rosemary, bay leaves and spices and divide them between two sterilised jars. Return the liquid to the heat and boil for 5 minutes. Remove from the heat and pour evenly into the jars. Seal the jars and leave to cool before storing.

MAKES 2 X 1-LITRE JARS

Preparation time 15 minutes
Cooking time 20 minutes

350g granulated sugar
50g sea salt
400ml cider vinegar
4 strips of lemon rind
1 small cinnamon stick
1 tsp allspice berries
1 tsp black peppercorns
½ tsp cloves
2.75kg small seasonal British pears, peeled
 sprigs of rosemary
2 bay leaves

Parsley Sauce

SERVES 6

Preparation time 5 minutes
Cooking time 10 minutes

20g butter
20g plain flour
175ml whole milk
75ml gammon stock
handful of parsley, leaves chopped
50ml double cream
good grating of nutmeg
squeeze of lemon juice
sea salt and freshly ground black
 pepper

This is another classic I don't see enough of these days, and one I absolutely love. Despite involving cream, the vibrant freshness of the parsley and zingy acidity of the lemon prevent it tasting too heavy or rich.

Melt the butter in a small saucepan, then add the flour and stir well. Cook for 2–3 minutes. Gradually stir in the milk and the stock. Bring to the boil, lower the heat and simmer for 6–8 minutes, stirring every so often. The sauce should be fairly thick. Stir in the chopped parsley, cream, nutmeg and a squeeze of lemon juice and then season to taste.

Crispy Shallots

These are a running theme in pretty much all my books. When I cook Asian food I love using these crispy shallots as a garnish. You can buy them in huge bags at the Asian supermarket, but make sure you read the label as many are cooked in palm oil, which is the worst for the planet due to the deforestation of rainforests to make room for palm plantations. I cook these in batches and store them in airtight containers so I always have them around.

SERVES 8

Preparation time 10 minutes
Cooking time 15 minutes

4 tbsp rapeseed oil
4 banana shallots, thinly sliced into
 rings

Heat the oil in a frying pan over a low heat and fry the shallots for 10–15 minutes, or until they start to crisp up and turn a light golden colour. Scoop out the shallots and drain on some kitchen paper to absorb any excess oil.

Mayonnaise

Whisk the egg yolks together in a food processor with a pinch of salt and pepper, the mustard and vinegar.

Pour the two oils into a jug and very, very slowly add them to the egg yolk mixture, a teaspoon at a time, whisking as you go, until half the oil is used up. The mixture should be fairly thick at this point. Pour in the rest of the oil in a fine stream, continuing to whisk, until it is all combined. The mayonnaise should be thick and wobbly. Add a squeeze of lemon juice and season to taste.

Marie Rose Sauce

For the classic prawn cocktail sauce, add 2 tablespoons of tomato ketchup, 1½ tablespoons of tomato purée, ½ tablespoon of horseradish sauce, a few dashes of Tabasco or Sriracha, 1 teaspoon of brandy (optional), a few dashes of Worcestershire sauce and a squeeze of lemon juice.

Russian Dressing

For a really feisty Russian dressing make a portion of Marie Rose Sauce and add 2 tablespoons of finely chopped onion, 1 tablespoon of pickle juice and ¼ teaspoon of paprika.

Aioli

Mix 1–3 finely grated garlic cloves, depending on how garlicky you like it, into the prepared mayonnaise.

Tartare Sauce

Add 2 tablespoons of chopped gherkins, 2 tablespoons of chopped capers, 2 finely chopped shallots, 2 tablespoons of chopped fresh parsley, 2 teaspoons of chopped fresh dill, followed by a squeeze of lemon juice at the end for the only accompaniment to battered fish.

Rouille

Add 1–2 crushed garlic cloves, 1 puréed roasted red chilli and 1 puréed roasted red pepper at the end. Serve on French bread with a fish soup such as Bouillabaisse.

Coronation Sauce

Add 1 tablespoon of curry powder, 2 tablespoons of mango chutney and 2 tablespoons of natural yoghurt at the end.

MAKES 275ML
Preparation time 10 minutes

2 free-range egg yolks
1 tsp Dijon mustard
¼ tsp white wine vinegar
150ml olive oil
150ml vegetable oil
squeeze of lemon juice
sea salt and freshly ground
 black pepper

Salted Caramel Sauce

Put the sugar and water in a large saucepan and melt the sugar over a low heat, stirring gently. Turn up the heat and bring the sugar syrup to the boil. Do not stir as this will cause crystals to appear. The sugar syrup will slowly turn into caramel. It is ready when it has become a medium mahogany colour and the room smells of caramel.

Quickly but carefully pour in the double cream then beat it back to a smooth texture as the cold cream will make the caramel lumpy. Beat in the butter, vanilla and salt and when smooth and combined transfer to jam jars to cool. This will keep in the fridge for a couple of weeks.

MAKES 500ML
Preparation time 5 minutes
Cooking time 10 minutes

320g sugar
2 tsp water
250ml double cream
120g butter
seeds from 1 vanilla pod
½ tsp Maldon sea salt

Chocolate Sauce

Melt the chocolate with the milk and cream in a saucepan over a low heat until the sauce becomes thick and glossy.

MAKES ENOUGH FOR 1 CAKE OR PAVLOVA, OR 4 ICE CREAMS
Preparation time 2 minutes
Cooking time 5 minutes

100g plain chocolate, grated
100ml whole milk
2 tbsp double cream

Whipped Cream

Whip the cream in a bowl with the vanilla and icing sugar until it's thick enough to hold its shape but still soft. Be careful not to overwhip it!

MAKES 300ML
Preparation time 2 minutes

300ml double cream
1 tsp seedy vanilla extract
1 tsp icing sugar

Rhubarb & Blood Orange Jam

We live in a world where very few of us make our own jams, because a lot of the time there is no point. Fresh fruit is expensive and jam making originated as a way to use up a glut of fruit at the end of the season, as the addition of sugar preserves it. End of season fruits tended to be abundant and therefore cheaper, something we don't see so much these days, because so many fruits are imported and we can eat them all year round. This is a shame as it means we're now buying jam and making it is becoming a dying art. I tend to make jam out of my favourite rare fruits that we only get in season. This Rhubarb & Blood Orange Jam requires no pectin – the starch that makes the jam thicken – and showcases rhubarb brilliantly. You will need two 500g or four 250g sterilised jam jars with waxed jam covers.

MAKES 2 X 500G OR 4 X 250G JARS

Preparation time 10 minutes
Cooking time 20 minutes

600g rhubarb, cut into 2.5cm pieces
600g caster sugar
juice of 1 blood orange, plus the rind, peeled into strips and cut into small pieces
2 tbsp lemon juice

Put the rhubarb pieces into a heavy-based casserole and pour over the sugar. Throw in the blood orange rind and squeeze in the juice along with the lemon juice. Place over a gentle heat initially, stirring to prevent the sugar catching. Once the sugar has melted whack up the heat and bring to the boil.

Allow to boil for 10–15 minutes, or until tiny bubbles stop appearing. You can check whether the jam is syrupy enough by dropping a blob on to a cold plate, leaving it for 30 seconds, then seeing whether a finger tip makes it wrinkle. If it does, it's ready. Turn off the heat. Divide between the jam jars and seal. Allow the jam to cool completely, as it will thicken as it cools.

Index

Planet Friendly Bolognese **25–7**

Pork & Apple 'Stroganoff' with Hot Dog Onions **80**

Wild Mushroom & Madeira Sauce **174**

Mustard Gravy **179–80**

N

noodles

Sichuan Hand Pulled Noodles **205–7**

Xian Lamb & Cumin Hand Pulled Noodles **209–10**

O

onions

Beef & Potato Sauce **30**

Hot Dog Onions **80**

Onion Gravy **154**

oranges

Rhubarb & Blood Orange Jam **248**

Roast Duck with Blood Orange Gravy **158**

ox cheeks

Beef & Potato Sauce **30**

Ox Cheeks Stewed with Wine & Beer **32–3**

Steak & Kidney Pudding **69–71**

Oxtail Stew **34**

P

pancetta

Sausage, Roasted Squash & Potatoes with Pancetta & Chilli **154**

Paneer Makhani **110**

Parsley Sauce **244**

parsnips

Root Veg Mash **123**

pasta

Baked Kale, Spinach & Ricotta

Stuffed Conchiglioni **118**

Crab, Chilli & Lemon Linguine **55**

Fresh Hand Rolled Pasta **196–9**

Planet Friendly Bolognese **25–7**

Vegetable Lasagne **141–2**

Venetian Duck Ragu **39**

pastry **127–8, 212–13**

baking blind **213**

lining a tart case **213–14**

Puff Pastry **222–7**

Shortcrust Pastry **215**

Suet Pastry **69–70**

Pavlova

Chocolate Pavlova with Poached Pears **149–50**

Peaches, Poached **76**

pearl barley

Golabki **104–7**

Under the Weather All the Veg Soup **20**

pears

Chocolate Pavlova with Poached Pears **149–50**

Pickled Pears **243**

Poached Pears **75**

peas

Braised Peas with Little Gems, Spring Onions & Wild Garlic **88**

Pease Pudding, Gingery **57**

peppercorns

Green Peppercorn Sauce **241**

peppers

Rouille **246**

Vegetable Lasagne **141–2**

Pickled Pears **243**

Pierogi Dumplings **200**

Beetroot & Horseradish Pierogi **202**

Potato & Cheese Pierogi **202**

pies **35**

Chicken, Buttermilk & Wild Garlic

Pie **127–8**

Lemon Sherbet Meringue Pie **144–7**

see also pasta; tarts

Planet Friendly Bolognese **25–7**

Plums, Poached **76**

poaching crab **48–9**

poaching fruit **75–6**

Polenta, Cheesy **100**

pork

Blonde Ragu with Pork, Veal & Sage **28**

Golabki **104–7**

Pork & Apple 'Stroganoff' with Hot Dog Onions **80**

Pork Meatloaf **174**

Souped-up Kimchi Jjigae **14**

potatoes

Aligot **84**

Beef & Potato Stew **30**

Big Plate Chicken **37**

Caldeirada Fish Stew **93–4**

Lamb Hotpot **138**

Potato & Cheese Pierogi **202**

Sausage, Roasted Squash & Potatoes with Pancetta & Chilli **154**

Ultimate Salt Baked Potato **134–7**

poultry **159**

see also chicken; duck

prawns

Caldeirada Fish Stew **93–4**

Dirty Prawns, Spring Onions & Bacon **101**

Puff Pastry **222–7**

Q

Quiche: Leek, Bacon & Cheese **216**

R

ragu

Blonde Ragu with Pork, Veal &

Acknowledgements

Right, so this bit is always filled with emotion, because writing a book takes a lot of yourself. You rack your brains for memories, drag up good stuff, bad stuff, revisit tastes and smells. This book has pushed it even further; I've been forced to face many moral issues in food and questioned how I look at the ethics of how we source the food we eat, which has been heartbreaking, but also heartwarming, when I look at the fantastic movements by many small producers and how the agricultural industry is slowly but surely pushing for change. There are some incredible people out there. Then to the cooks that inspired me to push through with this. This book has been called a coming-of-age book for me and I do feel like this year I have matured in many ways. Opening two businesses, Mare Street Market and Pure Filth, and writing this book has let me be what I've always aimed to be, but maybe never had the confidence to achieve.

The number one person who needs thanking is my side-kick, right arm, soul-sister, best friend, and therapist Rose Dougall. Another blinder. There are simply no words to describe my feelings for you and what you do for me. You are the single most important person in my life. I cannot function without you.

Thank you doesn't seem enough to my Editorial Director at HarperCollins, Rachel Kenny, for totally supporting me as a unique and complex creature and standing by my vision when others didn't. I knew when we met things were meant to be. This has been the easiest team I've ever worked with. You girls are all so calm, fun, creative and cool. A total JOY! Thank you, Celia Lomas, Sarah Hammond, Louise McGrory, Mary-Jane Wilkins and Clare Sayer. I'm sorry for occasionally being late with copy and often in a bit of a flap, but you all got me there and did a sterling job.

Thank you to my guyz! The food and art team. So chuffed I finally got to work with you Issy Croker, and what a fantastic eye you have. The photographs are outstanding – so perfect. Plus thanks for introducing me to Red Vermouth on the beach in Winchelsea. What a time. Still gutted I couldn't wake up for one of your gym classes on the beach! Special extra thanks to my bae Emily Ezekiel. Every book gets stronger and stronger. You're an eternal inspiration to me and I love and cherish you as one of my greatest friends. The only person in the universe who can put me in my place too, gotta love that. Also thanks for endless hard work and fun times, Steph McLeod, Kitty Coles, Cissy Difford. To Dean, I don't

even know where to start. I think you are finally beginning to believe in your talent. Your work always speaks for itself, but this time I've seen a switch. You've been a joy to work with. I'm so proud of us: we were a couple for 10 years and we had a funny few, but now a few years on we're tighter than ever. I love you so hard!

Enormous thanks as always to my management, Severine. I'm sure I must have said this in every acknowledgments, but you are more my sister than my agent. This has been another bananas year but thanks to you I've achieved all my wildest dreams. Thanks for constantly pushing me on, being so honest with me and not ever blowing smoke up my arse. I know sometimes when I revolt it seems as though I don't value you, but it all goes in and we always get there. Love you so, so much. To Jonathon Shalit. It's been 10 years can you believe it! Thank you for bearing with me the last few years. I know I've made some professional decisions that have left me not working as much through the agency, and with that you have provided me with continual support both, emotionally and financially and I am eternally grateful for this. I'm so lucky to have worked with the same people for so long, to the point of being family. Tim Beaumont, my publicist, we've had a great year. I'm so glad we found our groove again. Look at what we've achieved. I love you to pieces. Thanks also to Arthur Day and Yazmin McKenzie.

My partner at Mare street; Marc Francis Baum. My right hand man and head chef Phil Smith, and every single one of the cooks, floor staff and KP's at Mare Street Market, Rose Ferguson, Dougal Brech, April Morgan, Jonathan Downey and all at Street feast and London Union. Warren Johnston at W Communications, James Whetlor at Cabrito, Matt Chatfield at Cornwall Project, Andreas Georghiou from Andreas of Chelsea Green, Mark from Dingley Dell, James George and Richard Turner of Turner and George, Daniel Murphy at Fin and Flounder and my ever suffering best chef friend Neil Rankin. To Martha, Sophie, Vic, Caroline, Nick and Stephen, thanks for always being there for me.

My family, starting with my mother, Mother Maria, another book full of your classics. It blows my mind that even on book five, I still find inspiration in what I've learned from you. To Heni, Cora, Matt, Kieron, Sholto and Beck! And a special shout out to Edie who, after many chats in the pool in Spain last year, helped come up with so many recipes and get me on the right track. Love you all to the ends of the Earth.